INNER
GUIDANCE
and the FOUR
SPIRITUAL GIFTS

INNER GUIDANCE
and *the* FOUR
SPIRITUAL GIFTS

● ■ ▲ ∞

How to Maximize Your Intuition
and Inspirations to Become More Creative,
Successful and Fulfilled

HOWARD WIMER

INNER EXPANSION PUBLISHING, INC.

Library of Congress Control Number: 2007928053

ISBN-10: 0-9789645-0-0
ISBN-13: 978-0-9789645-0-4

10 9 8 7 6 5 4 3 2 1

For information, contact:
Inner Expansion Publishing, Inc.
P.O. Box 53906
Irvine, California 92619-3906
Telephone: 1-866-241-6708 Toll-Free (U.S. and Canada) or
001+ 949-474-5542 (international)
Website: www.innerexpansion.com/publishing
E-mail: publishing@innerexpansion.com

Cover design: James Bennett Design
Interior design and production: Sara L. Malloure

This book is dedicated to you
and to everyone you will inspire after reading this book
to live a better and more fulfilling life.

Contents

PRACTICAL EXERCISES

Acknowledgments

I feel as if I have been working on this book for over thirty years now, and I want to thank everyone who has ever come to one of my lectures or workshops in the many countries I have visited during this time. The opportunity to work with people from around the world is the best occupation a person can have. I was welcomed by everyone I met and was able to integrate into the communities I visited. In addition, sharing through the media wherever I have gone has been a highlight of my life. There is nothing better than being able to share tools and techniques that people can use in a practical way to improve their lives and the lives of everyone around them.

If it had not been for my dear friend and colleague Dr. Francisco Coll, this book would never have been written. Dr. Coll had a profound influence on me during our many years together and, along with others, taught me that inner communication is the most important asset a person can attain during his or her life. His dedication to making the understanding of spiritual energy simple and accessible to those who have a sincere desire to grow and share their own wisdom with others was a wonderful example to me.

Following Dr. Coll's passing in 1999, after we had returned from Australia and New Zealand training people in

spiritual energy techniques, it took me about a year to decide whether to continue my own work in this area. I have since committed over half of my life to doing exactly that, and in the process, Inner Expansion Workshops was born.

Inner Guidance and the Four Spiritual Gifts is the first in a series of insightful books that I hope will give you some keys to living your life the way you have always wanted to live it—for yourself first. If you follow the simple techniques at the end of each chapter and practice them as needed, you will find that your outlook on life will change dramatically.

I also want to thank my friend and colleague, Lauren Rose, who has invested many hours proofreading all of the manuscripts that were the forerunners for this book, and Patricia Spadaro and Janet Chaikin, who edited and crafted the final manuscript so that the concepts and ideas presented would make perfect sense to you, the reader. Thanks also to Nigel Yorwerth of PublishingCoaches.com, whose enthusiasm and publishing expertise has made this a fun and enjoyable experience.

Your Personal Communication System

We all get hunches and inspirations. In fact, we can get as many as eighty to ninety a day. These inspirations are what energize us, fuel our creativity and give us clear direction—but only if we listen to them. Often we're so busy that we don't tune in to what our inner guidance is telling us, or when the messages do get through we discount them.

Imagine what it would be like to have your life flow more smoothly because you are alert and attentive and act on the inspirations you receive moment by moment. You can do just that by heightening your inner sensitivity, trusting your true feelings and relating to yourself and others through your own innate style of communication. All this is part of your personal communication system.

Communication is the key to living a fulfilling life. It's what connects you with others—and with yourself. When you use your personal communication system to listen to your inner guidance, not just every once in a while or at peak moments but every single day, you will find that things just fall

into place. You will get the specific and very practical direction you need in all areas of your life. But when you tune out that guidance, you may find yourself out in left field, wondering what happened and why.

When I first started out in the film business in my early twenties, I learned what can happen when we ignore our inner guidance. It was a lesson that has stayed with me ever since. A friend came to the office one day and asked me if I could help him edit a small-budget feature film. It was an independent production based on a wildlife adventure story. The idea of editing a full-length motion picture was an exciting prospect for me at the time since I had just started my new career. What an opportunity! But something inside me didn't feel right about it.

I had just learned how important it was to follow my hunches, and I wanted to be true to myself. I told my friend that I couldn't do it because we had some other projects coming in that I had to work on before I would be able to finish his ninety-minute feature film, which was a three-month endeavor. He kept asking me to help him, but I stood my ground because I knew that something wasn't right. After about a week, he was begging me to do it. I didn't want to let him down, so I gave in and said, "Okay, I'll do it."

The project went smoothly for about a month and then everything fell apart. The team ran out of funds to finish the film, and my friend asked me if I would continue on without pay and agree instead to get a percentage of the profits once it hit the theaters. Because of my personal integrity and my commitment to my friend, I said that I would. The schedule was so tight that we barely got the film to the first showing on time. It was held up in the film lab and arrived at the theater

ten minutes late. As you may have guessed by now, the film never made a profit, and as a result of my spending so much time trying to help my friend, my company lost one of our biggest clients. Did I learn my lesson? You bet I did.

Trusting Your Inner Guidance

The more you learn to pay attention to the hunches, ideas, feelings and visions you get, the more open you will be to your life unfolding in ways that you never thought possible. You never know when that guidance will come or where it will lead you, but it will always help you be in the right place at the right time. In contrast to the experience I had editing the feature film, take the story of a woman I met recently who discovered the power of trusting her intuition no matter what. After reading it, ask yourself if you have ever had a similar experience of following a feeling or a hunch and getting just what you needed—and just in time.

Claudia was born in the Ukraine and grew up under the rule of the Soviet Union. From the time she was a small girl, she was fascinated by the English language. Though she insisted she was going to be an actress, all of her friends knew she would become an English teacher. For many years, she continued to study and eventually started teaching English to a group of medical students at a prestigious university. She loved her work, but found herself moving from place to place every four years. She knew she was searching for something, but she didn't know what it was. This pattern continued for twenty-five years.

In 1985, Claudia got a copy of the United States Constitution from the local library to do some research for her

class. The faculty of the university found out about it and labeled her as anti-Soviet. She was devastated. She applied to several other educational institutions, but no one would hire her. For five more years, she took whatever job she could find in order to survive.

Luckily, in 1990, democracy was in full swing and a massive migration had started. The Berlin Wall had come down and the Soviet Union was crumbling. Many people were going to America, and Claudia thought to herself, "Why not me? At least I know the language!" She applied for a passport and it was granted. She procrastinated for six months, until she had only two days left before her passport expired. Even though she was an educated woman, she was still apprehensive about moving to a completely different country, especially when she didn't know a soul there. What would she do and how would she earn a living? She decided to throw away her doubts and made a decision: "I'm going!"

She raced down to the nearest travel agency—they were closing in fifteen minutes—and bought the last plane ticket to Moscow, which had been reserved for someone who had not shown up. When she arrived in Moscow the following day, she was interviewed at the American Embassy. Would they notice that her passport would expire the next day? They granted her a visitor visa for six months, but she still needed to extend her passport. She rushed to the Office of Visas and Registration, and it was granted.

Claudia arrived at the Moscow airport at seven the next morning in hopes of getting a plane ticket, but there were hundreds of people standing in line, some to buy tickets and others to pass through customs control and board their flights. A plane was leaving for New York City in forty min-

utes and someone suggested that Claudia get in the line with people who already had tickets. She wasn't sure why, but something inside her said that this was what she should do. Although she felt embarrassed, she started talking to the man in front of her. When she explained that someone had told her she would have a better chance of getting a ticket in this line, he quickly said, "That person is wrong! Tell you what, go to the hall and find some mafia." He told her that this was the only way to get a last-minute ticket. At first Claudia thought he was kidding but then realized he wasn't. She only had twenty minutes left.

She rushed into the hall, urgently looking for someone who might be part of the mafia, even though she had no idea what someone in the mafia would look like. Then she spotted two men renting luggage carts and, without knowing why, felt compelled to ask them how much it would cost to rent a cart. "Three rubles. Do you want one?" asked one of the men. "I would if I had a ticket," she replied.

The man told her to stay close by so that he could see her. Then he asked for her name and where she wanted to go and said he would get her a ticket. He disappeared and, not long after, a woman who looked like a stewardess appeared in front of her and asked if she had gotten her ticket yet. When Claudia said no, the woman replied, "Go to any window. Rush! We are taking off!" Claudia suddenly realized that someone had reserved a ticket for her at the counter. Even though it seemed that it would be next to impossible to get through the crowd to the ticket office cash register, the people let her through to pay for her ticket.

The stewardess suddenly appeared again and asked her if she had paid for the "service." Claudia realized she still

had one more piper to pay and rushed over to the man with the carts, who was surrounded by a crowd of people. She grabbed him and said, "Please, help me!" By this time, she was frantic and handed him her purse. Neither he nor she knew how much money he actually took. Miraculously, Claudia made it to the plane in time because the flight to New York had been delayed for twenty minutes. She thought to herself, almost out loud, "Someone is leading me." Claudia still doesn't know how that man made it happen— and so quickly.

The story doesn't end there. When Claudia was safely on the plane, she met an American woman who was a scientist and had just finished a tour of Russia. She advised Claudia to never go back to Russia but to stay in the United States, whatever it took. This gave Claudia the confidence she needed to pursue her mission. When she landed in New York, she had exactly $367—the amount she was allowed to bring by the Russian government—so she decided to continue on to Detroit, which left her with exactly $100 in her pocket after she purchased her ticket. She knew something was guiding her.

After only ten days in America, she came across a Ukrainian and American museum and knocked on the door. An old man answered and invited her in. Another Ukrainian gentleman, who was taken by Claudia's soft southern Ukrainian accent, joined them a few minutes later. The son of a professor and an opera singer from the Lvov Conservatoria, he said that he could listen to her voice day and night, as it sounded like music. The two fell in love and married. They were together for six years when he passed on—just one week after she had been granted full American citizenship. Claudia

feels that part of her husband's mission in life was to help her complete hers and that she had been in the right place at the right time because she followed her inner guidance each step of the way and was true to herself.

Learning to become sensitive to what your inner guidance is trying to tell you is not just a matter of listening. We also have to get beyond the concepts we learned as children—those "tapes" inside our heads that tell us what we should or should not do. What we learned about life and about relating to others from our parents or those who raised us can actually run counter to our innate and most effective way of communicating.

Each of us is born with a natural way of receiving inspirations and insights and then sharing them with others. I call this our "inner and outer communication system." Your personal communication system may be completely different from those who raised you. If you have taken on their mode of expression rather than relying on your own, you may at times find yourself getting confused, feeling frustrated or doubting your inner promptings.

It doesn't have to be that way. What you will explore in this book is a new and effective way of identifying and working with your individual communication style based on four distinct avenues of communication. You will learn how to identify which of those avenues is your strongest and how to use it to access your inner guidance and make your best decisions every day.

Making the most of your inner guidance by fully developing your personal communication system is one of the most important skills you will ever learn. It's an inner skill that will bring greater creativity and fulfillment into your life

and help you live true to your life's purpose. It will also help you to help your friends, loved ones and business associates because you'll be better able to tune in to their needs, share your wisdom and choose the best way of communicating with them, no matter how different they are from you.

The Four Avenues of Communication

Do you ever talk with people and have absolutely no clue what they're trying to communicate to you, even though they're speaking the same language? And then you talk with others and feel as if you're immediately on the same wavelength? There's a simple reason for this. It has to do with the way each of us is wired, so to speak. This inner wiring affects not only how we communicate but also why and how we do the things we do.

The way we communicate with ourselves and with others is determined by something most of us don't normally associate with communication. Below the surface, the real factors that determine how we communicate are the four spiritual gifts. Every one of us is born with all four of these gifts—the gifts of *prophecy, clairvoyance, clairaudience,* and *healing* (or *feeling*). Each gift has its own qualities that determine how we pick up information, express ourselves and relate to our environment and other people. The gifts that are most fully developed within us even shape our personality. In essence, you can think of the four gifts as modes of expression that help you navigate through life.

Here's a snapshot of the four gifts you will be learning about in detail in this book.

Prophecy: If prophecy is your main spiritual gift, you will get hunches, or inner knowings, about things that are going to happen to you or in the world. You look at the big picture and can keep track of many different projects at the same time. This ability makes you a great manager. Those whose primary gift is prophecy (prophetics) can easily see the potential in themselves and others, and they express themselves freely and openly. They are also highly creative and often become artists and musicians.

Clairvoyance: If clairvoyance is your first gift, you are easily able to picture people and events in your mind's eye. This is how you receive and retain information. Because you are consistently creating images in your head, you are able to recall those "movies" whenever you want. Clairvoyants gravitate toward professions where they can "see" themselves making a difference in the world. They make great professors, teachers, salespeople, designers and decorators. They are analytical, love to read and have tremendous empathy for others.

Clairaudience: If clairaudience is your first gift, you will have a conversation running in your mind all the time. You may think you are talking to yourself, but often you are communicating with your inner guidance. You are introspective, practical and discerning and can accurately read other people. Your hearing is sensitive, so you often hear sounds that no one else hears, and loud noises may bother you. Clairaudients

like to have all the facts, can keep things organized, have a strong sense of inner direction and are good decision makers—qualities that make them natural leaders.

Healing: Finally, if you have healing (or feeling) as your first and main gift, you will tend to get a feeling inside about what is best for you and what is not. Relationships are very important to you. You have a warm and bubbly nature and a knack for helping people feel good about themselves. You can sense when others need healing and will have the desire to put your hands on them or give them a hug. Healers are great with details and are often drawn to work in the healing arts.

While every one of us has all four of these gifts, we have them in a different order of prominence. The order of your gifts determines which means of communication you use most frequently and how you pick up information and inspiration. For prophetics, their inspiration comes as an inner knowing, hunch or impression; for clairvoyants, it comes as an inner vision or picture in their mind's eye; for clairaudients, inspiration comes as an inner thought or idea; and for healers (or feelers), it comes as an inner feeling.

You may not be aware that you are using one or two of your gifts more than the others to communicate, but you are. When you were born, you chose which one of the four gifts would help you the most to accomplish your life purpose. This is your main, or first, gift (or avenue of communication). You also chose the order in which you wanted to use the

other three gifts. You make your best decisions when you rely on your main gift, so when you use that gift to tune in to your inner guidance and then follow your first impression, you will always be moving in the right direction for you. Your second spiritual gift is your next best way of communicating, the third is next, and your fourth gift is your least preferred way of communicating.

When you pick up an inspiration, you will experience it through all of the spiritual gifts at the speed of light, based on the gift order you have chosen for yourself. For example, if you are clairvoyant first, a prophetic second, a clairaudient third and a healer fourth, you will receive an inner vision first, a hunch second, a thought or idea third and an inner feeling fourth. All this will happen almost simultaneously, but in that order. Because we are most comfortable communicating through our strongest gifts, we tend to communicate better with people who have the same gift order as we do. While you may share the same gift order with many other people, obviously you are unique, because there is no one on planet earth with the same experiences or attitudes as you. As you will come to see in these pages, we can learn to communicate with anyone as long as we first understand how he or she innately prefers to communicate with us.

Connecting Effectively with Everyone

In chapters 4 through 12, I will be explaining each of the four gifts in depth. You will learn how to recognize the balanced and unbalanced sides of each gift and how to bring yourself back into balance so that you are using your gifts to your greatest benefit. Although you have gifts that you

naturally use more than others, by working with the infor-
mation and examples in these chapters, you will learn how
you can unfold each gift to 100 percent of its potential within
you. That's to your advantage, because when you develop all
of the gifts, you will be able to move in and out of each mode,
as the situation requires, and communicate effectively with
everyone you come in contact with. You will also be able to
identify the spiritual gifts that other people are using to com-
municate with you. Wouldn't you like to know where people
are coming from and what they need so that you can be of
greater service to them?

When any two of us are not in sync, communication takes
longer. This throws off our timing and makes it difficult to un-
derstand each other. Here's an example of what it can look
like when people with different primary gifts try to communi-
cate with each other. Say a husband's first gift is clairaudience
and his second gift is prophecy, and his wife has clairvoyance
as her first gift and prophecy as her second gift. I have found
that married couples will sometimes communicate with each
other through their second gift if that is the gift they share in
common. Therefore, in this example, because the husband
and wife share the prophetic gift as their second most favored
way of communicating, they will unconsciously communicate
with each other through their closest common denominator—
in this case, prophecy. They just get an inner knowing of what
the other is thinking or needing. But that isn't the ideal way
for them, or any of us, to communicate.

Once the husband understands that his wife (a clairvoy-
ant) needs to see a complete picture in her mind before she
can make a clear decision, he will have no problem commu-
nicating with her through her first spiritual gift of clairvoy-

ance if he gives her what she needs in order to "see" the big picture. By the same token, once she is aware that her husband (a clairaudient) needs a complete understanding of all the relevant facts of a situation—the what, when, where and why—she can communicate those facts to him. When she does, she will find that he will "get it," and she will feel as if he's listening to her. Think of how many marriages that could save! Chapter 12 explores in greater depth the relationship between all of the gifts and how you can effectively communicate with people who have different gifts than you.

What I have shared so far is just a taste of the four gifts and how they can influence your life. Throughout this book, you will have an opportunity to discover your personal communication style and learn how to put your spiritual gifts into action in every area of your life. You will also learn that in order to communicate effectively with others, you must first know how to communicate with yourself by paying attention to the inspirations you get every day. Both skills are essential for success and happiness in any area of your life.

The first step to exploring your inner communication system is to understand where your inspirations come from. Do they come from within you or from a higher source that you can tap into? The answer is both. Many times what we think is our inspiration really comes from the spiritual helpers who work with us. What we think of as our intuition is the avenue, or conduit, through which we pick up these inspirations. By heightening your sensitivity and realizing that the inspiration you receive is not just a passing thought or feeling, you can start to unfold a more solid relationship with yourself as well as your personal team of spiritual helpers, a topic we will explore further in chapter 2.

● ■ ▲ ∞

Learning to Listen

A PRACTICAL EXERCISE YOU CAN DO NOW

How can you tell the difference between what is true inspiration and what is not? One way to discern this is by the tenor, or tone, of what you are thinking or feeling. Whenever you receive an inspiration from your personal team of spiritual helpers—whether as a hunch, a visual image in your mind's eye, a thought or idea that "pops" into your head or a gut feeling—it will always be positive. If what you're thinking or feeling is negative, it is not coming from them.

You can also tell where the inspiration is coming from by the way it is phrased. For example, when your spiritual helpers are giving you guidance, they will never tell you what to do. They may make a suggestion, but they will never order you to do something, and they certainly wouldn't suggest that you do something that would hurt you or someone else, either spiritually or physically. They will never say, "You should do this" or "You should do that." If you hear a voice inside your mind telling you that you must do something, this is not your inner guidance! Rather, it is part of your inner programming that originated in the first seven years of your life. You may be hearing a replay of a tape from one or both of your parents. But if the inspiration you are getting is positive and encouraging, it is most likely a hint from your inner guidance to steer clear of a bump in the road or to move in a direction that will benefit you.

Here are some key phrases that can help you distinguish between positive inspirations that you are picking up from your inner guidance and negative thoughts that are coming from your past programming. While you may not actually "hear" these words being said, you may sense them in your mind.

Positive inspirations:

1. We suggest ...
2. You might want to ...
3. A good idea might be ...
4. That feels right ...
5. I wonder if ...

Negative or complacent thoughts:

1. You should ...
2. If you don't do this ... (you will regret it)
3. I can't ... (do something)
4. What will people think of me?
5. I'm not good enough ...

Why is it so important to distinguish between these positive and negative thoughts and feelings? If you indulge in the negative or complacent thoughts and concepts that you picked up from your early indoctrination and assume that they are the voice of your inner guidance, you will continue to indulge in this negativity for the rest of your life.

The following simple practice can also help you take note of the inspirations you receive and distinguish them from other kinds of thoughts and impressions:

1. Keep a pen and pad of paper with you during the day for making notes. Whenever you feel that you are getting an inspiration, write it down.

2. Take note of the hunch, picture, idea or feeling that comes into your head as a result of the inspiration and how it is phrased (refer to the above lists).

3. Take a second look to see whether it stimulates feelings of guilt, obligation or heaviness within you.

4. At the end of the day, underline the phrases that are positive and inspirational. Then look at the others to see if they are related to how you have been programmed to think by people other than yourself.

Another aspect to look at when discerning what is and what is not your inner guidance is the motivation surrounding the thought or feeling. If you are getting an inspiration to help someone so he can learn how to help himself, your motives are most likely clear. If you are helping a person because you feel sorry for him or because the person is making you feel guilty, you may want to take a second look at why you are doing what you are doing.

················· ● ■ ▲ ∞ ·················

How to Start Identifying the Four Spiritual Gifts in Yourself and Others

A PRACTICAL EXERCISE YOU CAN DO NOW

You can begin to unfold your spiritual gifts and learn about your inner and outer communication system by paying attention to how you communicate with others. If you say "you know" a lot, you may be working much of the time in the gift of prophecy. If you are clairvoyant, you will wonder why others don't see the same picture as you when it is so clear in your mind. If you're a clairaudient, you may find yourself getting impatient with your loved ones when they don't give you all of the facts you need to make an intelligent decision. If you are a healer (feeler), you may get emotional when you watch a movie, or you may take on other people's feelings and think they are your own.

Take the time to listen to how you convey your thoughts and feelings. Then listen to how others communicate with you. Here's an exercise that can help you begin this process.

1. Find two friends with whom you have a special rapport.

2. At separate times, have each of them communicate to you an experience they had during the week that meant something to them.

3. Listen to the words they use when they are describing the experience.

4. Pay attention to key words or phrases, such as:

 "I knew that was going to happen" or "I just knew they were going to do that to me." (prophetic gift)

 "I could just see that this was not going to work out" or "Do you see what I mean?" (clairvoyant gift)

 "I understood what they wanted and I made sure that they got it—no matter what it took" or "I just couldn't understand what this person was trying to tell me." (clairaudient gift)

 "Something just didn't feel right" or "I just wanted to cry, I felt so bad for her." (healing gift)

5. Write down the key words your friends are using when describing their experiences and note how many times they say them, if you can.

6. Then tell them about an experience you had this week and use the same key words or phrases they used when they shared with you. Do it naturally so they don't think you are mimicking them.

7. Ask them if they understood everything you said to them. If they don't have any questions, it means that you have totally tuned in to how they communicate with themselves.

8. See if you can figure out the main spiritual gift of each of your friends.

9. Then share with each friend the personality traits you have learned so far about each one of the spiritual gifts and ask them if they can relate to any of them.

10. Share with them which of the spiritual gifts you feel may be your main avenue of communication.

CHAPTER TWO

Where Does
Inspiration Come From?

Whether or not we are consciously aware of it, each and every one of us comes to planet earth with a team of helpers to assist us with our life purpose. Before we are born, we decide what we want to accomplish and we choose the spiritual helpers who can best assist us. They are totally benevolent beings who want to help us get to their level of awareness, and so they are continually sending us inspiration.

Your personal guides are no different than you; they have simply already learned the lessons that you now need to learn. I often call these spiritual helpers "guardian angels" or "personal angels." Some people think that guardian angels are a fairy tale, or they associate them with some religious doctrine. But they are, in fact, very real. This chapter may provide a different way of thinking about the term *angels* than you have been taught. My experience has shown me that they work with us at personal levels, providing us with guidance that is both specific and practical. Let me start by telling you how I first

became aware of my angels and how they helped me discover what I was supposed to do with my life.

When I was twenty-three years old, I learned that I had a whole team of spiritual helpers working with me. I was not a particularly religious person and never really thought about guardian angels helping me and guiding me through life. What I came to realize is that everyone has a team of these spiritual guides that they can tap into on a moment's notice to get creative inspiration. Because I had invested over ten years of my life learning music and had become an award-winning jazz musician and filmmaker, creativity was extremely important to me. It was my whole life.

My experiences with my spiritual guides began in 1973, when I attended a seminar sponsored by a group started in the mid-60s by the late Dr. Francisco Coll, a gentleman who became aware early in life that he could tap into this inspiration anytime he wanted. Later, after we started working closely together, he shared with me that at the age of only six, his inner guidance would tell him where everyone was hiding when he played hide-and-seek with other kids in the neighborhood. As a result of paying attention to this inner voice, after a while no one would play with him. They thought he was cheating!

Thanks to Dr. Coll and others, I found out that I, too, could tap into this kind of inner guidance. Even though this was foreign to me at the time, I was open. Dr. Coll also taught me how we pick up inspiration through the four spiritual gifts and how each avenue influences the way we communicate with ourselves, our spiritual helpers and other people in our environment. Since then, I have unfolded these spiritual gifts within myself and developed my own techniques to

show thousands of others a practical way to communicate with their spiritual helpers to bring out their full potential.

Getting Inspiration Every Day

After learning how to communicate with my angels, I started getting inspiration from them right away. During this period, I drifted away from the music business, where I had devoted most of my time during my college years, and started a new career in film and video in Dallas, Texas. My goal was to be a producer, director and writer. To get the experience I needed and to earn a living, I started by working with a film editing post-production house. Every time someone would come in to edit a marketing or educational film, I would tap into my intuition and come up with the perfect ideas.

One day, the public relations director for the Dallas Tornado Soccer Club came to my door (this franchise was owned by the late Lamar Hunt, an oil millionaire in Texas and the person who invented the term *Super Bowl* when he was the owner of the Kansas City Chiefs football team). He wanted to produce and edit a seasonal highlight film. Three days after we started on the project, he overheard a conversation I was having with a friend about working with my metaphysical abilities and asked me what it was all about. At that time, telling people that there was spiritual guidance they could access was not part of my personal agenda. I thought it might interfere with my professional and business relationships.

Even so, he pressed me about it, and I gave in. I referred him to an associate of Dr. Coll's who had also helped me connect with this guidance. When the PR director didn't show up for three days to work with me, I decided to call him at his

home and find out if there was a problem. He admitted that he had been meditating and finally said, "I had so many things to ask my angels, I totally lost track of time!" I had to laugh because I knew exactly what he was experiencing.

After that, the two of us worked so closely with our angels, getting inspiration every day, that everything fell into place. Since we were working on a sports film, we put together the highlights and he wrote the narration. When we laid in the narration track, it fit perfectly. We didn't have to cut one single frame! What an amazing experience. Anyone who has ever been a film or video editor knows that it is virtually impossible for someone to write copy that fits perfectly into a thirty-minute project the first time around. But it happened.

After about a year and a half, I was having so much fun working with my personal team of spiritual helpers using my new-found communication system that I decided to go on a full-time lecture tour and show others how to get answers for themselves. To me, being able to tap into the inspiration I am receiving all the time is total spiritual freedom. It means that no matter what I do or where I go, I always have a spiritual lifeline—I can ask questions and get direct answers. Since then, over the last thirty years, I have lectured in thirteen countries and reached thousands of people throughout the world with Web seminars. I've never looked back, although I did make a handful of pit stops along the way.

In 1979, I decided to take some time off from touring around the United States and headed for California. As I drove through Phoenix, I told my angels that I wanted to work with the best people in Hollywood. I didn't know if this was something I would do as my final career, but I just couldn't get the idea of producing and writing out of my system, at

least at that point in my life. When I arrived in Los Angeles, I got an inspiration. I said to myself, "Wouldn't it be great to work with someone like Steve Allen, and then I could do lectures on the side whenever I wanted." Steve was the famous comedian, musician and author who created *The Tonight Show* on NBC television in the 1950s. I had grown up watching his shows. Known for his diverse talents, Steve was one of the most admired celebrities in Hollywood at the time.

The next day, as I was navigating down the 405 Freeway, I had this feeling to get off at Sepulveda, which took me to Burbank Boulevard in Van Nuys. As I was heading down the street, I got this incredible feeling to stop. It was so strong that I couldn't have gone any farther if I had wanted to, but I knew that if I stayed where I was, someone was going to ram into the back of my car. So I turned left and found myself in a parking lot next to a two-story building. I looked up, and in front of an empty parking space I saw the words *Steve Allen*.

I had met Steve and Jayne Meadows, his wife and a talented actress in her own right, several years earlier on a visit to California when I was in high school. A friend of my father's had worked with Steve for many years and so I had gotten the chance to be in the audience for one of his syndicated talk shows and met him backstage. But I had never been to his office. I got out of my car and followed two women up the stairway to the second floor of the building, not really knowing if I was heading in the right direction. I was. I soon found out that this was Steve Allen's office.

At the top of the stairs, one of the women I had followed came up to me and asked if she could help me. I said, rather curiously, "My name is Howard Wimer, and I was wondering if there might be an opportunity to work here." She looked

at me for a moment and then said, "Why don't you go into the music room. I'll join you in a minute." Reality started to set in. Just five minutes before, I had been traveling down the San Diego Freeway not knowing exactly where I was headed or why. Now I was asking for a job at Steve Allen's office.

True to her word, she showed up and found me sitting at the piano and staring at all of the pictures on the wall and the file drawers where "Steverino," as he was called by his many fans, stored all of the lead sheets for the four thousand songs he had written up to that time. She again looked at me strangely and said, "By the way, how did you know that there was a gentleman here who turned in his two-week notice three hours ago?" At that point, I realized that my angels were working overtime and simply said, "Really?"

Over the next few minutes, I showed her my résumé. Sensing that I was overqualified for the job that this young man was leaving so that he could go back to school, she proceeded to try to talk me out of applying for the position. "You really don't want this job," she said. "You would be working in the office, and you have more of a production background." All the time she was telling me this, I could hear one of my angels clairaudiently in my head saying, "Take it—just take it!" I finally convinced her that I was serious and that the hourly wage really didn't bother me, since I had just arrived in L.A. the night before and I needed something to tide me over. Of course, I knew that this would be a great opportunity to get to know other people and to learn as much as I could from Steve himself.

Over the next few months, I truly was able to work with the "best people in Hollywood." I had the opportunity to see

the inner workings of a top celebrity office and I learned a lot from Steve about how to communicate, not only through the written word but also by seeing how he promoted his television programs and books. Since Steve didn't read music, I was able to help him by transcribing the numerous songs he had recorded on audiocassette.

I stayed in the position for nine months. At that point, I decided that my true desire was to share with others how beautiful life can be when we learn how to have this inspired communication with our personal angels. I wrote a note to Steve and he graciously accepted the fact that I was going to head out and make my own way. It wasn't long before I was lecturing and giving seminars in Europe as well as Australia and several other countries.

Learning from Those Who Have Gone Before Us

What happened to me in those situations is not out of the ordinary. We all have at least one or two spiritual helpers who have been working with us from the time we were born, and even before, giving us inspiration and specific guidance to help us with our life purpose.

If you come from a more traditional or religious belief system, you may think of divine inspiration as coming from angels or the Holy Spirit. If you have studied metaphysics or are involved with Eastern philosophy, you may think of it as coming from spiritual guides, ascended masters or master souls. In this book, I refer to our spiritual helpers as guardian angels, personal angels, our spiritual guidance or simply as our guidance. Whatever name we use, these helpers are one and the same. There is only one basic system in the cosmos.

Unfortunately, many different names have been given to the same experience or phenomenon, which is why there is so much confusion and competition between different religions and philosophies. Many of our problems are just the result of semantics.

No matter what terminology we use, it comes down to this: it takes souls who have mastered their total experience on earth to help others grow spiritually and understand who they really are and where they are going in life. The only way your angels can help you is if they have experienced and mastered the same challenges in their own lives when they were on earth. If it were any other way, it would be like the blind leading the blind. In life, just as in business, it helps to have people who can share what has worked for them and what has not. This way, you do not make the same mistakes they made, or at least not as many. As long as you are open to the inspiration and creativity your helpers provide, you will be able to reach your destination more quickly and easily.

There is a commonly held belief that angels have never embodied on planet earth. This idea has taken hold because it has been part of religious teachings and doctrine for so long. In reality, the world is a spiritual university, where we come to learn about ourselves and then share this wisdom with others. Every soul goes through this school of higher learning and then graduates to help others, like ourselves, who are still finding out how beautiful life can be. We are all evolving together. The only difference between you and your spiritual helpers is experience. They are not better than you just because they have already learned what you are still trying to overcome, so it is important not to hold them in higher esteem than yourself. Having been through it all, they

have ultimate patience and the commitment to help you succeed with your life purpose. Do they ever get tired of helping you? Absolutely not. They are learning just as much as you are, only on a higher level and without a physical body. You can think of your personal angels as high souls— they do not need to return to this school to learn more lessons because they have mastered everything here. High souls are different than what some people call old souls, who have been on this planet many times but have not necessarily graduated from earth. Old souls have been reborn many times and are still evolving here, but they haven't mastered all that there is to learn from being in a physical body. When they pass on, they can choose a new team of spiritual helpers and decide to continue on their journey in the physical world with a fresh approach.

There is no end to the learning process. Just because you lose your physical body doesn't mean you stop learning. Once you have learned everything you can by evolving through this school we call earth, you can also graduate and become a wayshower, or guide, for someone who still needs to learn what you have mastered in yourself. Wherever we are in our state of development, on earth or beyond, we are continually growing and helping others who need to learn from us. For instance, there are special teams of spiritual guides who help our personal angels or who provide assistance for people making their final transition or who help those in need of healing, such as in hospitals, and so on. These very advanced souls are called "helpers of helpers," master souls or archangels.

There are millions of master souls who are involved with special projects when the need arises. If you are spiritually

inclined, sometimes your spiritual guides will take you out while you sleep at night to help with disasters occurring around the world, such as in the case of earthquakes or tsunamis, where many people die. This way, you can help souls caught up in the confusion to move on with their spiritual guides. I have heard many people say that they have woken up feeling tired or that they have felt as if they had been very busy while they were asleep, and it's because they were involved in these types of events. There is no limit to the spiritual backing your guides will provide if you are open and ready to accept it.

Some people believe that one of their personal angels is a famous archangel depicted in the Bible or the teachings of some other spiritual tradition, such as Archangel Michael or Gabriel. Others say that their personal guides are great spiritual leaders or figures from the past, such as Jesus, Mary Magdalene, Buddha or, more recently, Yogananda. In my experience, this is unlikely because your angels are personal *to you*—they are there for you and no one else. This is not to say that spiritual leaders, once they graduate from planet earth, don't help others, but they have other roles and jobs to perform than serving as our personal angels.

The Meaning behind the Symbols

To get a more accurate picture of what our personal angels can do for us, we need to look at some of the conceptions and misconceptions we may have been taught about angels. It's important to understand that the Bible and other religious texts were written in parables, using symbols that had been passed down verbally from generation to

generation, sometimes hundreds of years after the actual events they describe. Many of these stories were designed to illustrate spiritual lessons and may or may not be historically accurate. Once when I was in church with my grandmother listening to the minister read a biblical passage, I decided to ask my spiritual guidance if what he was reading was true or not. Before I could even formulate the question in my mind, I heard one of my angels say to me, "Well, it was a little bit like that, but . . ." After that experience, I realized that many of the religious concepts we have been taught throughout the ages were based on parables that were never meant to be taken literally.

There was a time when the scientific community and the Church believed that the world was flat and that the sun and the universe revolved around us. Galileo Galilei, the Italian scientist and astronomer, was brought before the Roman inquisition in 1633 and sentenced to life imprisonment for believing that the earth revolved around the sun. We are now aware that our small planet is only a grain of sand in the vastness of the cosmos, and we can see how limited and egocentric that early perspective was. Even now, scientists are continuously trying to discover how our own galaxy was created. One theory is that the Big Bang was caused by two universes colliding with each other. Every few years we realize that there is a bigger picture to life than we were aware of before.

In the Bible and throughout history, angels have been seen as celestial spirits who bring us divine guidance from the universe. The word *angel* comes from the ancient Persian *angeros* and the Greek *angelos*, which mean "courier" or "messenger." In Hebrew, the word for angel is *mal'akh*, which also

means "messenger." Since peoples of ancient cultures did not depend on scientific theories to provide them with these concepts, it is clear that they knew from their personal experience that they were receiving inspiration from something apart from themselves.

To communicate this concept of spiritual guidance to the masses, artists and sculptors of the time looked for a symbol to help people understand where this inspiration came from. They found one in a bird that never starts to fly until it knows where it is going—the dove. Many religions and cultures throughout history have seen birds, especially the dove, as bearers of heavenly messages of guidance. Another way that artists chose to symbolize these messengers of crystal-clear guidance was by putting wings on the body of a child, a symbol of purity and innocence. That is how the image of the cherub was born. It can also be traced back to the original Greek and Roman mythology of Eros and Cupid, both symbols of divine love and inspiration. Of course, our guardian angels do not really have wings. That, too, is the symbolic conception of those original artists.

The Bible is full of symbols and parables. These early depictions of angels provided people with something they could relate to and receive inspiration from at their level of consciousness. That was how religious leaders were able to communicate spiritual concepts to their followers throughout history when the general populace was mostly illiterate. Only the most wealthy, including the nobility and clergy, had access to the written word. It wasn't until Gutenberg invented the printing press, making the Bible and other religious texts available to the masses, that these types of symbols, however beautiful and poetic, were no longer necessary to communi-

cate the true meaning of the experience. Today, we can have our own direct experience.

Your Inner Guidance Will Never Fail

Have you ever had the experience of feeling that you were being guided to take a certain action or you said something that you did not even know that you knew? At times like that, your team of spiritual guides was working closely with you to help you and the people around you. You can consider them the spiritual board of directors for your life, so to speak. When they are near you, you may feel a surge of energy throughout your nervous system. Some people describe this sensation as chills or goose bumps. In Hawaii, the native people call it chicken skin.

Whatever you call it, it means that your angels want to communicate with you. You may even feel their touch in certain areas of your body. I remember seeing an interview with Clive Davis, an icon in the recording industry who has discovered many of the most famous recording artists of all time. He said that the way he knows whether to sign a new artist is if he feels that chill down his spine. Even though you may not always feel chills or tingling sensations, your angels are still near you, seeking to help you every step of the way.

Your personal angels communicate with you through your hunches, visions, ideas and feelings, and you can work with this inner guidance to help you in any kind of situation, including issues of timing. After my grandfather passed on, my grandmother became my best friend, as grandparents often do with their grandchildren. When she was in her 90s, I told my personal angels that I wanted to be around when

she passed so that I could be there for her. I had been traveling full time and was attending a conference in Puerto Rico for a few weeks, when my schedule abruptly changed. I got the inspiration from my personal angels to go to Dallas, where my grandmother lived, before I moved on to California. She was indeed nearing the end of her life and I was able to spend three days with her. Even though I was not by her bedside at the moment she died, I was able to share some special moments with her, which we both appreciated. If I had not listened to my inner prompting and stopped in Dallas, I might have missed that opportunity.

Following your guidance, even when you don't understand the reason, can save you in countless ways. One morning, a friend of mine, who was a CEO for a subsidiary of a large company in Dallas, was awakened early by her personal angels. They gave her a hunch to move all the money in the company's corporate account from one bank to another. It was too early for her to contact anyone on the board of directors, so she followed what she was told to do and moved millions of dollars to another bank account. She thought for sure she would be fired by the board, but she also felt that she must be getting this prompting for a good reason. Later that morning, she learned that the bank from which she had moved the company's money had foreclosed. She had moved the funds just in time! She obviously didn't lose her job and received only gratitude for her actions.

Misconceptions That Can Slow You Down

For centuries, spiritual people have tried to channel their guardian angels and spirit guides through mediums

or psychics. There are many organizations and churches that do this on a regular basis. As a matter of fact, it has become so popular today that you can register for a mediumship training class in just about any city in the world. This practice has been called spiritualism or spiritism and is practiced by spiritualist churches in many countries, particularly in England and Latin America. Spiritualism was especially prevalent in the late 1800s, and at that time had millions of followers, including famous people like Victor Hugo and William James.

Throughout history, various groups and individuals have managed to keep alive the belief in life after death, especially through the Dark Ages in Europe and in other parts of the world. However, many of their ideas and practices have contributed to misunderstandings that can compromise our ability to work with our spiritual helpers and to receive and share our inspirations.

For instance, spiritualist organizations and individuals, sometimes called psychic channelers, attempt to connect you with your loved ones who have passed on. Many times they will tell you that a late family member or friend is your spiritual guide or even one of your guardian angels. This is impossible because your spiritual helpers have been with you since you were born—and before. When people you have known during your lifetime pass on, they are no different than they were when they were here on the earth plane. The only difference is that they no longer have a physical body to anchor them here. In all truth, then, would their advice to you be any better once they have passed on? Not really, because they have the same life experience and state of consciousness as when they left.

Without realizing it, these departed souls could actually interfere with the communication you might otherwise receive from your own spiritual guidance. They may feel obligated to stick around and make sure that you and others they used to know are okay, even trying to help you on a consistent basis, but this is not healthy for them or for you. You may have seen some of the popular TV shows that deal with this subject. You will notice that the ultimate message that comes from each episode is that it is not those who have passed on that need help but rather their friends and relatives who remain behind. Because those who are still on earth have unresolved issues and therefore haven't been able to release their loved ones, the departed souls feel obligated to hang around until everyone they love is at peace with their passing. The best thing you can do is release your loved ones so they can go with their personal angels and move on spiritually to the next level that is right for them.

Most of the time, psychic mediums are simply channeling discarnate souls who have crossed over to the other side. Even if these souls have a lot of spiritual wisdom or experience, they may not have fully evolved and graduated from the earth plane. As a result, their motives may not be totally clear. They may be looking for power, glory or devotion from their earthly followers. One way to discern this type of energy is by noting if what they have to say is complicated, lofty or hard to understand. In contrast, your spiritual helpers will never try to impress you. And they will not tell you that they are trying to save the world.

Believe it or not, the world does not need to be saved—just improved. You do not need to be saved either. This may sound contrary to popular belief, but it is easier to under-

stand once you realize that we are living in a dynamic school. There will always be territorial wars and conflicts because people are in the process of learning how to love and respect themselves and each other. This is the basic reason for our physical existence. We do not come to this spiritual understanding overnight. Sometimes it takes many lifetimes to learn how to treat others as we would like to be treated. The Golden Rule is not just a nice cliché. It is the key to graduating from this advanced school system of ours.

Think about it. What percentage of the day do you really adhere to this basic standard of living? Is it over 50 percent? Over 75 percent? As much as 100 percent? Think of all the times in your life when you "forgot" to follow this simple guideline. Just as importantly, we need to remember that we can't force others to live by the Golden Rule; we can only practice it ourselves. If we try to save people from themselves, we take away their opportunity to grow spiritually at their own pace and end up doing them a vast disservice. We need to respect one another's rate of growth. This doesn't mean we can't make the world a better place. It has been said that "whoever has the knowledge has the power." If you know a better way of doing things, you can be an example and help others by sharing your well-earned wisdom so that they can follow in your footsteps when they are ready. This is what mentors are all about—setting a positive example.

Spiritual Guidance and Your Life Purpose

Sometimes your spiritual helpers want to tell you something that will help you accomplish your life purpose. At

other times, they want to warn you not to move in a certain direction. They will never lead you into situations that you can't cope with. Even if you decide to go off on a different path than you had originally planned, they will always protect and guide you. They will be with you no matter what. If you end up very confused and reject the inspiration they are giving you, they will never judge you or tell you what to do. Your spiritual guides have ultimate patience because they have had to face the same challenges themselves. Once you realize that you have gone down an avenue that is not healthy for you spiritually, you can still access your spiritual guidance for assistance, and when you do, you will feel even closer to your helpers than you did before.

Most people are taught that they have only one guardian angel or spiritual guide. This is often true for those whose purpose in life is to accomplish something in the physical realm, such as pure research in the scientific field. All they need is an idea and a whiteboard! They sometimes have no more than one or two guides to help them with the inspiration they need to put together great theories.

I remember a gentleman my father worked with when I was growing up in the 1950s who helped develop the transistor for Bell Labs. We were always told that he was an absolute genius, but when it came to dealing with people, he never talked or socialized much. He may not have needed more than one or two spiritual guides to help him come up with the mathematical formulas to create a product that would change everyone's life for the next fifty years and beyond. Without him and others focusing their energy on what inspired them the most, we would not have personal computers, the Internet or other technology we take for granted

today. It is not unusual, however, for those whose purpose in life involves working with people to bring three or more spiritual helpers with them. They need more help to communicate well with people from all walks of life.

Many people think that their purpose in life is to accomplish some significant work, like building great buildings or finding cures for diseases that plague our lives, such as cancer or Alzheimer's. Some think that they came here to heal people or work with children. These are certainly important endeavors to pursue, but they are simply an avenue to accomplish their main reason for being here. In other words, there are many avenues you can use to express what you learn about yourself throughout your life—and your job or profession is not your life purpose. Your purpose is to share your unique spiritual message, or philosophy of life, by living it in whatever you do.

We all have a unique spiritual message that comes from our innermost essence. That message is a spiritual quality we have developed from the sum total of all the experiences we have ever had and what we have learned from them. The key is to choose the best avenue for us to express this spiritual message so that others can benefit from what we have accomplished. Of course, we have to live that message for ourselves first. By being true to ourselves, we set the example for others to be more loyal to themselves and find their own spiritual essence and message.

You have all the help you need to be successful in life. By listening closely to your spiritual guidance, you will acquire and achieve whatever is necessary to accomplish your life purpose. Even if you believe you only have one life to live on this planet, isn't it important to live it to the best of

your ability and share your wisdom with others? This is what makes life worthwhile. Your angels are there. They are not a fairy tale. They have been with you ever since you were born. All you need to do is relax and focus your energy on being the best you can be—for yourself and everyone around you.

Staying Relaxed, Open and Focused

Knowing that your personal angels are around you is only half of what it takes to make sure you are tuning in to the guidance that is available to you at all times. It's also important to realize that they can only help you when you keep your personal energy high and directed.

Remember that you are energy and what you think and feel affects your energy. You are a soul with a physical body and not the other way around. As a soul, you are pure spirit, or energy. Einstein discovered that we cannot create or destroy energy. If that is true, it makes perfect sense that as a soul you exist now, you have always been before, and you will always be throughout eternity. Could it be that this energy is the same energy that people call God? I believe this is what the Bible is pointing to when it says we are an "expression of God" or "made in the image of God." Whatever your concept of God is—and if you ask a million people, you will most likely get a million different answers—you are a part of God, or the universe. There is no separation between the real you and the Whole.

Before you were born, you and your guardian angels sent energy to your physical body in the womb to help it grow and mature into a unique human being. This is why there is always

a beautiful aura, or glow, around pregnant women a few months before they give birth. You can actually feel this energy yourself by rubbing the palms of your hands together for a few seconds and then, with palms facing each other, pushing your hands back and forth like an accordion. You may start to feel a tingling sensation or a magnetic pull between your hands. The energy you feel is the same energy that holds the cells of your physical body together and that is used in spiritual healing. Nurses have told me that whenever they start to put their hands on a patient, their hands get warm and they can feel this energy flowing through them.

This energy is, in reality, the energy of your soul, which survives after you pass on. It is the real you, or what some people call intelligent energy. One time I visited my grandmother at her home and I could see she was very angry about something that had happened to her that day. Suddenly I noticed she had a red aura around her head. I said, "Mama, that is the biggest red aura I have ever seen." She immediately forgot what she was upset about, and the energy around her changed to a pale blue. This clearly showed me that we can change our personal energy on a moment's notice by how we think.

If you allow your energy to get low or depressed, your spiritual helpers will have a difficult time communicating with you. Sometimes they will wait until you are relaxed before they put a great idea into your mind. That's why you may get inspiration just before you go to bed at night or right after you get up in the morning or after taking a nap. But imagine what it would be like if you could be open and available to them twenty-four hours a day.

When you indulge in your problems instead of the solutions to them, emotions like depression and anger can block

your receptivity to your angels' inspirations. One way to keep your energy field clear is to use the Personal Energy Cleansing and World Cleansing techniques at the end of this chapter as part of your daily routine. The purpose of these techniques is to help you relax your personal energy so that you are always in tune with yourself and your guidance and to spiritually cleanse the energy in your environment. These practical techniques only take a minute or so to do. Once you start using them, you will feel relaxed and be open to inspiration in every situation in your life.

I will never forget the time in the 1980s when I showed a group of people in a small town near Manchester, England, how to do the Personal Energy Cleansing technique. The group was run by a psychologist who had invited me to speak to a class of manic depressives. After my talk, I led them through the technique. Afterwards, they began having fun and enthusiastically sharing with each other. They totally forgot how depressed they were! The interesting part about the experience was that their counselor, the psychologist, suddenly became angry and depressed. I guess he thought he had lost his job. I was never invited back.

I recommend doing the cleansing techniques before you get out of bed in the morning so that you can set your personal energy for the day. In addition to helping you be more relaxed and receptive to your inner guidance, they will help you to be focused on what is most important rather than feeling distracted or fragmented. The reason we often get tired during or by the end of the day is that we're thinking about all the things we still haven't accomplished from yesterday, all of the projects on today's to-do list and everything we're planning to do tomorrow. No wonder we get tired and worn

out! Remember, you can only do one thing at a time. The Personal Energy Cleansing technique will help you compact your energy so that you have 100 percent of your personal energy available to you at all times. I also suggest that you do this technique before you work on the exercises at the end of each chapter. It will help you tune in to your inner guidance and get the inspiration you need.

····················· ● ■ ▲∞ ·····················

Setting Your Energy for the Day: How to Cleanse Yourself, Your Personal Environment and the World

A PRACTICAL EXERCISE YOU CAN DO NOW

We would all like to feel great all the time. Here's a practical exercise you can do right now to raise the level of your personal energy to be 100 percent positive and focused. With this technique, you can also choose to spread the positive energy around in your immediate environment, your neighborhood, the country you live in and the entire world. There are no limits to where you can send this healing energy. After you cleanse yourself, you can even send out positive thoughts and feelings to the places you will be going during the day, such as your work environment or the stores where you shop. You should notice the change right away. You may want to practice Steps One through Five before you get out of bed in the morning and then do Steps Six and Seven during the day.

Step One: Feeling the Aura

1. Rub the palms of your hands together, using swift motions.

2. Hold your hands apart, palms facing each other, and feel the energy between your hands.

3. Pull your hands apart and push them together like an accordion and feel the energy getting stronger and weaker as they move back and forth.

4. Take note of how this feels to you.

Step Two: Personal Energy Cleansing Technique

You can do this exercise with your eyes open or closed.

1. Gently take two deep breaths in through your nose and then out through your mouth. (The best way to breathe is as if you are taking air into the stomach first and then completely fill up your lungs. Make sure to fully let go of your breath when you breathe out.)

2. Gently shake both of your hands in front of you to recharge the energy in them. You are not throwing off negativity, simply recharging the energy in your hands. There is a lot of healing energy in your hands and this replenishes it.

3. Place the middle three fingers of each hand on the center of your forehead (vertically).

4. Move them away from each other and across your forehead, down over your temples, down the length of your face and then underneath your chin. (You can take deep breaths in through your nose and out through your mouth as you're doing this.)

5. Gently shake your hands again to recharge your energy.

6. Repeat steps 3 through 5 two more times, taking note of how you feel each time.

7. Now place the tips of the fingers of both hands together with your palms facing your forehead. Move your hands over the top of your head, down the back of your head and neck and then separate them as you sweep them underneath your chin.

8. Gently shake your hands to recharge your energy.

9. Repeat steps 7 and 8 two more times, taking note of how you feel each time. (You can take deep breaths in through your nose and out through your mouth as you do this.)

10. Then, cross your arms by putting your hands on your shoulders and stroke both arms all the way down to your hands.

11. Gently shake your hands to recharge the energy.

12. Repeat steps 10 and 11 two more times.

13. Finally, take three big, deep breaths—in through your nose and out through your mouth—allowing your jaw to relax. It's hard to get angry or upset when your jaw is relaxed.

14. You can repeat the four-part process as many times as necessary until you feel totally relaxed and in tune with yourself: (a) over the face, (b) over the head, (c) over the shoulders and arms, (c) breathing deeply three times.

15. You may also wish to say a positive affirmation in your mind as you do these steps. Some people say, "In the name of peace within, I cleanse my mind, I cleanse my body and I cleanse my soul." Feel free to say whatever you like, as long as it's a positive thought.

Step Three: Cleansing Your Energy Mentally

This is the same exercise as the Personal Energy Cleansing technique, but you do it clairvoyantly by simply picturing in your mind the

motions described in Step Two above—with your eyes open or closed. This is a great way to cleanse your personal energy and feel refreshed when you are in public or in situations with people—whether at work or at home—who would not understand what you are doing. You will normally experience a similar effect.

Step Four: Cleansing the World

Take a big, deep breath in through your nose and out through your mouth.

1. Cleanse yourself personally, either mentally or physically.

2. Picture a bright light in the middle of the room. See the energy swirling around in a big ball of white light.

3. Take the energy around the room until it encompasses the entire room, cleansing it from top to bottom.

4. Now see the energy expand throughout the entire house or office, etc., until it cleanses the whole building from top to bottom.

5. See the white light expanding throughout the neighborhood, your place of work and throughout the entire city.

6. See the entire state or region of _____ being cleansed and healed by the light.

7. Expand the light so that you see your entire country filled and coated with this light.

8. Finally, see this white light cleansing the entire world. See it glowing with cleansing and healing energy.

9. When it feels right, gently release the light out to the cosmos.

10. Come back to your body and cleanse yourself again.

Step Five: Getting a Key Word for the Day

It's helpful to tap into your inner guidance to get a specific focus for the day. Maybe you have to work on patience or on extending more compassion or on drawing your boundaries. A key word gives you a pivot point around which you can regroup during and at the end of the day. It will have special meaning for you because it comes from your inner guidance. This exercise can help you get into the habit of checking in with your team of helpers first thing in the morning. You can do this exercise with your eyes open or closed.

1. Take three deep breaths in through your nose and out through your mouth. Do this slowly and steadily until you feel totally relaxed inside.

2. Ask your personal angels to come around you and cleanse the energy around you. (If you are doing the Key Word exercise separately from the Personal Energy Cleansing technique, make sure you personally cleanse yourself before asking for your key word.)

3. Ask your angels to give you a key word for the day. The first word that pops into your mind is usually the right key word for you.

4. Write it down and keep returning to it throughout your day.

5. In the evening before you go to bed, focus on your key word again to see how well you have been able to keep your energy and attention focused on your intention and guidance.

Step Six: Cleansing Your Immediate Environment

You can cleanse your immediate environment—your room, house, office, building, shopping area, neighborhood or city—by going

through the same process in Step Four (World Cleansing), except to a lesser extent. You may perform this cleansing with your eyes open and visualizing mentally so that no one in your surroundings knows that you are sending out this healing light.

1. Do the Personal Energy Cleansing technique (Step Two), either mentally or physically.

2. Picture a bright light in the middle of the room. See the energy swirling around in a big ball of white light.

3. Take the energy around the room until it encompasses the entire room, cleansing it from top to bottom.

4. Now see the energy expand throughout the entire house or office, etc., until it cleanses the whole building from top to bottom.

5. See the white light expanding throughout the neighborhood, your place of work and the entire city, if desired.

6. Release the energy of the white light out to the cosmos.

7. Cleanse yourself again.

Step Seven: Cleansing a Personal or Business Project

You can also incorporate important projects into your cleansing routine, either during your general cleansing or as a separate exercise.

1. Do the Personal Energy Cleansing technique (Step Two).

2. Picture or sense in your mind the people you are working with.

3. Send positive white light, or energy, into the environment where they are working with you on the project.

4. Do the Personal Energy Cleansing technique.

You can also use this technique to cleanse the environment of a person you are about to e-mail or call on the telephone. You can even cleanse the phone lines to the person or group of people you are calling. This will help them feel more open, relaxed and receptive when you are on the phone together. Make sure to cleanse personally before and after doing this exercise, as it replenishes the personal energy you will need to use to help yourself and others.

<center>● ■ ▲ ∞</center>

How to See and Feel Your Angels around You

A PRACTICAL EXERCISE YOU CAN DO NOW

Believing is not as important as experiencing. You can believe in your inner guidance all you want, but until you experience it for yourself, how do you know it is a reality?

To become more in tune with your personal helpers and the inspiration they provide, start paying more attention to the chills or goose bumps you get when you are listening to music or sharing with a loved one. This could be a sign that your spiritual helpers are there with you and giving you inspiration and wisdom that you didn't even know you had.

Not only are we able to hear and feel our helpers, but we can see them, too. This exercise will help you see and feel your angels around you.

1. Find a light-colored or white wall where the lighting is good and there are no shadows.

2. Ask a friend or family member to stand in front of you against the wall and relax.

3. Ask her (or him) to take a couple of deep breaths, in through the nose and out through the mouth, to relax even more.

4. Gaze through her forehead as if it is an open window and let your eyes go out of focus.

5. After a few seconds, you may start to see a glow around her head. Tell her what you are seeing.

6. You may see a white glow or even pastel colors in her personal energy, or aura. Have your friend or family member take two more deep breaths and think of a pleasant experience. Make sure it is positive.

7. Then say to her, "Ask your angels to come close around you."

8. See what you observe in her energy field now.

9. You may see her aura become very compact or expand as her spiritual helpers come into her energy field.

10. Continue to look while keeping your eyes gently out of focus and you may see her angels moving around or spot one or more balls of white light in her aura.

11. Tell her what you are seeing.

12. Ask her how she felt after she asked her spiritual helpers to come around her.

13. You can trade places so that both of you can have an uplifting personal experience seeing and feeling your personal angels come close to you.

Sometimes it takes time to relax your eyes enough to see the colors around a person. The key is to let go. Don't focus on the

person, but look through the person. Also, if you are more of a feeling-type person, you may find that you just sense or feel the energy rather than see it. Either way, share what you feel.

Note: To see a streaming video demonstration of all of the practical exercises and techniques in this book, go to the following Web link: http://www.innerexpansion.com/innerguidance.

CHAPTER THREE

Living True
to Your Feelings

Paying attention to the hunches, visions, ideas and feelings you get from your inner guidance every single day will open up a whole new world for you. To fully tap into your inspiration and inner guidance, though, you must be in tune with yourself—your real self. The problem is, there are two people inside of you—the real you and the person you have been taught to be. In order to understand yourself more and to achieve what you really want to accomplish in your life, you need to know who is acting.

The real you, your soul, is the sum total of all the experiences you have had throughout time and what you have learned from them. Your soul is who you really are. It is what makes you unique. Many obstetric nurses have told me that they sometimes see a little spark of light when the soul actually enters the physical body at the point of birth. While you were in your mother's womb for nine months, you and your spiritual helpers were sending energy to your new physical body so that it could mature and grow into a total human

being. When you were born, you were not yet openly exposed to the environment you would be moving into and you were 100 percent in your true feelings.

As soon as you entered this whole new world, you were immediately bombarded by emotions and reactions from your parents and the people around you. At first, because your intellect had not yet had a chance to develop to its fullest potential, you did not know the difference between your feelings and other people's feelings. Anything that you came in contact with was one big experience. As newborns, we are all like human sponges. Gradually, as our physical bodies grow, we learn to discern our own feelings. However, because our emotional conditioning is often deep-seated and intense, even after the first seven years of life we may still have trouble discerning the difference between our feelings and the emotions generated by others.

Today, we are a combination of the wisdom we have gathered through many lifetimes *and* the concepts we have inherited from our parents, friends and society. Both of those factors have molded our personalities into who we are today and influence why we do the things we do and why we feel the way we feel. If we don't come to realize that we are sensitive to picking up other people's concepts and emotional energy, we could spend our whole lives thinking that the emotions we experience are our own feelings. This lack of discernment can keep us from understanding who we really are.

The first seven years of life are the most important. That is when your entire personality is created and molded. What you experience during that time influences how you communicate within yourself and with others. It also determines

how you act in relation to the stimuli in your environment. You will either respond from your true feelings—from your own inner beingness—or you will react in the same way as your parents reacted in similar situations. Even if you are aware of the difference between who you really are and how your parents reacted, when you are not relaxed or you are under stress, you may revert to your parents' personalities. To snap out of this mode, you must know how to go back to your true feelings, or what I also call your inner sensitivity or higher self.

How do you tell the difference between your true feelings and what you have taken on from others? The first way is to have an inner gauge of how you are feeling at all times. Do you feel happy or sad? Do you cringe inside whenever someone criticizes you? Do you feel you have to prove yourself? Do you judge yourself whenever you believe you haven't measured up?

These types of responses are not your true feelings. Rather, they are emotions you have been *taught* to feel. When you are in your true feelings, you are being "who you really are," a unique and beautiful soul. You are not *reacting* to your environment; you are *responding* to it. For the sake of clarity, you can think of the innate responses that come from who you really are as your "feelings," and you can think of your learned reactions as "emotions."

When you are not responding from your feelings, you will find that what you say comes from your intellect and reflects what you have heard or theorized rather than what you yourself have experienced. When you do come from your true feelings, your intellect plays a valuable role. It helps you discern what you are feeling so you can then make a decision

to do something about how you feel, and it also serves as an avenue to share how you feel about your experiences. But if you use your intellect to analyze and dissect everything, it's like playing mental gymnastics. Some people think and think and think and never feel. Others act out of their learned emotions or they act without first feeling what they need to do. You've probably heard the old adage "Believe nothing you hear, half of what you read and everything you feel." Relying on your true feelings is essential when it comes to using your four spiritual gifts to communicate with your loved ones and others in your environment.

Discovering the True You

In your first seven years, your parents either provided a good example for you to follow or a not-so-good example. They may have shown you that other people were more important than you, especially grownups. Many people still remember being told, "Children are to be seen and not heard." Every time you were told not to do something "because I said so!" you were being trained not to question authority. This is how we learn to put others on pedestals or to think that somehow they know more than we do about how to live our own lives. This kind of conditioning may cause us to see everyone we have a relationship with in the role of our parents and then give away the authority for our lives to them. We may take other people's suggestions as commands. We do all of this because we have been taught to be loyal to everyone but ourselves.

Of course, not all the concepts that get passed down from generation to generation are bad. Tradition is necessary and

good because it sets certain standards to live by, such as not stealing another person's property and respecting human life. Blindly following tradition, however, can work against us when we do what we have been taught to do without knowing why we are doing it. This is where we get into trouble and put our relationships in jeopardy.

Only when you discern the difference between you and the concepts you learned from your parents (or whoever raised you) will you be able to start peeling away the layers of the onion and discover the true you. There may be many outer layers or there may be just a few. It all depends on how much pressure you had in your environment when you were growing up.

Those who grew up around alcoholic or drug-addicted parents may have searched for other examples to follow. When I was growing up, my parents got divorced when I was just ten years old and my brother was five. I never actually remember them saying a kind word to each other. All I heard was the yelling and the threats they made as their violent fights became more frequent and intense. As a result, they used to call me "the old man" because I was such a serious child. It wasn't until I was around seven or eight years old, when I finally had the opportunity to be around kids my own age in school and didn't have to be at home all the time, that I was able to express myself and start to have more fun. It was a good thing that I learned how to become detached from the negativity in my home environment; otherwise I would have been a basket case later in life. I began to find other avenues to express myself, and I discovered that my direction and fulfillment did not depend on having a good relationship with my parents.

My grandparents were my saving grace, especially my grandmother on my mother's side. Mama was a solid role model for me during my formative years. Out of necessity, my grandmother served as the disciplinarian for my mother, whom she had adopted. Because of their relationship, I had to screen the letters my mother wrote to Mama later in life, as they were so hateful and demeaning. My mother had been catered to by my grandfather, so she expected everyone to treat her as he did. When other people didn't play this parental game, she would throw wild temper tantrums until she got her way. Of course, not everyone would succumb to her demands, especially my father, and that was the beginning of the end of their relationship. It's not that my father didn't love her, because she does have some very positive traits that he needed to bring out in himself, but the challenge of communicating with her was so overwhelming that they were never able to resolve their issues.

You Are Not Your Parents

I still remember an experience I had when I was only two years old. This is my earliest childhood memory. We had just returned from a family outing and it was late at night. I remember being wrapped in a warm blanket and carried into the house by my grandfather. I felt so secure and safe as I heard the screen door opening into my parents' house in Dallas, Texas, where I spent the first nine years of my life, that I told myself, "I'm going to remember this moment for the rest of my life." And I did. As a result, I always knew that someone cared, no matter what was happening in my environment—and I always have a space within me where I can

go to regroup and feel loved and whole.

Not everyone experiences a bad upbringing or has parents who do not respect them. Still, no one is perfect. Even the best parents sometimes slip into how they were taught to act in the first seven years of their lives and treat their children the same way they were treated when they were young and impressionable. All of us are doing the best we know how and are trying to do the right thing, but sometimes our concepts get in the way of communicating how we actually feel inside. Then we regret saying things we didn't really mean.

This happens especially during times of stress. When you're under pressure, you may revert to what you have been taught to feel rather than acknowledging how you really feel. Then you may wonder, "Why did I say that? That wasn't me." In reality, it wasn't. You may have been repeating something that was said to you when you were a child. You may not remember it, but it was still there in your subconscious mind, just waiting to come up when you got under pressure.

By awakening to the fact that you are not your parents and that you are a unique soul having your own experiences, you will be able to detach yourself from anything that may have happened to you in the past. This may not be easy to do, but you must do it. You do not have to hold on to any anger or resentment that was caused by people who did not respect your personal boundaries. The key is to know that they were the ones who were confused, not you. It was their problem that created the situation in which you felt violated or encroached upon.

For example, even though my parents were not the best role models a person could have, I have known for many years now that they were just trying to work out their own

problems. It had nothing to do with me. This understanding is crucial if you want to have a positive and constructive relationship with your husband, wife or children. Most of us have been taught that the negative emotions we experience belong to us. They don't. They actually belong to our parents or whoever raised us.

If you can separate yourself from what you have been taught to feel, and communicate with yourself and others from your innermost feelings, you will find that you will attract only positive responses. As a matter of fact, when you take that approach, the people you communicate with will have to be positive, too—or else they will automatically be gone from your life because they won't be able to stand being around you. It's like mixing oil and vinegar. You may be projecting Mozart or Beethoven while they are communicating via gangsta rap or acid rock. The two don't mix easily. Ultimately you have to decide whose standards you want to live by—yours or theirs.

You Don't Need to Be Fixed

Most of us think that there is something wrong with us—that we need to be fixed. The truth is, you are not broken. You are already perfect. All you need to do is clarify the difference between what you learned about yourself from your parents (or whoever raised you) and how you truly feel about yourself. You do not need to analyze and dissect yourself in order to grow spiritually or psychologically. You are who you are. No one has a spiritual right to tell you how you should feel; you are responsible for your feelings and they are responsible for theirs.

If you ever feel guilty about something you said or did, this is an immediate clue that you are trying to live by someone else's standards and not your own. You are basing your feelings on the personal standards of others and what you think they expect of you. If you feel guilty about an experience you had, try to make this the last time. You learned your lesson. Your experiences are meant to help you grow beyond your present state and develop wisdom you can then share with others. Once you have an experience and discover what you need to learn from it, release it and move forward. That is one of the biggest secrets of life. Don't dwell on the past. Just learn from what you have done and build on it. This way, you will be free to experience life more fully.

When you realize that you are the most important person to yourself and that your own opinion about who you are is the only one that really counts, you will have a whole new lease on life. I once knew a young woman I'll call Susan,* who was bright and enthusiastic about life. She was always willing to help everyone. Susan didn't seem to have any problems, especially in her family life. A mother of two, she was devoted to her husband and children. It seemed like a perfect marriage. She would take her kids to soccer games and was very involved with the family business.

Susan did have one problem, though. Her husband insisted that she be in therapy, and she went along with it for over seventeen years. Simply because he said so, she assumed that there was something wrong with her. The only real problem she had was her husband's possessiveness and

* Some of the names throughout this book have been changed to protect the privacy of the individuals whose stories are being shared.

his desire to see her change for his personal convenience. Wanting to avoid confrontation at all costs, she gave in to his obsession to make her into someone she was not. She felt that she needed to be taken care of and that he had the answers for her. She wouldn't make a move unless he gave his permission.

Susan put up a good face, but inside she was crying. Once she learned that she had spiritual helpers she could tap into for inspiration, she came to some new realizations. She started to see that the problems she was having were not even her own. She had bought into her husband's concept of the way she should be and act, and she assumed this was the way things were supposed to be. As a result of the constant therapy and thinking there was something wrong with her that she needed to fix in order to please her husband, Susan always tried to be perfect—at everything. She couldn't share how she really felt about anything for fear of being judged.

Susan had bought into the traditional concept—inherited as a thought pattern from her mother and stimulated by her father—that other people, especially men, knew what was best for her. Because she was used to thinking that everything was her fault, she felt guilty whenever she wanted to break out of this unhealthy pattern and self-image. When she learned to distinguish between her own feelings and the emotions she had been taught, Susan started to understand that she could take care of her own basic needs for food, health, love, shelter and self-expression. She began to express herself more and share her own opinions about life. Of course, her husband didn't like this at all. The happier she became, the sadder he became. He was used to her being obedient and subservient.

Once Susan started respecting herself more, her husband started looking around for someone else he could control and became involved in another relationship. Because of this, their marriage fell apart. Since Susan no longer catered to his every whim, the relationship ceased to be founded on false pretenses and ended in divorce. Susan had been faced with a choice: she could spend another twenty years of her life assuming she was a bad person who needed constant therapy or she could respect herself and live her own life. She chose to be herself.

Many times, depression is caused by thinking that we need to have permission from others to do what we really enjoy doing or to freely express ourselves. Whenever you feel stifled in your communication with others, you are not respecting yourself. Holding back your true feelings will cause you to become emotional. No one has the right to keep you from sharing how you really feel. If this is something that is happening in your life, now is the time to take a second look and consider changing your strategy.

Communicating through Your Own Gifts

The inspiration we receive from our personal angels, or inner guidance, only comes to us through our true feelings. So if you are consistently indulging in the emotional side of life, you are cutting yourself off from experiencing this inspiration as well as the real beauty of life. You may end up denying yourself the one thing that makes everything worthwhile—being the true you and listening to your inner guidance. Unfortunately, many of us bypass our best way of communicating with ourselves and with others because we

react emotionally rather than respond from our true feelings. As I said, when we are under pressure or simply out of touch with our feelings, we have a tendency to come from our emotions and communicate with our loved ones, friends or business associates using the spiritual gift of our mothers or fathers rather than our own primary gift.

For example, if healing is your most prominent gift, but your mother's primary gift is clairaudience, you may find that you bypass your true feelings when you communicate and make decisions. Instead, you may attempt to get all of the facts before making a decision, which is a clairaudient trait. This will throw off your inner timing. Because you are a healer first, you need to get a feeling for what you want to do so you can move in the direction that is best for you. Simply getting the facts doesn't do it for you. What you have done is used your second, third or fourth gift to make a decision. This may have been the way your mother did it, but it is not the best way for you to do it.

In my own case, when I learned that my prophetic gift was the main way I communicated with myself, I felt as if a weight had been lifted off me. I realized that I had been trying to communicate like my mother, who is a healer, and my father, whose first gift was clairaudience. Whenever I would get under pressure or feel stressed, my inner communication system would revert to the system I had picked up from my parents during my first seven years of life. Inside, this felt like I was playing ping-pong. I would try to get a feeling for what was going on, but that didn't work because it was my fourth spiritual gift. Then I would try to get an understanding for what was happening around me through my clairaudient gift, but that didn't work either. Finally, after I

had a chance to calm down and relax, my first gift of prophecy—my inner knowing—would let me know how to resolve the situation and I would feel assured that everything was going to be okay. My timing was back on!

Living true to your feelings means staying relaxed and allowing your inner sensitivity to work for you, free from any outside influences that would make you doubt or rethink your decisions. Your first impression is usually right. How many times have you wanted to kick yourself because you didn't follow a hunch? It happens all the time to people simply because they have been taught to communicate like their parents instead of listening to their own intuition. When your intellect takes over and discounts the inspiration you are getting from your inner guidance, it slows you down and can even drain your energy. Instead of tapping into the spiritual energy that is available to you from your spiritual helpers, you are spending extra effort to make decisions in ways that aren't natural for you.

Look at it this way. You have a certain amount of personal energy flowing through your physical body. Each one of your personal angels has even more energy than you because they are 100 percent positive and directed all the time. If you have a team of at least four or five spiritual helpers constantly giving you extra energy and inspiration, just think of what you have at your disposal! If you cut off that flow of energy, you are using only a fraction of the total spiritual energy that is available to you. This is why you may feel at times like you're swimming upstream and that life is hard. On the other hand, if you consistently flow with the stream, relaxing and allowing yourself to feel and express your true feelings, you will move easily and get much farther along, both spiritually and materially.

You are the only one who can get the answers that are right for you. By listening to your inner sensitivity, you are tuning in to your higher self. There's nothing wrong with listening to other people's ideas or suggestions, but make sure that you go within to confirm that what they're offering is best for your life. Remember that you have the final say about what you want to do with your life. If people plant fear in you by telling you your only solution is to go through them, their motives are not pure. This should be a red flag to steer clear of a situation that could lead to confusion and devotion toward someone other than yourself. Many people try to get answers by going to psychics or card readers, many of whom will tell you that they are channeling your angels. If they ask for large sums of money to take away the "negativity" from around you or to "clear your chakras" (energy centers), it may be a good idea to just walk away.

Your Personal Life—Being Loyal to Yourself

To make the most of our inner guidance, it's important to keep our energy positive, focused and directed. What prevents us from being clear and focused is our tendency to mix up the three key areas of our life. Each of these areas—our personal life, business life and social endeavors—defines who we are and our relationship to others. One of the main causes of feeling stressed, drained or confused is that we don't treat these areas as distinct units and don't always understand how to move from one area to the other at the right time, depending on the situation. When the lines between our personal, business and social lives become blurred, we run into problems. We muddy the waters and things aren't as

clear as they could be. The key to functioning successfully in these areas is to recognize that each has its own energy and that you need to be 100 percent in the energy of whatever area you are operating in. I call this living in compact units. When you understand how these three energies affect you and how to have your energy fully engaged in one area at a time—whether personal, business or social—you will never doubt yourself or feel tired.

The remainder of this chapter will give you a quick look at the main characteristics of each area. Throughout the rest of the book, I will also be showing you how you can use each of the four gifts to the best of your ability in these distinct areas of your life to create successful inner and outer communications. For a moment, set aside what comes to mind when you think of the terms *personal, business* and *social,* because some of what you read here will be a new way of looking at these areas of your life.

Your personal life is characterized by how you feel about yourself in your innermost being. This area of your life is not about your personal relationships or anyone else. It is all about you—your unique purpose in life, your true feelings and respecting yourself for who you are. Your personal life is sacred territory. Your feelings are yours and yours alone. When you do not respect yourself or your true feelings, you open yourself up to be taken advantage of. You allow people to get involved in your personal life without realizing it. If their motives are not pure, once they know all about you, they may manipulate you to do what they want by making you feel guilty or obligated to them. Once you realize that no one can encroach upon you unless you let them, you will have a strong inner pivot point to return to at any time.

If you don't respect who you are, how do you expect to earn respect from others? If you are constantly allowing others to give you advice and tell you what to do or if you interpret their suggestions as commands, you are not being who you really are inside. In addition, when you are in this state, your spiritual helpers have a hard time getting through to you since they communicate with you through your true feelings, or inner sensitivity, which is your real self.

The first step to getting clear about your personal life is to take away all the "shoulds" in your life. In other words, stop feeling guilty about what you think is right for you and what is not, which is often based on what you think others expect of you. If you make other people more important than yourself, you will never accomplish your true life purpose.

Most people think that being loyal to yourself first before you are loyal to others is being selfish, but nothing could be farther from the truth. When you are not loyal to yourself first, you usually end up feeling frustrated, which then causes anger and resentment. Who wants to be around someone who is depressed and unhappy about his life? Does that inspire others and provide a good example for them to follow? Of course not. When you are being true to yourself first, not only are you doing yourself a favor, but you are also helping others in the process. Developing greater self-loyalty is something your personal angels will give you insight into if you are open to it.

Anytime you allow someone to interfere with your personal boundaries, you are not being loyal to yourself. If you allow yourself to buy into other people's opinions instead of honoring your own, you are not respecting who you really are. This can easily happen in relationships. You can always have an opinion of someone else's opinion. Try this ap-

proach when people criticize you or tell you that their way is the only way. Instead of putting them on a pedestal or thinking that they know more than you about a particular subject, *follow your own feelings*. Remember to apply this principle in your business life as well. Even the most knowledgeable and experienced executives will sometimes listen to other so-called experts before they listen to themselves and then live to regret it. Learn to trust and rely on your own feelings first.

I started realizing how important it was to listen to my own feelings early in life. When I was twelve years old, I told my father I wasn't going into the family business. He owned a multimillion-dollar private telephone conglomerate and was destined to become the president of the National Telephone Association (NTA).

An electrical engineer by trade, he had started out building telephone exchanges in small towns in Texas and came upon an opportunity to buy a rural telephone company of thirty-three communities in northern Texas. This was back in the days when the telephone business was a monopoly and there was no competition. Even though I loved my father very much, I just *knew* inside that this was not my life's work. I always felt that this was *his* challenge and opportunity to express himself through his work.

So I told my father that I was going to be a musician. His reaction at the time was "Sure, kid." I don't know if he really believed me, but I was determined. By the time I was in college, I was writing arrangements and playing professionally with celebrity dance bands throughout the country. Even though I ultimately did not continue my music career but chose instead to follow my heart and work with people spiritually, I did listen to my own inner knowing, which led me in

the right direction. Sometimes our path to getting where we want to go is indirect, and we may not even know why our inner guidance is inspiring us to move in a certain direction. As long as you listen to yourself, you will always end up in the right place.

To look at this question of self-loyalty from another perspective, remember that you came to planet earth alone and you will leave alone. Even if you have wonderful relationships with your family, friends and business associates along the way, in the end you are going to pass over alone. That is why it's so important to be loyal to yourself first, no matter what. You want to be able to leave without any regrets and with wisdom and experience, which, after all, is the only thing you can take with you. You can't take the television set, your laptop or your Harvard degree. Once you leave your physical body, you have no use for any of those material things. You just take you.

Your Business Life—Your Service to Others

The second area of your life is your business life. Your business life is your service to others, but do not think of this area as being exclusively about business in the work-a-day world. It's more than that. You can be of service to others no matter what you are doing. What I refer to as your business life has to do with the business of getting something done—whether it's on the job, in your kitchen or with your family. It's about getting down to the business of figuring out the facts—the what, when, where and why—in any situation. Without having the business side intact, you cannot translate your personal feelings and inspirations into concrete service to others and interact with them effectively.

Through the arena of business, you create not only material abundance but also spiritual abundance. That's because your business life is an avenue through which you can share your personal spiritual message, your philosophy of life. Even if you have as many as a hundred jobs or professions during your lifetime, your spiritual message never changes. It is who you are. By sharing your wisdom with others in your job or profession or in your everyday encounters, you help others accomplish their purpose and create opportunity for many people down the line. If you just sit around and think about yourself all day long, you will never feel fulfilled. Your business life is a way to learn about yourself by interacting with people in your environment.

Whenever you provide a service, your motives must be spiritually clear—to help people to help themselves. Just think about people like Bill Gates, who simply created a system and products that allow people to be more productive. He didn't become a billionaire by doing the work for them. All he did was take existing technology and package it so that the greatest number of people would benefit. This is the key to success in any business.

If you channel your true feelings—your enthusiasm and passion to be of service—into your business, you will always be successful. When you do this in an organized way, everything falls into place. But what happens when you get your emotions (rather than your true feelings) involved? What if you start pushing yourself too hard or you try to please others just a little too much? Or what if you get into personality conflicts with people at work as a result of jealousy or competition? What does this do to the purity of the business?

When you put your emotions into your business life, you create an energy of confusion, which people can sense. They will feel that you are so distracted by your own problems that you can't possibly concentrate on them, and you may drive them away. Then the company might end up suffering a downturn in revenue or a turnover in personnel. When it comes to being of service, you can't be thinking about your personal problems at the same time. This is mixing your personal life with your business life, and it will prevent you from fully sharing your spiritual message through your job or profession. In addition, whenever you indulge in your emotions, you dissipate the energy that you need for your clients or customers. Detaching your personal life from your business life may seem hard to do at first, but once you put this into practice, you will create a positive habit that will last a lifetime.

It's also important to recognize when others are getting their personal emotions involved in your business. If you cater to them, you will have two people with a problem instead of just one. It will prevent you from engaging your true feelings in your service and deplete the energy of everyone involved. This type of situation often happens when someone is afraid of being successful because of the responsibility that comes with success. As a result, he may try to tear down what he has built and end up destroying relationships along the way. Don't blame him. This behavior is driven by a fear that he inherited from his parents. It takes understanding and patience for people to overcome these habits and rise above the limitations of their early environment.

Once you see this happening in your business environment, you need to stop it right away. Help the person real-

ize that he has your backing and ask him if he needs help. Without being condescending, let him know that he is part of a team and that he has all the support he needs. Reassure him that he is not alone. Give him a step-by-step plan to achieve the success he wants to create for himself, and put him in a situation where he can do it. He will thank you for it later.

Sometimes people get their emotions involved in business because they feel left out of the big picture. All of us want to belong and feel as if we are needed in the overall scheme of the operation. By letting people know how they fit into a project and how their role affects the whole system, they will be more willing to put 100 percent of their personal feelings and energy into the endeavor, which allows a tremendous amount of synergy to be created. Remember, a group is only as strong as its weakest link. By anticipating the areas that need reinforcement, you can keep everything moving in just the right timing. Your spiritual helpers are always giving you inspiration in your business life. They will give you warnings as well as hunches about the different ways you can be of greater service to yourself and the people around you. If you pay attention, everything will fall into place according to plan.

Business and Emotions Don't Mix

There may, of course, be instances where we need to take more drastic action when people bring their personal concerns into the business area and are not able to self-correct, even with support. I've seen firsthand in my own family how destructive this can be. In 1941, my father led

the first top-secret radar unit outside the United States and was stationed in the Philippines when World War II broke out after Pearl Harbor. During his first week of duty, he was captured and spent three and a half years in a Tokyo prison camp. He returned home weighing around 85 pounds. Four years later, he met my mother and was ready to settle down and start his own business. Despite the fact that his first consulting company failed, he continued to find consulting jobs and eventually bought his first independent telephone company.

When my father was just starting out in business, he traveled a lot. My mother was left at home to take care of me and, later, my brother, who was born four and a half years after me. Early on, my mother wanted a lot of "things." She used to threaten my father that she would leave him if he didn't pay more attention to her and give her everything she wanted—a true formula for a failed marriage. They saw a marriage counselor, but my father was not willing to follow the advice that was given. He was told to just give in to her demands, no matter what, and everything would be all right. Of course, today we know that that was less than stellar counsel. The psychologist told him that everything was his fault. My parents managed to stay together for ten years, but finally my father couldn't take the constant harassment and they divorced.

After the divorce, as my father became more successful, my mother continued to harass him for more money and take him to court whenever she could find a lawyer to take her case. When she won, she would take the extra funds, even the child support, and spend it on herself. My father always wanted to make sure that my brother and I were cared for and would help me out whenever I needed it. We were never

deprived in any way, despite my mother's actions to keep everything for herself.

Once when my mother was suing my father again, he had an opportunity to buy another small telephone company in southeast Texas, near Houston. My grandmother had some shares of stock in her name that he was able to use as collateral for a loan to buy the firm. Luckily, my mother was not able to get her hands on the new company since it was not available as an asset. Otherwise he would have gone bankrupt and everyone would have suffered.

Finally, after six years of testifying in Congress for the rights to buy the telephone exchange on the expansive Navajo Reservation based in Window Rock, Arizona, my father was awarded the opportunity to build a company that would not only create a tremendous amount of income and equity for him and his shareholders but also give the Native American community an avenue for jobs and training. The tribal counsel chose him over and above all of the major companies he was competing with because they knew he had their best interests at heart. He vowed to put a telephone in every hogan, a traditional Navajo home.

After my father passed on in 1978, his holding company sold for many millions of dollars. My mother got nothing. I always felt that if she had just backed him when he needed it the most, it would have paid off for her many times over. But because she only thought of herself and demanded many things before he was capable of giving them to her, she lost out in the end. She insisted that her emotional needs came before the business, and she did not have the patience or the benevolence to allow my father to do his job and create a secure environment for the family. He

was looking for a mature relationship. She was not. Unfortunately, this happens too many times with people who want others to take care of their personal needs. (Just to clarify, being selfish is entirely different from being loyal to yourself. When you are loyal to yourself, you are an example of how to enjoy life and you back others who are doing the same thing.)

My parents' story is a perfect example of what can happen when the emotions and issues of our personal life get mixed up in our business life. In the case of my father, he managed to make the business successful despite the constant distractions from my mother, though many times he felt as if he couldn't focus on his work. Most of us would find it hard to maintain our focus under conditions like that.

When you get your emotions involved in your business dealings, you also run the risk of altering the purity of the service you provide. For example, this might happen if your motivation is to help others more than they are willing to help themselves, and so you promise them more than the company is capable of giving. Or maybe you favor certain individuals. We all want to provide stellar customer service when we have a passion for the product we're offering, but our emotions might prompt us to do more for the people with whom we have a special rapport. The opposite can also be true. When we're doing business with people we don't feel an affinity with, we may allow our personal emotions to interfere with giving them the service they really deserve. Everyone has experienced these feelings at some time. Even though it's difficult to keep our emotions (rather than our true feelings) out of our business, it's essential to do

this so that all the customers who buy our product or service feel that we really care about them.

Your Social Life—Interacting with Others

The third area of life is your social life, which involves your interaction and communication with others. Your social life is the give and take you have every day with the people you love, your business associates and your friends and acquaintances. It is a chance to let your hair down and share your experiences and what you are learning. If you share from your true inner feelings, these relationships will be successful. If you come from your emotions, you will have assumptions, unrealistic expectations and demands in regard to yourself and others. This is not healthy for you or for them and is the underlying cause of most divorces we see today.

The reason you are on earth is to gather wisdom and share it with others. This is why it is so important to understand who you are in relation to the people around you. Most of our problems in life have to do with people and our environment. Have you ever noticed that you don't have many problems when you are by yourself? It's when we interact with others that we run into trouble.

At a lecture I gave a few years ago, I talked with a woman who asked me if I could help her with her problems. "What are your problems?" I asked. She responded by explaining that her husband had a problem, her son had a problem, her daughter had more than one problem, and so on. Then I said to her, "So what is your problem?" She immediately began to repeat the problems of her family members. I stopped her and said, "You don't have any problems!" Once

she thought about it for a few moments, she finally admitted, "You're right. I don't have any problems. Everything that I just mentioned to you is happening to my family, not me. The only problem I have is that I'm trying to solve all of their problems!"

Sometimes it's difficult to detach ourselves from what our loved ones and friends are going through in the process of learning how to be more loyal to themselves. We just want to shake them and let them know how much we care and may even try to solve their problems for them. This never works. By the time you get involved in their situation, you have no energy left for yourself. So who wins? No one. This doesn't mean that you can't make suggestions or propose possible solutions. But trying to do it for them is a quick way to start feeling that your life is going by the wayside and that you're not accomplishing what you came here to do. Some people waste their whole lives in this way, and when they get to be forty-nine or older, they have a mid-life crisis. The only real crisis is that they have tried to take care of everyone else and left themselves out.

Your inner guidance is always there to help you discern what is right for you and what is not. But you have to know the premise for your life. If you start out with the wrong premise and do something you think you "should" be doing, it will take quite a lot of inspiration and direction from your guides to bring you back to your inner pivot point. The key is to listen to yourself first and do what is right for you. Then you won't have to apologize to yourself later for not paying attention to what you were saying to yourself earlier. Don't discount the hunches, visions, ideas

and feelings you get every single day showing you which way is the best way for you.

When you allow others to tell you how you should feel, you are getting your social life mixed in with your personal life. Likewise, when you let emotions that you have been taught to feel—like anger and resentment—affect your relationships, you are mixing your personal life with your social life. This can cause tremendous problems and misunderstandings if you're not careful. Whenever we force our feelings or emotions on others, it creates pressure and does not leave room for them to have their own opinions.

Sometimes people will socialize with you in a business situation in order to get special favors. That's why there is a grace period in certain situations after signing a contract in case you signed it under duress. Someone may try to butter you up or get chummy with you beyond the bounds of just being friendly in an attempt to break down your barriers and get you to do what they want, not necessarily what you want. It's important, then, to be clear about what you want before you make a final decision in business. When you come from your own feelings and not from what others want for you, taking care not to mix up your social interactions with your business life, you will be on top of your game and have the ability to discern exactly what is right for you and what is not.

Knowing which area of your life you are in at all times—personal, business or social—will help you to live the life you have always wanted. On the following pages, you will have an opportunity to discover your personal communication style and learn how you can best use your spiritual gifts in each of these three areas of your life.

●■▲∞

Clarifying Your Personal, Business and Social Priorities

A PRACTICAL EXERCISE YOU CAN DO NOW

Just setting a goal in any area of your life is not enough. You first need to set your priorities so you are sure you're heading in the right direction for you. Setting priorities will help you clarify the premise for your life, which you can then use to create the spiritual and material goals you want to accomplish. When we don't set our priorities first, we may find ourselves working against our true feelings. That's when we start to think that life is hard. But it isn't hard if you're doing what is right for you rather than trying to please everyone around you.

Your priorities can change over time, so it's a good idea to make a habit of doing this exercise periodically. You may want to do it every month, every quarter of the year, yearly or whenever you feel the need to clarify your priorities in life. Start by taking out a pen and pad of paper. You'll get the greatest benefit from this exercise if you determine to be honest with yourself as you go through the steps.

1. Meditate for a moment and write down your personal priorities. For example, how do you want to feel from now on, what makes you happy, how can you be more loyal to yourself, etc.?

2. Meditate for a moment and write down your business priorities. For example, what kind of business do you enjoy being involved with, how can you be of more service in the business you are in, how can you change jobs to make sure you are happy with what you are doing, etc.?

3. Meditate for a moment and write down your social priorities. For example, what types of people do you want to be around, how can you share with people more, where do you want to go with your personal relationships, etc.?

4. Once you have your priorities down on paper, meditate on each one and ask yourself and your inner guidance what the first step is to make these priorities a reality. Pay attention to the inner knowings or hunches that come up, as well as the visions or pictures in your mind, thoughts or ideas, feelings, and even emotions.

5. Take some action related to the inspirations you received. Check every day to see how much progress you have made.

6. Do something nice for yourself every week as a reward for following through with your personal loyalty to yourself. And invite a few friends!

CHAPTER FOUR

The Big Picture of Prophecy:
The Challenge of Trusting Yourself

Knowing yourself is the most important thing you can do for yourself. That includes knowing how to listen to your hunches and understanding how your unique inner and outer communication system works. The four spiritual gifts are an essential part of your communication system. Each gift represents a unique way of receiving inspiration, processing it and then communicating it to others. By learning about the four gifts, you will be able to use your inner sensitivity at a much higher level and communicate more effectively with your friends, loved ones and business associates.

To recap what I said in chapter 1, every one of us has access to and can develop all four gifts, or avenues of communication, but we naturally favor one gift more than others as our preferred way of communicating. Our primary gift also influences the kind of personality traits we have. By unfolding the full potential of each of the gifts within you, you will become more highly attuned to the energy in your environment and you will be able to use whatever gift is best to deal

with the situation you're in or to meet the needs of the people you're with.

This chapter on the gift of prophecy will be most applicable to "prophetics"—people who have prophecy as their preferred avenue of communication. But even if you're not a prophetic, by reading this chapter you will learn more about your own prophetic gift and how to overcome the obstacles to unfolding and using that gift effectively in your everyday life. You will also understand what makes the prophetic people in your life tick, valuable knowledge you can use to improve your relationships.

Keep in mind as you read about each of the gifts in chapters 4 through 11 that your second gift is also an important factor in determining your personality. So if you're reading about a gift that describes you but not completely, you might want to take a peek at chapter 12 for a description of the gift combinations that may account for your unique personality.

Creativity, Curiosity and Executive Action

If your first gift is prophecy, you are the type of person who likes to be creative, and you express yourself with enthusiasm and passion. Because you are so creative, you tend to gravitate toward professions that give you the opportunity to share of yourself in many different ways. You may become a musician, an artist, a designer or a philanthropist. In business, you are capable of becoming an accomplished executive because of your ability to coordinate and communicate effectively with people and to hold onto the big picture when there are many things going on at once. In fact, when teenage prophetics do their homework, do not be surprised

to see them reading a book, watching television, surfing the Internet and instant messaging one of their classmates all at the same time—and still making the grade!

Before moving into action, prophetics need to have a big picture of everything going on around them. If prophecy is your first gift, you are naturally very curious and are always scanning for information. You want to know what everyone else is doing so that you can see where you fit in relation to others. If you're not careful, however, you might get a reputation for being nosy. We've all heard the expression "curiosity killed the cat." That's a warning that prophetics need to take to heart. Curiosity can be the bane of their existence. Prophetics have to learn to mind their own business so they don't get caught up in situations that don't directly affect them.

Those with the prophetic gift also have a heightened sense of taste and smell. They have an uncanny ability to detect smells that others miss, and if something doesn't smell right, they will have an adverse reaction. You will often hear them talking about food, and you can usually count on them to tell you where to find all the best restaurants in town. After a good meal, they will feel satisfied that all is right with the world.

When prophetics haven't eaten for a while, their energy may become thin, causing them to become irritable. Sometimes the best solution is for them to eat snacks during the day to keep their energy high and consistent. If you live with a prophetic-type person, you will notice that he or she is always munching. Prophetics may get very quiet if they need to eat, but once their stomachs are full, they will either fall asleep or talk your head off. This is because they feel relaxed and grounded again and are taking a respite from their

constant scanning for information, either by taking time for themselves or having a lively conversation with you.

Scanning and Sifting at the Speed of Light

From a psychic, or metaphysical, point of view, prophetics have the natural ability to go into a semi-trance or full trance, although they may experience this as simply "spacing out." Prophetics actually do this all the time, whether they realize it or not, because they are constantly going outside of their body to scan for information. This may sound a little strange on the surface, but have you ever been driving down the freeway and missed your exit or have you ever been listening to someone tell you a story and all of a sudden gone off into your own dreamland? If this happens to you a lot, you may have prophecy as your first or second spiritual gift. The funny thing is, although you may be gone for a few minutes thinking about something else, when you come back, you can carry on the conversation as if you had never left!

As a prophetic person, you will sometimes find yourself talking out loud. You may think you're just talking to yourself, but you are really picking up information from the cosmos. Whether you realize it or not, you are regrouping and talking with your angels. In the middle of one of these conversations, you may find yourself suddenly exclaiming, "That's it!" and know that your spiritual guidance has just given you a solution to a problem you have been contemplating. Communicating in this way helps you stay organized. In the process of scanning for information, you are also constantly evaluating and putting things into perspective, which helps you understand the bigger picture.

No matter what gift is most prominent in our lives, we all need to communicate with ourselves first in order to clearly communicate to others the inspiration we're receiving. We do this by sifting the information we receive through our gifts in the order of their prominence, almost at the speed of light. For example, someone with the gift of clairvoyance first, clairaudience second, feeling third and prophecy fourth would get a picture (clairvoyant gift), an understanding (clairaudient gift), a feeling (healing gift) and then a hunch (prophetic gift). You don't even have to think about it; it's the natural flow of your inner communication system.

For prophetics, their inner knowing is actually a combination of getting a picture, an understanding and a feeling—all at the same time. This accounts for why they are so fast at picking up information and understanding things. But it's difficult to describe a prophetic "knowing" or hunch when you have one because it just *is*. So prophetics usually use their second gift to communicate their hunches to others. For example, if a prophetic has clairvoyance as his second gift, he will have a tendency to communicate visually by painting a picture with his words. If his second gift is clairaudience, he will need to have all of the facts—the what, when, where and why—in order to understand what to say. If his second gift is healing, he will share his hunches primarily from his innermost feelings.

When we process information in a way that is not natural to us—perhaps because we've been taught to communicate the way our parents did rather than by using our primary gift, as I explained in chapter 3—we throw off our inner timing and will have trouble discerning the inspiration that comes to us. That's

why it's so important to know what your first gift is and to concentrate on unfolding it first. If you do that, your other gifts will fall into place in their natural order of prominence.

Acting on Your Inner Knowing

When I discovered that my first spiritual gift was prophecy, I felt as if I had come home. It felt natural to me, and I realized for the first time that I had my own way of communicating with myself and others that was different from other people. Inspirations would come to me as an impression or hunch. I just "knew" things, but I didn't know how I knew them. Throughout my life, I would often find myself finishing other people's sentences because I knew what they were going to say next. When I was growing up, I just knew the difference between right and wrong. Whenever I would challenge my parents' authority or do something to get myself into trouble, I felt as if the punishment I received was redundant. I had already learned my lesson. They didn't have to drill it into me.

I've had countless experiences using the gift of prophecy in my everyday life. About six months before my dad passed on, I knew something was not right. You couldn't have convinced him of that because he was preparing to go to Africa on a photographic safari and was planning his retirement so that he could enjoy the fruits of his life's labors. Both he and I had been very busy in recent years and so we hadn't seen each other that often. But something inside told me that I needed to visit him and rekindle our friendship. So I did.

I made several trips to his home and office, and we had a chance to talk about life and what had meant the most to

him. He showed me a picture of a priest he admired who had been imprisoned with him in Japan during the war. The priest was his inspiration—his spiritual mentor—during this incredible time of sacrifice and survival. The time I spent with my father also gave me the opportunity to reflect on our life together. One of my fondest memories is of us going out fishing and hunting on the weekends in the pontoon that he built for me. I think he got more enjoyment out of it than I did!

When my dad returned from Africa, he began planning another trip to the Yukon to go bighorn sheep hunting on horseback. He looked like he was in great shape, although we noticed he had a persistent cough. When he returned from the Yukon, he was not feeling well and soon discovered that he had lymphatic cancer. The doctor told him he had about two more weeks to live, and he was right. I was so thankful that I had listened to my inner knowing and had made a special effort to take a break from my busy life—and he from his—so that we could get to know each other better. He shared with me experiences in his life that meant a lot to him, and I had a chance to share with him my true dreams and aspirations. It was the perfect closure for both of us.

One of my business associates, Sylvia, once told me a story that also illustrates how our inner knowing works. She was on a weekend skiing trip in Colorado with her family. They had rented their condo from Thursday through Tuesday. On Monday morning, she woke up just knowing that something wasn't right at home and told her family that she needed to leave that morning and get back home to Boulder. "My family was saying, 'Oh no! Stay, and we can spend the last day shopping and have dinner together.' But my gut was

just screaming at me, 'Go home now!' So even though I only got to see my family once a year and we were having a great time, I listened to that prompting."

The drive home turned out to be very quick and easy, which was not usually the case coming down that mountain, and this confirmed to Sylvia that she had made the right decision. When she got home, she went directly to her phone. There was a message from the kennel where she had left her dog for the weekend saying that they had to run the dog to the vet that morning because he had become very ill overnight.

"I got back in my car and went to the vet and was able to spend the last few hours of my dog's life with him," she said. "Had I not listened to my guidance and the true intuition that I had, I would not have been able to be there with him and help him through that process. I would have felt that I had not done all I could do for him, and I probably would have been beating myself up for not paying attention to what I needed to do for myself."

Sara, whose primary gift is prophecy, believes that trusting her inner knowing while hiking probably saved her life. "Being a prophetic has helped me in more ways than I can count," she says. "One time, my niece and I were hiking in a canyon in Colorado and we suddenly realized we were no longer on the trail and had no idea where we were. The weather looked like it might turn bad and it was late afternoon, so I was also concerned that it would get dark. I walked away from my niece and started doing the Personal Energy Cleansing technique and asking my guides for help getting out of the canyon quickly and safely. I asked which direction we should start hiking in and got a response to

go in a different direction than I thought we had come from. I asked again and got the same response, so we started hiking in that direction.

"Every so often I would stop and ask which way to go, and within forty-five minutes we found ourselves walking toward the car from the complete opposite direction than we had started out from. As we got closer to the car, we saw some people running from our original direction, so we asked them what was going on. They told us that there was a mother bear chasing someone who had accidentally come up behind her and her cubs. Had my niece and I come back the same way we had gone into the canyon, we would have also found that mad mother bear. I firmly believe that my guides got us 'lost' to keep us away from the mother bear and a very dangerous situation. I learned from this experience to always trust my inner guidance, even if I am not sure where I am being led. My guides always have my best interest at heart and are always looking out for me."

Optimism, Versatility and Gullibility

Prophetics are the optimists of the world because they know that anything is possible. This also makes them gullible, and they will often believe the strangest things people say to them without realizing that they are being duped. I will never forget a math teacher I had in the seventh grade who told the class on the first day of the new semester that if a flying saucer were to land in the field outside the window behind us, she would be sure to tell us so that we could turn around and be eyewitnesses to that historic event. It took me a few seconds to realize that all

she wanted us to do was face the front of the room. But I remember thinking, "It could happen . . ."

Being open to all possibilities is a positive trait. When you have the inner belief that you can do anything, even when you experience a setback you can usually shrug it off and say to yourself that everything is going to be okay, no matter what. One of the most memorable and dramatic experiences of my life came when I was on a two-week excursion in the mountains of southern Colorado at the age of twelve with my Boy Scout Troop 678 from Johnson County, Texas. We took this trip every year, and I loved camping out among the aspen trees and swimming in the cold mountain streams. Our scoutmaster was an accomplished bowman and archery enthusiast, and his best friend was the game warden in this beautiful wilderness area. They both loved to go deer hunting in season during the month of August, and the scouts sometimes had the opportunity to tag along.

One afternoon, during one of these outings, my best friend, John, and I were with the assistant scoutmaster, who was also along for the hunt. After a couple of hours, he spotted a buck between the trees, aimed his bow and took the shot. The deer ran off into the forest and we followed. After a while, we realized that it was going to take a long time to find out if the deer had fallen, and so the scoutmaster asked us to go back to camp to get help. The only problem was that he pointed us in a direction that was about 20 degrees off course.

We walked for several minutes and looked around. Nothing looked familiar. We decided to continue a bit farther and suddenly realized we were lost. As I turned my head around, all I could see was ridge after ridge after ridge. There was

no civilization or campsite to be found. It was around four in the afternoon by that time and starting to get dark. I told John, who was thirteen, that we had better go up the side of the ridge we were on so that if they came looking for us, we would be easier to spot. He started to panic and kept saying to me, "They'll never find us!" I said, "We couldn't have walked that far. All we need to do is stay put so that we don't wander too far away from the main camp."

John was still not convinced, but he managed to help me build a small fire, which I thought would provide us comfort and also serve as a smoke signal. During the night, it rained and the temperature dipped down to at least 40 degrees Fahrenheit. We were in T-shirts but fortunately found good shelter under a giant fir tree. John became depressed, and we both wondered if we would be visited by a not-so-friendly bear looking for food when we least expected it. But inside myself, I knew that everything was going to be all right. I just knew it. At around 6 a.m., the local sheriff started shooting his gun into the air, and we managed to yell loud enough for him to hear us. We found out later that the main camp was just over the ridge from where we were.

Because prophetics just "know" things, they may earn a reputation for being know-it-alls. Have you ever said, "I *told* you that was going to happen" or "I *knew* this was going to happen!" Most people consider this an obnoxious attitude, even though you are not trying to be better or smarter than they are but are just trying to prove to yourself or take pleasure in the fact that you can trust your own hunches. Sometimes prophetics display a flamboyant personality because of their creativity and passion for life, also earning them the reputation for being the "actors" of the world.

Prophetics may feel as if they have several different personalities. Their innate versatility allows them to adapt to almost any environment and to communicate with just about anyone, including people from other cultures. For example, since 1973, I have had the opportunity to travel throughout the world and have felt comfortable wherever I have gone.

In 1984 I was on a lecture tour of Paris, Strasbourg and Marseilles with a friend of mine. Raised in both New York City and Paris, he spoke perfect French and served as my translator. We appeared together on a radio program while we were there, and I don't even speak French. Even though I didn't understand anything they were saying, I just knew what to say when they asked me to share how I felt about the topic under discussion. After the interview, as we were driving back to our hotel, my friend said to me, "Howard, when you shared, it just clarified the whole thing!" I just *knew* what to say.

Keeping Organized and Focused

One challenge for prophetic people is to stay interested in all the projects they start. They may move from project to project, not finishing any of them, and put things off that bore them or are not interesting at the time. People with prophecy as their first gift need constant stimulation and are therefore sometimes considered to be flighty in their actions. As they are always receiving information from many different sources, they have a tendency to do too many things at once, causing them to become scattered. This is the unbalanced side of the prophetic. They would much rather delegate to someone else than finish a project they

were so excited about at the beginning. Once it becomes a routine, they easily get bored.

The way to overcome this tendency is to focus on one project at a time, treating each one as a compact unit of energy. To do this, it's important to know the end goal of the project and clearly delineate all the steps in between so that you know exactly where you are, even if you have several projects going on at once. Before you move from one project to another, make sure that you close the energy on the project you're working on before opening your energy to work on the next one.

You can easily accomplish this with the Personal Energy Cleansing technique described on page 42. Simply do the technique as soon as you stop working on one project, and then do it again before starting something new. This will help prevent you from getting scattered. I do this all the time in my business. After every phone call, I cleanse myself to clear my mind and cut free my energy from what I have just been doing so I'm free to move on to the next order of business. When you fail to close the energy on a project, your mind will still be thinking about what you were doing before, which drains your energy and prevents you from devoting yourself 100 percent to the current task at hand.

A busy prophetic can also keep from getting scattered by learning to delegate. You don't have to be a one-man operation and do everything yourself. As long as you create a list of what needs to be done and oversee the project, you can go down your list and check off everything as it is completed. Don't give up until each project is finished. Because of the prophetic's enthusiasm for beginning new projects, this can sometimes be a major challenge. You may feel that every-

thing has to be new and fresh. The key is to delegate and check and recheck. Then double-check to make sure that what has been done is up to your standards.

When prophetics are balanced, they stop being workaholics and become examples for other leaders to follow. If you are a prophetic who is in balance, you can accomplish amazing things. Anything is possible as long as you organize yourself. You are a master at management and can track many different projects at the same time. Evaluating each impression you receive will help you to discern your priorities. Your main challenge is to write down what needs to be done (including all of the steps), when it needs to be finished, where it will take place and why it's important that it be done according to your standards. This way, others can follow what you are doing.

Prophetics also have a sense for the future and are good at planning ahead. Even as a kid, if I had the flu or some other childhood disease and stayed home from school, I would find myself planning which TV shows I would watch throughout the day, and depending on how sick I was, possibly for the whole week. Even today, I can sense what I want to do over the next week, month and sometimes years to come.

It's interesting to note that countries as well as individuals have an energy, or vibration, that can be correlated with one of the four spiritual gifts. For example, the United Kingdom has a prophetic energy because it loves to manage and get involved in different cultures. Even though the English started by conquering other countries, they brought education and organization into those societies.

The Challenge of Working with Others

When in total balance, prophetics have a great ability to work with people because they can see the potential in others before they see it in themselves. Prophetics have a strong desire to make a difference in people's lives and in society as a whole, but there are some pitfalls they need to be aware of. It's human nature to want to live in a positive culture and do your part to save the world from itself. But as I mentioned earlier, the world does not need to be saved, only improved.

Because you have a natural sense of the potential of people and societies, you may have a tendency to get involved with small or large moral issues and find yourself taking up causes. What's more, sometimes the causes may have nothing at all to do with what you came here to accomplish, and you could get sidetracked by getting angry or rebelling against injustices that are not pertinent to your life plan.

It's important to remember that it's not your job to save the world. Your job is to take care of yourself and be an example for others, not to get involved in their problems. You will find that when you're loyal to yourself and find the niche that is right for you, you will be relaxed and fulfilled and naturally more benevolent to others. Many prophetics in this position become philanthropists and ambassadors.

As a prophetic, realize that it's not *what* you do but *how* you do it that matters. Your drive to save the world and others can create an inner battle about what is really necessary for you to do as well as how to do it. For example, if you become overly aggressive, you will try to force others to live up to their true potential, even if they're not ready to do so. This

will earn you a reputation for being a papa goose or mama goose, always telling people what to do and how to do it, whether they like it or not. It could be that those you are concerned about need to work out their own difficulties so that they can learn how to stand up for themselves and set their own boundaries. Sometimes by taking up other people's causes, you rob them of the learning experiences they need to have.

Meddling in others' lives or being overbearing is the quickest way to have your children or the people you work with rebel against you. The key for prophetics is to understand the big picture of the situation they are facing and then see what needs to be accomplished and how others fit into the scenario. If you try to oversee and micromanage every step by telling people how to do everything your way, they will surely undermine your authority. How many parents do you know who try to run the lives of their children even when they are well into their twenties or even thirties? I know a woman who is seventy-three years old whose sister insists on treating her as if she is still her "little" sister, unable to make a decision on her own or take care of herself!

Some people, of course, will rebel no matter what you say to them. They are simply trying to prove themselves. They probably had parents who were overbearing, and now they are making you into the image of their mother or father. The solution to working with people like this is to give them the big picture of what needs to be done and then let them organize themselves. Give them a time limit in which to finish a project and recheck with them to see how it's going, always communicating with care and consideration. In addition, don't ever force someone to do something you

wouldn't want to do yourself. If you're not willing to do it because it's simply inconvenient for you, find someone else who will enjoy the opportunity and get something out of doing it. Forcing someone to do something will create anger and resentment and destroy any feeling of teamwork and companionship.

When prophetics keep a balanced perspective, they can help others to help themselves without smothering them or giving them advice. Everyone needs to be able to retain his or her self-worth. When you respect individual creativity, without having to sacrifice a project, people will admire you for your openness and support.

If there was excessive pressure in your family when you were growing up, you yourself will have a tendency to rebel against authority. This is because prophetics really enjoy their freedom and dislike the idea of being controlled. But if you are to be a good leader—of yourself and others—you need to learn to be a good follower first. You have to be willing to follow the direction of others before you can expect people to follow you.

Trusting Your Hunches

The most important key to making the most of the prophetic gift is trust. You may have been taught to doubt yourself. If your parents doubted the impressions they received, you will have picked that habit up from them during your first seven years, and it is likely that you will doubt yourself as well. It doesn't matter whether your prophetic gift is first, second, third or fourth in your gift order; whenever you doubt the hunches you get, you are communicating with

yourself through the unbalanced side of your prophetic gift. Since your spiritual guides give you almost one hundred impressions a day, wouldn't it be beneficial for you to pay attention to all of them? How much of the time do you get hunches and discount them? This doubt is unfounded. You might say to yourself that it's not the right time or that you don't have what you need to carry out your idea. If this is a familiar experience for you, you may be losing opportunities every single day—for no reason. You need to remember that your spiritual helpers are always there to give you solutions to problems or challenging situations. You just have to pay attention.

Sometimes, instead of listening to your inner guidance, you may think others know better than you. Have you ever wanted to kick yourself because you listened to someone else's advice instead of your intuition about what was right for you? Many of us do this all the time and then end up feeling miserable or having regrets.

Trusting yourself is more than just listening. It is also acting on your impressions. Many people get hunches and ideas but never put them into action. Have you ever watched an infomercial on television and discovered that some obscure entrepreneur had come up with the same idea you once had for a great product? At the time you originally had the inspiration, you probably said to yourself, "I could earn a million dollars with this idea!" Apparently, someone else was listening to her inner guidance at the same time. The only difference is that she did something with it.

When I was in college, I remember coming up with the idea of putting movies in pizza parlors and starting a franchise of day spas so that busy, overworked people could re-

fresh themselves during their lunch breaks at the spa down the street. Sometimes I wonder what would have happened if I had followed through with that idea. Yet doing so might have taken me in a whole different direction, one that wasn't part of my life plan. Because prophetics are highly creative, they do get a lot of great ideas and therefore need to be discerning about which ones further their purpose in life and which ones do not. In fact, all of us have to learn to discern whether an idea that comes to us is something we need to follow through with or not. If you get an inspiration and have a strong feeling to implement it and you don't, that's when you'll end up kicking yourself.

The doubt that keeps you from trusting the impressions you are meant to act on creates procrastination. People often procrastinate because they second-guess their ability to carry out what their inspirations are telling them to do. If you feel insecure about whether you will be successful at something you feel motivated to accomplish, break it down into smaller steps. Do the first step and then go to the next step. If you try to swallow the whole project at once, you may feel overwhelmed.

The moment you start feeling overwhelmed, it's time to take a break and do something different, not push harder. It's important to step back, take a breath and change your attitude or energy. Then your perspective will become more focused. Don't let anyone put pressure on you to perform. If you feel that you have to prove yourself, this will cloud your sensitivity. Only when you are focused can your spiritual guides give you clear inspiration.

If you want ideas or solutions, remember that all you need to do is ask. Your spiritual helpers are always willing to

help you. This is the spiritual contract that you made with them before you were born. And if you're following your guidance, you don't have to worry about getting in over your head—your helpers will never put you in situations you can't handle. However, you may put yourself in a situation that your helpers won't support because they know it's not in your best interest. How can you tell when that's the case? You simply won't feel any spiritual energy coming your way to help you out with the plan or action. If you decide to do it anyway, not only will you run out of energy, but your guidance will have to work twice as hard to protect you and keep you from hurting yourself. But no matter what you decide, your helpers will never interfere with your free will. If you really want to get into trouble, they won't keep you from it.

It's also true that your spiritual helpers will never force you to do anything you don't want to do. They won't push you to achieve in areas you are not ready to accept in yourself, and they will never lead you to do something that is harmful to others. People who say that a "voice" told them to go out and kill or hurt someone are never listening to a guardian angel or spiritual guide. These people are confused and simply indulging in their own negativity or picking up pressure from their environment and acting out their fantasies.

Interpreting Your Dreams and Impressions

The ability to foretell events is another aspect of the prophetic gift. Sometimes your personal angels will give you impressions about the future. You may even get these impressions, as well as inspirations, through your dreams. Have you ever had a dream that came true? Did you trust it at the

time? It's important to put your impressions about the future into perspective and understand how to handle them in the overall scheme of your life. You may be picking up information about something you need to do or that's going to happen, whether in just a few minutes or a few days or much later in your life.

To help you understand and interpret your dreams, your spiritual helpers may give you symbols that are relative to your second gift. (It would be hard to have a dream that consisted of just inner knowings.) For instance, if clairvoyance is your second gift, you may see vivid images in your dreams. Clairaudients are down to earth and practical; so if your second gift is clairaudience, your dreams will have a very real quality, whether you're flying or talking with someone you know. If your second gift is healing, or feeling, you will have deep feelings in your dreams, which you can understand by clarifying the relationships and the emotions that accompany your feelings.

Sometimes the people we see in our dreams are symbols for emotions or qualities, such as authority or friendship, or they may represent an aspect of ourselves. Therefore, when we dream about a specific person, the dream doesn't necessarily relate to that person. This principle also applies to dreams about death.

If you dream of a death in the family, don't look at this as a bad dream. The dream may simply be helping you prepare for the inevitable or it could be symbolic. A dream about death often represents a significant closure in one part of your life and a new beginning, as you move to the next level of your spiritual growth. If you dream of someone having an accident, it could mean that the person's spiritual helpers

cannot get through to him and therefore they are working with your angels to help prevent a dangerous situation. Just trust what you are receiving and evaluate it to the best of your ability.

When I first learned how to communicate directly with my spiritual helpers and to trust the impressions and dreams they gave me, I would ask them the meaning of the symbols. I would keep a pad and pen next to my bedside, and upon waking in the morning, I would write down all of my dreams before they escaped me. Then I would meditate and ask my inner guidance what each symbol meant. The answers would come to me very clearly, and I was able to interpret my own dreams easily. While there are some universal symbols that come up in dreams, when you read a book on dream analysis, be aware that the symbols and interpretations may be true for the author but may not necessarily apply to you. Only you—with the help of your spiritual guides—can interpret what *your* dreams really mean.

●■▲∞

Creating Your Own Future with the Prophetic Gift
A PRACTICAL EXERCISE YOU CAN DO NOW

Your spiritual helpers are always giving you inspiration. Why waste it? The gift of prophecy is all about trusting your inner knowing and acting on it (not procrastinating) so that you follow your life direction.

The key to interpreting your hunches, whether they come to you when you're awake or in your dreams, is to stay in your true

feelings so that you are clear about what you are receiving. This exercise will help you to identify your hunches and to start acting on them in an organized way.

1. Write down at least six hunches or inspirations you have received over the last year that you feel will make you more successful.

2. Check off the ones you have followed through with.

3. If you have checked off all six (or more) from your list, give yourself a perfect grade (100 percent).

4. If you have one or more left unchecked, ask yourself: "Why haven't I followed through with these inspirations?"

5. Write down all of your excuses (yes, excuses). Maybe you were too busy or you were making other people's dreams or aspirations more important than your own.

6. Write down all the reasons you feel acting on these inspirations will benefit you.

7. Make a commitment to follow through with these inspirations.

8. Set a goal and create a project that will help you accomplish each one.

9. Create a step-by-step checklist outlining how you are going to achieve each goal.

10. Write down a deadline for each goal.

11. Create a schedule to organize your time so that you know exactly when you will be acting on each step.

12. Recheck your list each week and make sure you are on track.

13. When you have finished one set of goals, come up with more. Write them down, using the steps in this exercise. Keep building on what you have already accomplished.

14. Make sure one of your goals is to stop procrastinating and to start listening to your inner hunches.

How to Unfold Your Gift of Prophecy in Your Personal, Business and Social Life

Whether or not prophecy is your primary gift, using your prophetic gift in a balanced way can help you to tap into a new world of creativity and accomplish more than you ever dreamed possible. This chapter takes a deeper look into this avenue of communication and shows how you can apply the gift of prophecy in your personal, business and social life.

Remember that each gift has its positive and negative traits, or, to put it another way, each gift has a balanced and unbalanced expression. When we are expressing the unbalanced side of a gift, it is because we have let our emotions get in the way of communicating effectively with ourselves and others. In this chapter, you will learn how to avoid the unbalanced prophetic tendencies so you are not unwittingly working against yourself. You will also learn how you can use the gift of prophecy in a balanced way to bring greater organization and direction into your life. We'll begin by exploring the personal side of the prophetic gift. As I explained in chapter

3, your personal life is all about you, your true feelings and respecting yourself for who you are.

THE PERSONAL SIDE OF THE PROPHETIC GIFT

The key to getting inspiration and using the gift of prophecy in your personal life—in the realm of your true feelings, or inner sensitivity—is to pay attention to the inner knowings you get on a daily basis. Sometimes you just "know that you know that you know." You may not be able to explain this knowing, but it is real for you. Do not discount these hunches or impressions that you receive from your inner guidance. Write them down. Keep a journal or a notepad next to you at all times so that you don't let any of these inspirations slip by you. They may be just the tip of the iceberg. The more diligent you are about listening to your inner knowing, the more insight your spiritual helpers will give you. As their communication increases, you may feel at times that you can't write fast enough!

Sylvia, my associate and a prophetic, uses her inner guidance and inner knowing to make sure she is heading in the right direction at all times. She shared this story with me about an experience she had at an important time of transition in her life: "At one point in my life, I needed to make a decision about where to go next. That morning, I said to my guidance, 'Let me know today where my next best direction is.' As I went through my day, I heard an ad on my car radio for bottled water from a company in Hot Springs, Arkansas. Later that day, I saw that a neighbor's car had Arkansas license plates, which I had not noticed the whole time I had been in this particular location. Then another neighbor

came over and mentioned that she was from Little Rock, Arkansas. I immediately started getting goose bumps, and that's when I knew that my next destination was going to be Arkansas and that my guidance was really backing me on my new direction. It gave me a very comforting feeling."

Sylvia's move to Arkansas turned out to be a great decision. It helped her to further her career. She developed a great rapport with the people she met there and felt comfortable and at home. "I have learned to *pay attention* to my inspirations," she says. "I know that when I ask for something specific and pay attention to what happens afterwards, my spiritual helpers will give me the inspiration to get me where I need to be. This makes everything so easy and less stressful."

Prophetics, as I've said, can be highly creative. Many of us have a misconception about creativity. We think that we are not creative just because we can't paint a picture as well as Picasso or play the violin like the great masters. We don't realize that we are expressing our creativity in other ways. If you don't think you're creative, start writing down all of the interesting ideas you have come up with in your everyday life, such as how you have been successful at keeping your children directed or at choreographing a family vacation adventure or at creating recipes that everyone loves. Pay attention to the ways you have discovered to communicate better with the people in your environment. Sometimes we take these simple things for granted and don't equate them with using our creativity. We just think they're a "normal" part of our life. The more you recognize how you use the creative aspect of your prophetic gift every day, the more you will appreciate and take an active approach in trusting what you get through your inner sensitivity.

Freeing Yourself of Judgment

If you are expressing the unbalanced side of the prophetic gift, you will be judgmental of yourself and others, which can cut off not only your own but others' creativity. If you have this tendency, you most likely picked it up from your parents. One or both of your parents, or other significant people in your life, may have judged themselves or criticized you every time you tried to express your creativity.

To begin freeing yourself from the blocks to your creativity, try the following exercise. You will need a pen and paper.

1. Do the Personal Energy Cleansing technique on page 42.

2. Think back to when you were a child and ask yourself, "What was the first experience I can remember where I felt my creativity was criticized or judged?" Write down your impression of the experience.

3. Ask your inner guidance to help you remember another experience. You can ask to remember as many situations as you like, but make sure to write each one down, along with your impression of the situation.

4. Identify which one of your parents stimulated the emotion in you of being judged. (By the way, whenever you are around people who remind you of your mother or father, you will have the same emotions coming up and will feel as if you cannot communicate openly and with an inner passion.)

5. Once you have written down all the experiences, picture the parent from whom you inherited these concepts and emotions (note that I am not using the word *feelings*) and send him or her a mental message that you do not need to judge yourself anymore. You can say that you love and respect them but that you no longer have any need for these concepts and that they can have them back.

6. Do this several times until you feel as if you have given them back the emotions.

7. Once you have released the emotions back to your parents, ask your inner guidance to help you change the habit that you created as a result of the emotions. Knowing that you are in total control of how you feel will give you a great sense of well-being.

Remember, you are only doing this on a mental level. You do not need to do this in person. It's important to realize that your parents inherited these concepts from their parents, so please do not judge them for passing these on to you.

The opposite of being judgmental of yourself is sensing your true potential. This is what the prophetic part of you does the best. Every single day for the rest of your life, tell your spiritual helpers that you want this to be the best day you have ever had since you were born. Just think what will happen if you do this for a year . . . two years . . . three years . . . a lifetime! Once you realize that no one can keep you

from living your life purpose and being the best person you can be, you will begin to build on a strong foundation of who you really are inside. You are not your parents. You are you.

THE BUSINESS SIDE OF THE PROPHETIC GIFT

Each of the four spiritual gifts is an avenue of communication we can consciously use to access the guidance and direction from our spiritual helpers. When I made the decision to start sharing my knowledge of spiritual concepts and techniques, I used the prophetic gift to kick start my new career. At the time, I was still a starving artist. But I knew what I really wanted to do and that was to educate people about inner guidance and the four spiritual gifts.

One day, I decided to give my spiritual helpers six months to get me organized, which included finding a way for me to support myself and invest in some training along the way. The next day, a friend came to my apartment and said that a gentleman he knew was looking for salespeople to sell mortgage insurance. My background was in music and film production, and I had never sold anything in my life, but something inside told me to check it out.

I met with the sales manager the next day and he explained the whole program to me. He said that after a husband and wife purchase the insurance, if one of the spouses dies, their house would be paid for. I thought this was a pretty good deal, especially since the cost of the program was included in their mortgage payment and it was only a few dollars per month. I realized the value of this years later when my father passed on and one of the first reactions my stepmother had was "How am I going to pay the mortgage?"

My first priority was not to sell a customer anything he didn't need. It just wasn't in my nature to be a hard-core salesperson. I thought this would be a good opportunity for me to learn more about how to share with people, since I was only twenty-four years old at the time. I developed a strategy, which I never shared with the sales manager, a retired air force colonel on his second career. Back in those days, the mortgage company gave us sales leads that were on IBM punch cards, and we went door-to-door to make our sales. Before I went on my evening or weekend run, I would take the stack of punch cards that were given to me and ask my spiritual helpers which of the people really needed this insurance. As I said, I didn't want to sell people anything they didn't want or need. I would go through each card and use my inner knowing to tell me which of the people to follow up with. This resulted in about half of the cards being set aside. I know my sales manager would have hit the roof if he had seen me do this.

After two weeks, I had sold more mortgage insurance than any of the other salesmen in the thirty-nine states in which the company did business. They put my picture in their national newsletter, and a lot of the older and well-seasoned salespeople would just look at me and wonder how I did it. After I earned enough money to do what I needed to do and get the training I needed, I turned in my resignation. I had accomplished my goal after only two months. Six years later, I bumped into my sales manager at a local department store and he told me that he still uses me as an example of what a person can do if he really puts his mind to it. If he only knew!

A woman who came to a lecture I presented in Denver, Colorado, also learned how trusting her prophetic hunches

and her second gift of clairaudience paid off in her business life when she followed her inner knowing and her inner voice. "For several years, I had played with the idea of opening a hypnotherapy school but never took any action on it. While sound asleep one night, something woke me up, and the first thought in my head was *'Do it now!'* I went back to sleep, and when I woke up in the morning, I realized it was time for me to take action and open a school. Within three weeks of that experience, I had a curriculum, a teaching staff, all of the State paperwork correctly filled out and most of the $1,400 I needed for State fees and licenses. Now, almost three years later, my academy for hypnotherapists is going strong and will soon be expanding its curriculum. I learned from this experience that my guides may make their point anytime, anywhere. I just have to recognize it for what it is and take action on it."

Staying Focused

As I mentioned in chapter 4, a big part of the prophetic gift is being able to keep tabs on many different projects—all at the same time. This can be challenging unless you stay focused on one thing at a time. If you get scattered, you may feel overwhelmed and everything will look cloudy in your mind's eye. You might even get dizzy!

Balanced prophetics have the natural gift of being able to go from situation to situation and project to project with ease. It looks as if they are doing many things at once, but really they are not. It's just that they know how to keep their energy in compact units. In other words, they are able to open the energy on one project, close it, and then open the

energy on another project without even realizing they are doing it. Of course, sometimes they forget to close the energy on a project they have started and that's what gets them into trouble. You don't have to have prophecy as your first gift to experience this. Whenever you feel scattered, this is what's happening.

You can become more focused and less scattered by doing the Personal Energy Cleansing technique before moving from one project to the next and by writing things down. Don't keep all the ideas you get and your to-do list in your head. If you do, you will always be trying to remember everything you have been thinking about as well as the many inspirations you have received from your inner guidance. This is hard work. Your brain will be bouncing from one thought to the next and you will never be able to focus on one thing at a time. This drains your energy and distracts you from being who you really are and concentrating on the task at hand.

When your mind is fragmented into so many pieces, it's difficult to put the pieces back in order, and you certainly won't be relaxed. People may feel as if you don't care about them because you are always drifting off into your own world. If you become frustrated as a result of all this, your emotions will take over your true feelings and your business side will be completely compromised. You might end up saying to yourself, "I just can't get organized!"

The key to getting back on track is to put all of these thoughts and projects in priority order. For instance, you may be concerned that you haven't finished a project you started last week, or you may be worried about something you need to do tomorrow. As I said, write it all down. Don't discount

anything. Then decide what is (1) essential, (2) important and (3) trivia. Take a big, deep breath and release any pressure you have been feeling as a result of keeping all of these ideas in your mind.

Now that you have everything organized in terms of (1) what is essential for you to do now, (2) what is important but doesn't need to be done right away, and (3) the trivia that you have been indulging in because someone may have convinced you that it was your responsibility to deal with it, you can finally make some sense out of what you really need to do. You will see more clearly what is essential for you to do for yourself and what you *think* you need to do for others. Having this awareness will keep you from living outside of yourself. Prophetics have a tendency to try a little too hard to please others because they don't want anyone to think that they are incompetent. Their desire to fulfill their potential in life can get them into trouble if they don't keep their personal energy focused.

I saw how the prophetic gift could help me and others stay organized when I was called upon to step in during an emergency in 1994. Prior to that, in 1993, I had decided to take a sabbatical from my full-time lecture tour and enrolled in some evening classes through Pepperdine University in Los Angeles, one of the best business schools in the country. Even though I had a lot of practical experience overseeing many different projects for the educational program I worked with at the time, I knew this would help me to be a better manager in the future. I felt that I needed more classical training in economics, accounting and management. It was a great experience. Everything they taught was focused on teamwork, and I got an even deeper appreciation of how

important it is to have everyone's input on a project to make it successful.

Soon after, I had the opportunity to use my new training along with my prophetic gift. On January 17, 1994, the Northridge, California, earthquake hit. I was in my condo in the San Fernando Valley, about three miles from the epicenter, when the second floor started shaking and bouncing up and down at 4:30 a.m. The earthquake measured 6.7 on the Richter scale, and we experienced several aftershocks following the initial rupture. Since the electrical grid was down, the only way to find out exactly what had happened was to turn on my car radio and listen to the news. I found out that an entire section of Interstate-10 had collapsed next to the San Diego Freeway and that the entire city was devastated.

I received a call from an agency asking me if I would be willing to work with the Red Cross earthquake operation. Since I was available during the daytime, I said that I would and was assigned to be an assistant to the director. I immediately realized that there was a lot of coordination that needed to take place between the district managers and the head office. Each day, around 4 p.m., the head of each district would fax a report to the headquarters in downtown Los Angeles. These reports contained valuable information about what was happening on the ground and the specific needs of each district. I got an inspiration to ask the director, a woman I admired greatly, if it would be okay for me to organize a daily report by function, according to Red Cross procedures. This included logistics, health care, shelters, service centers, etc.

She looked at the idea and design of the report and immediately gave me the go-ahead. I hung up a large poster

board that was divided into columns, with each department or function heading at the top. Every afternoon, after I received the completed report forms from the district managers, I would take a yellow highlighter, glean the key concerns from each department by district, write them on Post-it notes and put them under the appropriate columns on the chart. The next morning, I would debrief each of the assistant managers in the office about what was happening in the field. Once each concern was handled, I would take the note off the board and replace it with the most current communications. Everything ran like clockwork. It took us exactly thirty days to get everyone out of shelters and into alternative housing.

Using my prophetic gift, I was able to keep tabs on dozens of projects at the same time, but I never got overwhelmed because everything was organized into compact units. Three months after the initial disaster occurred, when everything had settled down, a management team from the Red Cross told me that they wanted to adopt my system for the state of California.

Managing the Departments of Your Life

Whether you're running a multinational corporation or managing a household as a stay-at-home mom or dad, the techniques you need to use to be successful are the same. You can organize any business endeavor, even if it's the business of running a household, into different departments. Let's look at how this might work for you. First of all, break down your "business" into separate categories in the same way that businesses are organized. For instance, there is (1) manage-

ment, (2) operations or administration, (3) marketing or communications, (4) human resources, (5) customer service and (6) accounting or bookkeeping.

What would happen if you managed your business through these six key departments? All you need to do is define what each one does and then fill in the specific projects that fall under each of the areas. Take management, for example. This is where you decide on the policies and procedures for your home or business. Let's say that you go shopping twice a week. Put that on your calendar. If you are involved with PTA meetings or social gatherings once a month, add that to your calendar. Fill in your schedule to see exactly what your routines are. If it looks as if you are overbooking yourself, you need to decide what will stay and what can be dropped.

Another area that could come under the management category is deciding on the policies and procedures for raising your children, that is, what is fair and what is not—for both you and for them. Once you and your spouse define what works for the family as a whole as well as for each family member, you will know where the boundaries are and the consequences that will result when someone doesn't follow these important guidelines.

You can use your creative ability to define every aspect of your home or business through each of the six simple categories listed above. Then you can decide what you can do yourself and what you need to delegate. If you are not a good bookkeeper, why not ask someone to help you? You could pay the person or offer to make a trade of some kind. There is always a way to get help when you need it. Don't let your pride get in the way. Be willing to allow others to be of service

to you as much as you are willing to be of service to them. If you don't, you will find yourself taking on more than you are able to handle in the service of others. This kind of situation will take away your sense of freedom, something those with the prophetic gift value highly.

THE SOCIAL SIDE OF THE PROPHETIC GIFT

The social side of our lives is the area that involves our interaction with others. For prophetics, sharing with people is a need, not a want. It is an expression of their creativity. The downside of this is that prophetics have a tendency to ramble on and on until they feel their listeners have the whole big picture, from beginning to end. They will talk your ear off if you let them. They love to embellish and enhance a story until you are on the edge of your seat. In a word, they are storytellers.

To bring this into balance, it is important for a prophetic to learn how to get to the point of the communication, whether it's in a business or a social setting. For starters, prophetics just need to be aware of other people's time. If prophecy is your first gift, keep in mind the purpose of your sharing, even if it's in a social situation. Always be aware of how important it is to allow everyone an opportunity to say what he or she wants to say and not to make the conversation all about you and your experiences. It's not that people aren't interested in what you have to say, but it's not wise to hog the conversation.

There is always unspoken leadership in every group. The leader is the one who is always in charge of the direction of the conversation, whether it is an official position or not. Prophetics are often the leaders, and as leaders they always

know the purpose of the gathering before they even step foot in the room. However, don't just hop out of your car and knock on the door without looking carefully at the situation. You will get more out of the gathering if you pause for a moment, take a big, deep breath and review what you want to accomplish and learn from your involvement with your friends or business associates. I have always attempted to follow the sage advice of Oliver Wendell Holmes, the nineteenth-century author and physician: "It is the province of knowledge to speak, and it is the privilege of wisdom to listen."

Another trait you will notice when conversing with prophetics is their tendency to finish your sentence before you've had a chance to say what you want to say. They already know how your story is going to end, so why wait? If you watch two prophetics having a conversation, you're likely to hear something like this:

"Do you remember the time when—"

"Oh yeah . . . I never will forget—"

"Oh my gosh . . . I'll never do that again!"

"Yeah I know what you mean . . ."

Conversations like this will drive clairvoyants, clairaudients and healers absolutely crazy. They have no idea what the two prophetics are talking about because they can't get a visual picture, do not have a clue what the facts are and certainly cannot get a feeling or blueprint for the conversation. Again, this is why it is so important for people with the first gift of prophecy to learn how to communicate effectively through their second gift, whether it is clairvoyance, clairaudience or healing.

In the social arena, prophetics also love to have fun. They are the life of the party when they are relaxed and comfort-

able with the people they are with. However, if they get bored, they can become despondent or depressed. This tendency is what gets them into trouble when it comes to finishing projects. Once something is no longer new and novel, they lose interest and want to move on to the next endeavor. They may also do this with friends and lovers and will shy away from commitments if they feel that their freedom is being threatened.

When prophetics are out of balance, they have a tendency to be possessive. If two prophetics are in a relationship, they will sometimes become very possessive and jealous and not allow the other partner to enjoy friendly relationships with others. Their possessive nature can also make them a mama goose or papa goose with their friends, loved ones and family.

If you have this tendency, you can easily rectify it by realizing that you do not need to control people in order for them to love you. As a matter of fact, they will love you more when you allow them to express themselves and be free to associate with whomever they want. This creates admiration beyond belief. Only when people feel restricted—especially prophetics, who love their freedom—will they rebel against authority.

In successful relationships, the guidelines are built on common sense and what works for everyone. No one should ever feel as if he or she is taking total responsibility for or control over any area of the relationship. If a woman feels that she needs to spend time with her friends, she should communicate this clearly to her husband ahead of time. For a man to spend all weekend watching sports without first coordinating with his partner is, at best, putting his relation-

ship at risk. Everyone needs to be alone and to enjoy time with friends occasionally, and these needs can be met by simply planning ahead.

Try having a planning meeting with the significant people in your life, either at the beginning of each week or at another convenient time. Even if you can't meet in person, you can always get together by telephone or even through instant messaging. A planning meeting will allow all of you to communicate your schedules. If anyone needs to make changes later in the week, you can coordinate with each other in a healthy manner so that no one feels taken advantage of. By doing this on a regular basis, with no exceptions, everyone will feel as if his or her boundaries are being respected. If you find that you are involved in a partnership where your needs are not being respected, you may want to rethink your involvement. Only a person who insists on being in total control of another person would be against this type of open relationship.

Learning to Live and Let Live

Another key for people who have prophecy as their first spiritual gift is to learn to live and let live. When prophetics are in balance, they can be great wayshowers and inspire others to lighten up and look at the bright side of life. Nothing is a big deal for them. They can let things slide, like water off a duck's back, because of their strong belief that everything is going to work out all right—no matter what.

Since I have the first gift of prophecy, nothing makes me upset—not even death. When my sixty-three-year-old grandfather passed on, I was only twelve years old. He had been

bedridden for over three years because of a deteriorating heart condition. At the funeral, my mother sat next to me crying and I noticed that everyone was sad. I felt myself wanting to smile but tried to hide it with my hands. I knew that my grandfather was in a better place. I felt elated that he was no longer suffering, but I felt guilty at the time for feeling good when everyone else was feeling so bad. Later, of course, I realized why I had these positive feelings. I just *knew* inside that there was really no such thing as death and that Granddad was in the best place he could be. I also knew that it was his time to go.

●■▲∞

Are You a Prophetic?

Basic Personality
Creative

........................

Personal Energy
Soft

........................

Favorite Color
Purple

........................

Key Sense
Keen sense of smell and taste

........................

Key Question
What?
I need to know what is happening around me at all times.

........................

Possible Professions
Musicians, artists, business managers

........................

Physical Concerns
Reproductive or groin area, digestive system

How Balanced Are You in Your Prophetic Gift?

Give yourself 10 points for each YES answer

(Check YES if you feel that you display this trait more often than you don't.)

Positive Traits	YES	NO
1. I have an inner knowing that everything is going to be okay.	❏	❏
2. I like to be creative.	❏	❏
3. I get a lot of hunches and impressions about the future.	❏	❏
4. I am a good executive and manager.	❏	❏
5. I can easily keep track of many different projects at once.	❏	❏
6. I easily see the potential in myself and others.	❏	❏
7. I express myself freely and openly.	❏	❏
8. I have prophetic dreams that come true.	❏	❏
9. I look at the big picture rather than the smaller details.	❏	❏
10. I just know when someone needs help.	❏	❏

TOTAL POINTS: _____

How Unbalanced Are You in Your Prophetic Gift?

Give yourself 10 points for each YES answer

(Check YES if you feel that you display this trait more often than you don't.)

Not-So-Positive Traits	YES	NO
1. I tend to procrastinate.	❏	❏
2. I have a tendency to be scattered in my thinking.	❏	❏
3. I have too many projects going on in my life right now.	❏	❏
4. I get bored easily.	❏	❏
5. I don't follow through or finish the projects I start.	❏	❏
6. I come up with great ideas but don't put them into action.	❏	❏
7. I wear myself too thin and am a workaholic.	❏	❏
8. I am a mama or papa goose and meddle in others' lives.	❏	❏
9. I am lazy and watch TV a lot.	❏	❏
10. I indulge in too much sleep in order to escape.	❏	❏

TOTAL POINTS: _____

TOTAL SCORE: Balanced _____/_____Unbalanced
(Fill in the first blank with the score from the previous page and the second blank with the score from above. Example: 80/50)

KEY:

If you are more balanced than unbalanced, congratulations!

If you are more unbalanced than balanced, concentrate more on developing the positive potential of your prophetic gift.

The Clear Vision of Clairvoyance: Creating a Positive Self-Image

Having a clear vision of what you want and who you are is the essence of the clairvoyant gift. As a clairvoyant, nothing is impossible for you once you see a picture of your goal in your mind. You can create anything as long as you can see yourself involved in it, whether it is of a material or a spiritual nature. Once you have visualized yourself achieving a goal, all you have to do is move in that positive direction—step by step.

Even if clairvoyance is not your first gift, you can use visualization to enhance your life. Just remember that in order to make your best decisions, you need to access your primary gift first. Visualization techniques have been used for centuries and are highly effective. As you visualize, you will attract into your life whatever you set your sights on. If you want to buy a Mercedes, see yourself in the driver's seat and you will eventually make it happen, as long as it is something you truly desire. If you want to feel secure speaking in front of large crowds of people, visualize yourself speaking before

a hundred people. Once you get the feeling for being in that situation, speaking will become easy and natural.

My best friend in high school was the valedictorian of our senior class. He was always the best student in the school and was voted "most likely to succeed." One day I asked him, "How come you always get a 98 or 99 on your tests and I usually get a 92 or 93? What are you doing that I'm not?" He looked at me and said, "Howard, I just picture in my mind the page of the book that the answer is on and I write down what I see on the test."

I was shocked. I didn't know what to say for a moment, and then I said, "That's cheating!" He laughed and said, "Can't you do that?" It's not that I couldn't picture things in my mind. I do it all the time (since clairvoyance is my second gift), but that was a little much for me. Then I realized that this is how memorization works. Most of what school is about is simply remembering basic facts in your mind and feeding them back on a test paper. When I went back to college for six months later in life, I was able to ace just about any test by remembering how to work the system.

Clairvoyants tend to gravitate toward professions where they can "see" themselves making a difference in the world. They make great professors, teachers, salespeople, designers and decorators. When in balance, clairvoyants have a sunny disposition. France and Japan are examples of clairvoyant countries. Both are visually oriented and create new looks that set the pace in their respective industries. The Japanese have made many innovations through both quality and design and the French are immersed in the fashion industry. Proud of their heritage, the French feel threatened when

they sense that their beautiful language and culture are being invaded with pop culture.

Clairvoyants can get a reputation for standing in front of the mirror a bit too long, making sure every single hair is in place. Their love of the visual realm sometimes translates into an overconcern about their personal appearance, and if they're even slightly out of balance, they may be self-conscious about how they look. They may even go so far as to wear uncomfortable clothes if it makes them look good. Balance, harmony and colors are important to them, and they like everything to be color coordinated.

If you're a clairvoyant, you may feel uncomfortable or even panic if you get a run in your hose or spill dessert on your best sports jacket. Should this happen to you in the middle of the day, you may become obsessed with how you look until you have a chance to change your outfit. If you're organized, as many clairvoyants are, you might even carry an extra set of clothes with you to the office or when you're away from home as a backup.

Getting the Picture

Because clairvoyants are so visual, they receive guidance from their spiritual helpers in the form of visual pictures. Sometimes people confuse the prophetic gift with clairvoyance. The difference is that the visual images you receive as a clairvoyant are guidance about what you need to do in a particular situation in your life, not predictions about the future.

Sometimes clairvoyants will get a prompting to look in a certain direction, and when their eyes fall upon a particular

object, they will know exactly what they need to do next. Maybe it's to pull a certain book off the shelf and turn to a page that has a message for them that is pertinent to their life at that moment. This happens often to a clairvoyant friend of mine. For instance, one day she was working at her computer and all of a sudden got the impulse to look in the direction of the TV and immediately knew she needed to turn it on. When she did, she saw that *The Oprah Winfrey Show* was dealing with an issue that was relevant to her life. This is one way the visual aspect of clairvoyance works—your attention will be drawn to "see" something in your physical environment that inspires you to move in a direction that will prove helpful to you.

Clairvoyants also receive insights from their personal angels through dreams. Unlike people whose primary gifts are prophecy, clairaudience or healing, clairvoyants dream in color. Of course, others may dream in color, but only if they have unfolded their clairvoyant gift to a high degree. Otherwise, they will dream in black-and-white or not dream at all.

As a clairvoyant, it is natural for you to remember faces and directions to places where you have been before, but don't expect to remember the person's name or the streets you turned on to get to your destination. If you didn't see the name of the person you were introduced to five years earlier and only heard it in passing, you will probably recognize the person but won't remember his or her first or last name. Likewise, you can see in your mind all of the landmarks you passed to get to your destination, such as the white house or the shopping mall on the left corner, but you probably weren't paying attention to the names on the street signs. Even though clairvoyants never forget a face, if they

don't want to associate with you, they will put you out of their mind forever. You have to earn their respect.

Clairvoyants love to read. They will visualize every scene of a book in their mind, including how the characters look and act. It is as if they are actually there. They might even identify with the hero or heroine and see themselves in his or her shoes. If they go to see the movie after having read the best-selling novel, however, they might be disappointed because what they had originally visualized may be quite different than the version the director created for the screen.

It's sometimes hard for visual people to be flexible because their inner pictures can become so rigid. Keep that in mind whenever you want to persuade clairvoyants to do something other than what they had envisioned. The key is to gently approach changing their perspective so that they don't feel lost or confused. It's not uncommon for clairvoyants to say no three times before they finally agree that what you're suggesting might be a good thing. For clairvoyants, "seeing is believing." They must first *see* the whole picture and understand how an idea can benefit them before they *believe* in the idea. Once they believe, they have no trouble putting all of the pieces of the puzzle together to make the plan or idea a reality. Also keep in mind that because clairvoyants see in pictures, you will get the best results when talking with them if you paint them a picture of your experience so they can see what you are saying.

During their school years, young clairvoyants may be made to think that they are not as smart as others around them. This is usually because their teachers are communicating through another spiritual gift and do not realize that these students need to see a picture of the problem in order

to solve it. In reality, clairvoyants are very smart, and many become teachers themselves. Once they get the picture, they are more organized than those who have one of the other three gifts as their primary gift.

Seeing Yourself as You Really Are

Just as clairvoyants form pictures in their head of everything going on in their lives, so they form pictures of themselves. If you're a clairvoyant, the picture you have of yourself can make or break you, depending on whether you use your gift to create a positive or negative self-image. If you have a poor self-image, you can trace this back to your first seven years of life, when every child's programming is strongest. If your parents felt rejected early in their lives, you may have picked up their emotion of rejection and taken it on as your own.

It's important to have a picture of yourself that is positive and comes from your true inner self. Take an honest look at your self-image. If you have a negative self-image, ask yourself where it came from—your mother, your father, the environment in which you grew up? Once you can peel that away and see who you really are, others will also see you in the same light.

Clairvoyants also have a tendency to bring back visions from the past that make them feel inferior, embarrassed or guilty. My second gift is clairvoyance, and I have still never forgotten one particularly embarrassing experience I had twenty years ago. I was sitting in a restaurant in Washington, D.C., and I started singing to myself silently. It was one of my favorite songs of all time—"Till There Was You"—from *The Music Man*, a play and movie I grew up with. It's a very

romantic song, and if you are going to sing it to someone, you had better mean it! When I reached the end of the last chorus, I found that I had actually been humming softly out loud. I looked around and saw a beautiful young woman gazing at me admiringly. To my total amazement, I had been serenading her for five minutes without even knowing it. I was so embarrassed that I quickly paid the bill and went on my way. Throughout my life, every time I've brought back that vision in my mind, I've cringed—and I have often wondered what would have happened if I had simply walked over and introduced myself!

If you are a clairvoyant (or someone with a strong clairvoyant gift) and you find it difficult to let go of memories that make you feel inferior, you may have a hard time accepting yourself for who you really are—a beautiful soul. Unless you take the time to figure out what you learned from a negative experience and then release the experience, you will remember it for the rest of your life. Let go of the feeling that something went "wrong." None of us can really do anything wrong, because our purpose here on planet earth is simply to learn lessons.

We have all said or done things in the past that we regret today. How many times have you blurted out something and then realized that it was the "wrong" thing to say? Even if you were being insensitive at the time, there is nothing you can do to remove it from your life experience. All you can do is communicate to the people who were affected by your words and attempt to heal the situation. If you constantly bring these scenarios up in your mind and then feel bad or depressed, you are not being loyal to your true self. Instead of dwelling on the past, realize that these experiences belong

in the past—they are not a reality in your life now. Allow what you have learned from these experiences to become part of your inner wisdom so that you can help others who are going through similar situations in their own lives.

Striving to Be Perfect

Many of us strive for perfection. Do we ever actually achieve it? Of course not, because we don't even know what perfection really is. If you're a clairvoyant, this may be an especially difficult area for you. The reason you never achieve the satisfaction of being perfect is that you don't realize that you are already perfect! Someone in your first seven years may have put the idea into your mind that you had to live up to his or her expectations. As a result, you are always striving to be accepted by others by being perfect in their eyes and trying to live up to their standards instead of your own. Your sense of self-worth may depend on the compliments of others, which will cause you to constantly look for approval. But no matter how much you get, you will still feel that you can never get enough.

Since perfection is an objective that is impossible to achieve, you may always feel unfulfilled. You may set such high expectations for yourself that whenever you reach one pinnacle, you feel compelled to reach for another. It is a never-ending process of being disappointed because you haven't lived up to someone else's expectations of what you should or shouldn't be. You will put yourself down, judge yourself or compare yourself with others.

This is one way that people who have clairvoyance as their main gift create pressure and stress in their lives. When

they're under pressure, they tend to focus on the dark side of life, because the stress makes them feel that they're not perfect. If they don't see the solution to a problem, they may get depressed. Sometimes, rather than admit that they caused a problem, they will let their pride get in the way and blame others because they're afraid of being judged and they don't want to look bad. On the other hand, when clairvoyants overcome these types of challenges and limitations and express the balanced side of their gift, they can create a life that is full of vision and enthusiasm. They can also create great visions for other people to follow because of their tremendous ability to see where everyone fits within a project.

Once clairvoyants see the overall picture, they can also see all the steps in between. Because of this clarity of vision and their desire for perfection, they tend to set very high expectations for themselves and others, which can create competition. Competition has both a good side and an unhealthy side. It is healthy when it stimulates you to do your best.

For example, when someone you admire encourages you to put 100 percent of yourself into accomplishing what might seem to be the impossible, he or she is giving you an opportunity to more completely express yourself so that, in the end, you can be proud of what you have achieved. Even if you lose, you win. Someone has to be the valedictorian or first chair in the violin section. But just because you didn't become the quarterback on the team doesn't mean that you weren't the best *you* could be. Doing the best you are capable of doing is what true success is all about. When you realize that you already have everything you need inside of you to measure up to your own standards of success, there is no need to compete with others.

Competition, however, can be unhealthy when it fosters self-condemnation and judgment. If a person tries to goad you by saying that someone else is better than you and that you have to try harder, this may actually stimulate feelings of anger and resentment within you. In the extreme, this could end up causing you to take revenge on another. Obviously that is not the best approach. Comparing yourself with others can lead you to belittle yourself and create in your mind a lesser image of who you are. You may hear yourself saying, "I'm not good enough to achieve that goal" or "Other people are better at doing this than I am." If you're a golfer, are you going to compare yourself with Tiger Woods before you step onto the golf course? Of course not. As long as you are doing the best you know how, you are doing it right. This doesn't mean you can't stretch your boundaries to accomplish a goal you want to achieve, but don't put your physical body at risk to prove yourself.

Competition is good when it is in balance. Unfortunately, there is a large movement today to equalize everyone. We don't want people to feel bad about themselves, so we make it too easy for children instead of challenging them to be the best they can be. If a teacher or mentor doesn't challenge you because he thinks you're not capable of doing something, he is discouraging you from doing your best. He is destroying a tiny seed that could blossom into a beautiful flower. Therefore, eliminating competition altogether isn't the best approach either. We all need good examples and role models to push us to grow. If we didn't have other people to compare ourselves with, we would never have a spiritual benchmark to understand what is possible.

Whose Approval Are We Seeking?

Because of their desire for approval, clairvoyants also have a tendency to seek feedback from others to gauge their self-worth. If you're a clairvoyant, you may assume that you know what other people's standards and expectations are and therefore do certain things you think will bring you approval. But trying to live by someone else's standards instead of relying on your own inner standards can only lead to disappointment and dissatisfaction. You may even find yourself trying to measure up to the expectations and standards of people or groups of people you've never met. For example, you may act in a certain way or try to earn a certain level of income to live up to other people's or society's definition of success.

As we have seen, however, other people's standards may not even be their own. They may be completely unaware that they have been influenced by what their parents expected of them and are, in turn, transferring those expectations onto you. In fact, if you take a good look, you might find that the expectations you have set for yourself may not only be your parents' expectations but the expectations of your family going back thousands of years. You do not need to live up to these expectations. It's up to you to discover what is true for you.

If you get caught up in trying to fulfill the expectations, assumptions and demands of others because they put pressure on you to do so (whether it's a teacher, spouse, minister, brother, sister, etc.), you may also find yourself doing the same thing with your loved ones, friends and associates. You are the only one who can break these patterns of assumptions

and misunderstandings. Don't feel guilty if you have already passed some of these concepts on to your children. They chose the environment they would be born into before they arrived on this planet, so at a soul level they understood what they were getting into. The best thing you can do for them and for yourself is not to blame yourself but to change. If there is something you don't like about yourself, release the concept and change the habit that it created. It doesn't belong to you to begin with. In that way, you become a good example for the other people in your life by showing them that change is possible.

Because clairvoyants tend to gauge their self-worth based on other people's approval, they sometimes overreact to what people say to them. Observing your reaction to someone else's comments can be a helpful benchmark for where you are with your self-image. Taking things personally indicates a lack of self-acceptance. If people's comments affect you now, it's because you are using others as a sounding board for how you feel about yourself. Again, this can stem from childhood experiences. Perhaps your parents never verbalized what they expected from you and so now you are always trying to figure out what others expect from you and whether you meet with their approval. This insecurity can cause you to become sensitive to the slightest remark that anyone makes, whether it's intentionally hurtful or not.

Children, especially under the age of seven, are naturally sensitive and take personally what anyone says to them. If they are told they are too short or too fat or not smart enough, they accept that statement just because someone told them it was so. This sensitivity is reinforced when we start interacting in a social environment, which usually be-

gins when we attend kindergarten or first grade. We bring with us into this new social setting whatever self-image we have inherited from our parents or whoever raised us up to that time in our life. Think of all those self-images interacting in that classroom. This is our first experience of competing with and seeking approval from people other than our parents and relatives.

As adults, if we still haven't developed our own vision of who we truly are inside, we will continue to take everyone's comments and opinions personally. On the playground in school and in life, bullies get their power from taking advantage of people with poor self-images. They wouldn't have this edge if we didn't give it to them.

Communicating Your Needs

If you're a clairvoyant, what can you do to overcome the tendency toward perfectionism? You can set reasonable goals without the perfectionist expectations that are common to clairvoyants, which will allow you to relax and work toward your goal. The challenge for you is to make sure that expectations are clear and that everyone else has the same picture that you have. This takes communication and coordination.

Many marriages and partnerships fail because of mismatched expectations—each partner has a different picture of what he or she expects from the other. If these expectations are not verbalized, each person may assume that the other partner sees the same picture. When these expectations are not met, one or both partners may start putting demands on the other. This is what causes communication to break down. To avoid problems in this area, communicate

your needs to those around you. Do not expect them to see the same vision that you see. This is a fundamental rule of inner and outer communication.

Because clairvoyants appreciate balance and harmony in their lives, they tend to avoid confrontation—at all costs. This can be good in certain circumstances, but it can be unhealthy if you avoid confronting others to your own detriment. If you don't communicate your personal needs and wants, you may end up creating wars later on. Frustration builds up inside of you and, when you least expect it, you blow up outwardly. By communicating earlier and acknowledging the problem, you can clarify the situation before it reaches the point of no return. I make the distinction this way: A *peacemaker* is a person who wants to maintain peace no matter how much it costs her and others. A *peace lover* is a person who is willing to communicate her needs early on so that the situation does not get out of hand.

Living Up to Others' Expectations

Another area where seeking approval comes into play is our profession. So many young people go into a parent's profession based on wanting acceptance rather than on their own desire for fulfillment. Ultimately, they may end up dissatisfied because they are achieving what they think others expect of them, not what they really want. What difference does it make what other people think if we feel strongly about something ourselves?

We can pay a high price for listening to other people's opinions instead of accepting our own inner guidance. My best friend from high school, the one I mentioned earlier

who had been voted "most likely to succeed," fell into this trap. He was probably the most well-liked person in the whole school. He was a great guy. Everyone, including his parents, expected him go to a prestigious university and become a doctor. In the middle of his first semester at college, he called me and said, "Howard, I think I have a problem. I hate biology." I was a little stunned by his confession but managed to say, "So what are you going to do?" He replied, "I guess I'll be a lawyer like my roommate." That didn't last too long either. He decided to quit school and therefore lost the scholarship he had worked so hard to earn. He did some manual labor for a while to earn money, and his mother also took on a job to help him pay to attend a different school.

The next year, he was ready to enroll at another university, which was not as prestigious as the one he had dropped out of. As he approached the registration desk to fill out the forms for his classes, he abruptly decided to take the money that both he and his mother had earned and fly to Hawaii. Everyone was shocked when they heard the news. We were just as surprised to find out that only two weeks later he flew back. I called him and couldn't wait to ask, "I heard you went to Honolulu, but why did you come back so soon?" He said, "There were too many people there." At that point, I didn't know what to say. I could see that he was deeply troubled and that he really didn't know what he wanted to do.

I recalled that when we were growing up, his mother wouldn't let him go to summer camp or venture out on the water because she was afraid he was going to drown. As a result of how he was raised, he was afraid to take responsibility and wasn't used to making his own decisions. He finally did manage to graduate from college and decided to take up his

father's profession and become a teacher. Whenever I would call him and ask, "How's it going?" he would say, "I hate it." When I asked him what he was going to do, he said, "Well, I guess I'll go into school administration like my father did." There was no passion in his voice. I know that he later went through two or three divorces and ran a couple of small businesses. It eventually got to the point where I wasn't inspired to call him anymore and tell him how much fun I was having traveling around the world sharing with people how beautiful life could be.

Everyone wants to be accepted, but is it worth being accepted at the expense of doing what you really want to do? Do you want to create your own self-image or accept what others have thrust upon you? The key to your happiness is to decide what it is that you want and go after it. If you are always trying to figure out what others want from you and are constantly trying to deliver it, you will become a servant to someone else's concepts about you instead of being who you really are. Remember, you are perfect already. All you have to do is realize what belongs to you and what belongs to others.

Your Profession Is Not You

An out-of-balance clairvoyant also has a tendency to be concerned about prestige. Trying to prove yourself is a doorway to frustration. Our society has taught us that we must have college degrees and pass difficult tests in order to be successful. Of course, there is always a certain standard that must be met by professionals who are doctoring our physical bodies or helping us with complicated legal matters so that we feel secure with the service they are providing. But to try

to measure up to an entire society's expectations of what we should or shouldn't do with our life is absurd and is based solely on prestige. This is not what makes us feel fulfilled.

You do not have to have a "position" in society to prove your self-worth or competence. The more you strive for prestige, the more insecure you will become. Many people identify or become obsessed with their professions or what they do for a living as a means of self-acceptance. This has led to the creation of prestigious-sounding titles for jobs that, though they may be routine, still take a lot of hard work or organizational abilities. Everyone has probably heard of positions such as "Sanitary Engineer" or "Office Specialist." Who said that being a "garbage man" or "secretary" is demeaning? If it wasn't for the secretaries of the world, nothing would ever get done. They are the ones who keep the company running. (Whatever you do, don't let the CEO know this. It might destroy his or her self-image!) Company business would come to a halt if it wasn't for the person who puts the stamp on the letter and takes it to the post office. Sometimes we forget these simple facts.

You are the only person who can discern the answers about what you need to do in your life. If a prestigious position helps you achieve your spiritual and material goals, it could be right for you. Just make sure you know why you are doing what you are doing and what you are learning from it. If you are having fun, you must be doing something right. If you are always worried that you will not meet society's expectations, you are living your life for others and not for yourself.

It used to be that people worked for the same company for thirty or forty years. After they retired, they would often

still be attached to the role that was no longer theirs. Because they had identified with their jobs for so many years, they had no identity of their own. Today, most of us change jobs many times during our lifetime. This is healthy because it prevents us from becoming locked into our profession as the only source of a positive self-image.

A job or profession is simply a vehicle for learning what you need to learn and a means to express your wisdom and experience. By staying flexible and open to new ways of expressing yourself, you will be able to channel your energy and wisdom through another avenue when things change.

I remember meeting a young man in Scunthorpe, England, when I was on a lecture tour and asking him what he did for a living. He said that he was a tree surgeon, a person who looks after the health of damaged or decaying trees, but that he was out of work and on the dole (the English version of social welfare). I suggested that he might want to pursue some other career or start a business of his own. His response was that this would not work because if he wasn't successful, it would take him six months to get back on the dole again! This is how the system, however well meaning, destroys incentive. I even met a couple who traveled back and forth between England and Ireland to collect government funds from both countries.

If you are not willing to do anything other than what you were formerly trained to do, how long are you going to suffer before you change your concept of who you really are? A great example of someone who was willing to do whatever it took to earn a living until his true profession and passion became available to him is Matt Lauer, the congenial host of *The Today Show* on NBC. At one point in his life, he didn't

have enough money in the bank to pay the next month's rent. He had been fired five times in five years and hadn't held a full-time job for over a year. As he was driving to get some coffee, he saw a tree trimming truck parked at the side of the road with a "Help Wanted" sign in the back window. When he got home, he called the tree trimming service and left a message, saying, "I'd love to come work for you."

When the phone rang three hours later, he thought it was the tree trimmers calling back. Instead, it was a television station in New York calling to say that the general manager wanted to interview him for a job as anchor of the early morning news. Once on the job, he was given more and more responsibility and was eventually offered a job as a newscaster for *The Today Show*. His willingness to go to work as a tree trimmer is the sign of a successful individual who doesn't allow his pride to get in the way.

Sensitivity and a Sense of Timing

One quality that stands out in clairvoyants is empathy— the profound sense of what it's like to be in another person's situation. Empathy is what makes clairvoyants great salespeople. If you are a clairvoyant, you can usually sense the needs of others and help them to fulfill those needs. When you see where people are going in their lives, you can help them get there without interfering with their free will. However, if you feel sorry for someone, you're no longer experiencing empathy, but sympathy. When that's the case, not only will you end up getting dragged down right along with the person you want to help, but you may also end up ignoring your own needs. The strength of the balanced clairvoyant

is not sympathy but empathy and being a great example to others of what can be done if you set your mind to it.

Because of their ability to sense the energy of others, when clairvoyants are relaxed they can easily read people's auras and can often tell whether someone is having a negative thought or is thinking positively. While clairvoyants are sometimes known for being cool or aloof, in reality, they are simply shy. They are checking things out to get a picture of where others fit in their life. This is especially common among young clairvoyants. However, as clairvoyants grow older, their sunny personality starts shining through. Even when they feel bad inside, they can put on a good front, and you might not know how they feel unless they tell you.

Timing is an important issue for people who have clairvoyance as their first gift. When they see a goal in their mind's eye, they want to make it happen "right now." They may experience stress because they can see the picture of everything that needs to be done and will try to cram it all into a small block of time. They don't want to wait. After all, if they can see it so clearly, it must be important. This impatience will sometimes blow their timing and put pressure on the people they are working with, especially in a business setting. Sometimes their co-workers will feel as if they have to live up to unrealistic deadlines. When the pressure on everyone causes the end result to suffer, no one benefits and the clairvoyant doesn't fulfill his desire for perfection anyway.

The best solution for clairvoyants in this type of situation is to write down the steps of a project and set realistic deadlines for each step based on the goal for completing the job—with a contingency plan built in. This way, no one gets overwhelmed, not even the clairvoyants. Once they realize

that everything has a time and place, they can relax and sense the best timing for each project. The tendency to be off in their timing makes clairvoyants notorious for being late for meetings and social gatherings. You will sometimes find them making grand entrances after everyone else has arrived.

When in balance, clairvoyants can make timing work for them. When I first started out in the film business, I considered myself to be a "visual writer." Because clairvoyance is second to my gift of prophecy, I would get an inner knowing for how I wanted the film to be edited, and then it was easy for me to see all of the steps—or scenes—in my mind. Each frame is a fraction of a second, and I got to the point where I could tell when the timing was off in a scene. By cutting only one to two frames off the beginning or end of the sequence, it would give the film a whole different feeling, and the timing would flow just right.

Visualizing the Perfect Life Using Your Clairvoyant Gift
A PRACTICAL EXERCISE YOU CAN DO NOW

There is no reason why any one of us can't achieve exactly what we want with the help of our clairvoyant gift and our spiritual helpers, as long as it is practical to do so. First, decide if your goal is something you truly desire. If it is not, you will not be able to create it, no matter how hard you try. If what you want will help you to be more loyal to yourself and to change your life for the better, your spiritual helpers will back you all the way. All you need to do is ask— and visualize in your mind what you want, step by step. Remember

the old saying "By the inch, it's a cinch; but by the yard, it's hard." Be patient and everything will work in your favor. The following exercise can help you to use visualization to take the necessary steps to achieve your goals. Do the Personal Energy Cleansing technique on page 42 before beginning.

1. Take three big, deep breaths—in through your nose and out through your mouth.

2. Relax and ask your spiritual helpers to come close around you.

3. Ask them to give you a picture or vision in your mind of how to create the best life for you at this time.

4. Ask them to give you a solution to the biggest challenge or fear you may be experiencing in your life now.

5. If you have more than one challenge, you can also ask them for solutions to the other challenges.

6. Write down everything you see in your mind, and create a practical plan.

7. Write down the steps it will take to accomplish your plan.

8. Write down the timing next to each step. Make sure it is practical to achieve in the time frame you have allotted.

9. Then repeat at least three times in your mind: "I commit myself to myself and to what I want to create in my life."

10. Ask your guidance to give you more pictures or visions as they are needed to clarify which way to go, and ask them to help you to be flexible enough to pay attention to the direction they are giving you.

How to Unfold Your Gift of Clairvoyance in Your Personal, Business and Social Life

Unfolding the gift of clairvoyance in your daily life is a surefire way to create the best life for yourself and for your family. Not only can you design and produce anything you want, but you can also make it even better. It's all a matter of attitude.

As a clairvoyant, it's critical for you to have control of your attitude and how you see life. You can choose to either be positive and inspired or you can visualize all the tragic experiences you have had and bring yourself down and be depressed. It's up to you. You are in total control of how you feel and think, and you do not have to indulge in anything that does not support you spiritually to be the kind of person you want to be.

You are what you think—not what you think you are. In other words, the concepts you have about yourself (what you think you are) may be totally different from your attitude and what you are projecting to others. Remember this key when looking at how to best use your clairvoyant gift in each of the

three facets of your life—personal, business and social. In your personal life, which is all about being true to your innermost feelings, you have the ability to see yourself being the best you can be. In your business life, you are able to see clearly how to create systems that benefit everyone. And in your social life, you can see how all of your relationships fit together and how to help others recognize the potential within themselves. When faced with any situation, you just need to ask your spiritual helpers for a solution and you will start seeing in your mind exactly what you need to do. This is your clairvoyant gift in action.

THE PERSONAL SIDE OF THE CLAIRVOYANT GIFT

Since your personal life is all about you and respecting yourself for who you are, you can't blame anyone else if you see yourself as a bad person or as someone who can't make it in the world. These types of concepts are fairy tales—and, unfortunately, no matter how old we are, some of us still believe in them. Because we create our lives based on whatever we've been taught in our first seven years, and every experience we have after that simply reinforces and hardens the personal belief system that is already set in place, most of what we believe about ourselves is not who we really are.

If you are not feeling happy 100 percent of the time, it's an indication that you are not being true to yourself and that you need to do something differently. Being happy doesn't mean you won't feel pressure from your environment. No one can avoid that. All you have to do is walk out your front door and you will feel pressure. The beauty of planet earth is that it gives us the opportunity to commune with others from every

walk of life and state of consciousness so we can learn about ourselves, and this can sometimes be challenging.

Yet you can learn to feel happy all the time. Use your clairvoyant gift to visualize inner peace and tranquility. It's easier than you think. All you need to do is work with seven simple concepts that will help you to see yourself as a whole and complete person. Once you visualize these seven concepts and integrate them into your life and make them a reality, you will be a different person than you are now. You will have 100 percent of your personal energy available to manifest your own destiny, and you can say goodbye to feeling lonely or depressed. But you have to do it for yourself. No one can do it for you. The secret is not to *try* to do this. Just do it—and don't feel guilty about thinking of yourself first.

The Seven Life-Transforming Concepts

1. **Total Self-Acceptance:** I accept myself as I am, and I am open to receive from myself and others.

2. **Wants and Desires:** I am free to want for myself, and I truly have the desire to get what I want.

3. **Self-Expression:** I can express myself any way I want as long as it doesn't hurt me or anyone else.

4. **I Am One with Everyone I Meet:** I can be myself without worrying about what other people think of me.

5. **Drive and Incentive:** I can move at my own pace; I don't need to rebel against authority or push myself to achieve my goals.

6. **Relationships:** I can relate to anyone, and I don't have the need to feel greater or lesser than anyone.

7. **Giving of Myself:** I can freely share from my true feelings, and I don't need to expect, assume or demand anything of anyone—not even myself.

Take a few minutes each day to sit down and visualize yourself living true to each one of these concepts in specific situations. See yourself overcoming any limitations you have to fulfilling them. You can work with one per day for each day of the week. Imagine what would happen in your life if you invested a whole day changing your attitude about "total self-acceptance," then focused the next day on your "wants and desires" and continued to move through all seven concepts, one at a time. Since there are at least four weeks in each month, every month you would be going through this positive routine four times. After one year, you would have spent a total of forty-eight days experiencing each one of these seven concepts.

You have no idea how much your life will change if you follow this simple routine of concentrating every single day on your goal of being the best you can be in each of these areas. You will have visualized yourself being the person you have always wanted to be—no excuses—just looking at the positive, not the negative. Here is what I recommend as a daily routine:

1. Start each morning by doing the Personal Energy Cleansing technique (see page 42).

2. Get your key word for the day (see page 45). This

will give you more insight into what you're learning about yourself and accomplishing each day.

3. Set your goal to work on one of the above concepts for the day.

4. Visualize yourself living that concept in specific situations in your life. See yourself overcoming any limitations you may be currently experiencing in relation to the concept you are focusing on.

Here's an example of what it might look like to work with your concept for the day. If it's your sixth day, you will be concentrating on relating to everyone you come in contact with wherever you go, and you will take care not to judge yourself or others. As you practice being nonjudgmental, you will find yourself having more soul-to-soul relationships with loved ones, business associates and people you meet, whether in the mall or on the street.

This doesn't mean you have to like everyone. When someone attempts to take advantage of you, you do not have to let that happen. But be aware that your past experience affects why you attract certain people into your life. Since like attracts like, the people you have in your life right now are the result of who you are inside. You will find that, over time, as you work on changing the concepts within yourself, you will attract mostly positive people. If some of the people in your life are still not positive, it usually means that they need to learn something from you in a particular area or that you still need to learn something from them. This is truly what life is all about.

How Your Body Reflects Your View of Yourself

As we grow older, one of the biggest fears many of us have is whether or not our physical body is going to hold up. Working on the seven concepts can also help improve our overall health, as negativity in each of the seven areas affects specific parts of the physical body.* Here are the ailments associated with these concepts:

1. **Self-Acceptance:** Headaches or pressure around the shoulder area

2. **Wants and Desires:** Lower back pain around the hip area

3. **Self-Expression:** Problems in the reproductive or groin area

4. **I Am One with Everyone I Meet:** Queasiness or discomfort in the stomach area, including the digestive system

5. **Drive and Incentive:** Pressure in the heart or lung area and shortness of breath

6. **Relationships:** Problems in the throat or thyroid area—being too thin or overweight

7. **Giving of Myself:** Problems with the forehead or third-eye area, which can manifest as migraine headaches and sinus conditions

* Please note that the information in this book is not a substitute for consulting with your physician or other health-care provider and getting proper medical treatment. All matters pertaining to your individual health should be supervised by a health-care professional.

Lauren, my business associate, shared a story with me a few years after we started working together about how changing her self-image and putting her own goals first dramatically improved her physical condition. As a single mom, she was raising two children when I met her and was balancing several jobs along with her home life.

"Being a single mother and raising two children is never an easy task, and my experience was taking a toll on my physical body," she said. "I had constant lower back pain and it got so bad that I could hardly walk without the aid of a cane. I was becoming stooped over because it hurt so much to stand up straight. I was in pain 24/7 and had just accepted that it was part of life and was only going to get worse.

"After attending a workshop that went into detail about the body's chakra centers and what each one represents, I realized that my physical problem actually stemmed from a personal problem regarding my wants and goals. I decided to change my attitude about my goals. I began by communicating to myself that my goals were important. I also started working with my angels on my main goal, which was to find a place to live for me and my children. Our landlord had decided to sell the property, which left us without a place to live.

"With a below-poverty-level income and poor credit due to my divorce, it seemed rather impossible that I would qualify to purchase a property of my own. However, that was my goal. Everyone said it couldn't be done, but I communicated what I desired to my angels and they inspired me to stick to my goal and helped me with important decisions. They made it clear to me that this needed to be done one step at a time, and that is exactly how the goal was achieved—one step at a time.

"I'm really glad I didn't listen to everyone else and instead listened to myself because within three months, my children and I moved into our own condo. The best part of this story is that while I was accomplishing each step of my goal, I noticed that my back was hurting less and less. By the time we moved into our new property, I no longer needed my cane, and I have not had a problem with my lower back in years."

Several years ago, when I was in Ohio presenting a workshop on how these seven life-transforming concepts affect the physical body, I was invited to appear on *Good Morning Cleveland*. I had the pleasure of following Dr. Benjamin Spock, the famous baby doctor. The station had invited about twenty-five young mothers and their babies so that he could give them advice on child-rearing techniques. Since I was the next guest, they decided to have me work with these mothers as well.

I asked my spiritual helpers to pinpoint exactly where each of these women was having problems with stress and how it was affecting her physical body. When one of the women stood up, I got a picture in my mind of her solar plexus, and I asked her, "Do you ever have problems in your stomach area or digestive system?" She gasped and said, "Oh my gosh, all the time! That's my biggest problem." When I asked her if she had a tendency to get involved in other people's problems and whether she had a hard time being detached, she said yes. The solar plexus is related to feeling one with everyone and having empathy, not sympathy. So struggling with the issue of empathy versus sympathy can show up as stress in the stomach area. Once you learn the cause of the stress you are under, you can work to free

yourself from its effects as you change your underlying concepts and visualize yourself as a whole new person—without limitations.

THE BUSINESS SIDE OF THE CLAIRVOYANT GIFT

The clairvoyant gift is your best friend when it comes to business. As a clairvoyant, not only do you have a talent for being empathetic with people, but you can also picture in your mind the kind of business you want to be in and how successful it can be. You do not have to *try* to make it work. You simply need to see all of the facets working together.

A few years ago I attended a seminar on entrepreneurship, and one comment the instructor made stood out in my mind. He said that if you can *picture* your business in your mind and see it working in all areas, it will be successful. But if you can't see it operating smoothly in your mind, it won't be successful. That's the key to using your clairvoyant gift in your business life.

Once one of my associates set up an interview with a local newspaper to promote a lecture I was giving—or at least I thought he did. I showed up at the designated time and asked for the features editor. When I approached his desk to introduce myself, he said that he had never heard of me. I told him that my representative had set up this time for me to come in and show a reporter how to see an aura for a feature article he was writing. He smiled and said, "If you can show us how to see an aura, we'll do a story!"

He called one of his staff over, a young man in his twenties, and said to him, "Go interview this guy—and make sure he shows you how to see an aura." The next day, I bought a

newspaper, and to my amazement, they had printed a feature article that was a full page and a half with a huge picture. The headline read: "Nice Man Shows New Way of Living." I guess I got my point across. Even though I had initially met with some resistance from the editor when I arrived for the interview, I didn't change my picture of what I wanted to accomplish. I could have simply left his office feeling embarrassed about the miscommunication, but I didn't let that stop me. I kept the visual image in my mind that I was going to have an interview so that more people would know how to get inspiration from their personal angels. Obviously, I also had the spiritual backing to make it happen.

One of the biggest pitfalls for people whose main gift is clairvoyance is compromising their life direction. To avoid this trap, first decide what job or business you want to be in. Don't discount any possibilities. You can do anything you want. All you have to do is want it. If you just *think* you want it but don't truly *desire* it, you will never achieve what you're looking for. You also have to have fun with whatever you do. If you're excited about becoming the best lawyer in town, you're probably in the right profession. But don't become a lawyer because your father was a successful attorney. When you do something just to please someone else or your family, you will never be satisfied with your life. Make sure you are doing what you enjoy. Otherwise, you may regret it for the rest of your life.

You can earn a living at anything you truly enjoy doing. I will never forget an older woman I met at a lecture I gave in Schenectady, New York. She asked me how she could possibly earn money doing what she loved to do the most—knitting. The audience laughed. And then I said, "Why don't you

show others how to knit? Start a knitting school or give private lessons!" Many people think their time is not valuable enough to charge for what they know. They would rather give it away for free, and that is their downfall. I'm not saying that you shouldn't volunteer your time when there are people in need, but if you are going to start a small business such as this, you have to respect your time.

If you want to start a business and earn full-time or extra income on the side, just organize yourself to do it. Buy yourself an appointment book and start networking. I told the woman who loved to knit, "Who knows? After a while you might have to hire other people to help you teach your knitting classes and pay them to do it!"

Making Important Decisions

Years ago, I came to a turning point in my life and had to decide what profession I really wanted to go into. I had been a successful musician and then decided to become a film producer and editor. I wanted to start my own film production company and didn't want to wait twenty years to do it. So at age twenty-three, I became a producer by putting together a team who had much more experience than I had, and I directed them. The first thing I did was go to a film distributor in the Dallas area and ask, "If there was a film you would want to distribute, what would it be?" To my surprise, the regional manager took a stack of papers out of his drawer and said, "If you make this film, we will distribute it."

To get the project started, I invested the next year taking care of all the logistics. I called the best directors in that genre in Hollywood and asked them if they would be inter-

ested in directing the film. I asked Rod Serling, the writer and producer of *The Twilight Zone* television series, if he would do the narration, and he agreed. As I was going through this process, I was getting more and more involved in spiritual things, and I started questioning whether working in the film business was really what I came here to do. Even though I was good at it, I was having more fun showing others how to access their inner guidance than I was organizing a six-million-dollar motion picture. I knew I had to make a decision whether to continue doing something that would make me a millionaire or do what I really loved.

Our office was close to a beautiful area in Dallas called Turtle Creek, which is surrounded by multimillion-dollar mansions. Many times I would go there to regroup and watch the ducks and turtles swimming down the stream. It seemed like the perfect place to go and be uninterrupted while I decided what I ultimately wanted to do for the rest of my life. To help me sort things out, I used a technique I had learned for making decisions. Even though it's a simple exercise, it still took me six hours to decide whether I was going to continue in the movie business or do what I really enjoyed.

I sat down on the grass and said to myself, "Do I want to earn a million dollars or do I want to do what I really enjoy doing the most—sharing with people about spirituality?" I knew there was no guarantee I would even be able to earn a living by doing the latter. For the next few hours, I kept asking myself that question, using the following technique. I would raise my right hand in the air to share what my intellectual side wanted. The intellect is where we hold the concepts of what is considered "right"

or prestigious according to society, our parents, friends or religious upbringing. Then I would raise my left hand, allowing my true feelings to talk and tell me what I really wanted inside. I always answered out loud, making sure that I was in a place where no one could hear me. (The act of raising your hands is a way to force yourself to take a stand and recognize the difference between your intellect and your true feelings. By doing something physical and talking out loud, you're not just lost in an endless process of thinking.)

Finally, after I had worn myself down, I said to myself, "I know that eventually I'm going to do what I really want to do, so I may as well do it now." Inside, I knew that if the first film was successful—which I knew it would be—I would feel compelled to make another one, and so on. Even though working on the film would easily give me the chance to become a millionaire by the time I was twenty-five years old, I decided that if I continued to work on the film I would be missing my opportunity to do what gave me the most fulfillment. I'm not saying that I would not have had a lot of fun being in the movie business, but it's not what I *really* came here to do.

Once I made my decision, I told my partners that they could continue on with the project without me. Since I was the driving force behind it, the movie never got made. Later, others took the idea of the film and produced their own version, which made them multimillionaires. Because that was what *they* came here to do, they were successful at getting it done. I have never regretted my decision, and my personal angels have backed me every step of the way ever since.

THE SOCIAL SIDE OF THE CLAIRVOYANT GIFT

Clairvoyants are natural communicators. As a clairvoyant, once you see a picture, you can draw that scenario in words or graphics, or what are known as word pictures, so that everyone understands your true meaning. When you listen to the radio or read a book, you naturally formulate visual images in your mind in order to understand exactly what the commentator or author is describing. Since every word can mean something slightly different to each of us, depending on our personal experience, it is necessary for us to use various "colors," or vivid descriptions, in our language so that our audience will comprehend our actual meaning. This is what makes languages so interesting, and challenging.

It's important to realize that not everyone will have the same picture as you of a particular experience you are explaining. To maximize your clairvoyant gift and help you communicate more effectively with others, don't assume that people know what you are talking about. Take the time to clearly describe your experience—when it took place, where it happened and why you experienced it. This will give others the complete message from your point of view. People will always insert their own concepts and prejudices into your description, but at least they will appreciate where you are coming from, even if they don't agree with you.

Look at it this way: if you share an experience you had, no one can say you are wrong. On the other hand, if you communicate a lot of theories that you have heard from someone else (in which case you are simply giving your opinion about someone else's experience), you are speaking or writing from your intellectual side rather than from your true feelings, and people can argue with you.

Communicating Effectively

In everyday conversations, a lot of misunderstandings can be avoided if you slow down and have empathy for others and where they are coming from. Talking too fast is an indication that you really don't want others to understand what you are saying to them. To demonstrate your true concern, listen to yourself, be aware of how you are speaking and make sure that the other person identifies with your point before moving on to your next one. Are you simply trying to impress others or truly wanting them to appreciate what you have to share? This is a crucial question to ask yourself, whether you are teaching others how to program a computer or how to write their name for the first time.

It's also inconsiderate of other people's time if you talk too slowly or ramble on and on, demanding, in effect, a sort of devotion from them. You will end up wasting their time while they wait for you to make your point. When you have a captive audience, such as a Sunday school class or other venue where people have come to hear about a particular topic and not specifically to listen to you, it's extremely important to respect your listeners' time and make your point without indulging in the energy they are giving you. People are benevolent up to a point, but after that, they won't invite you back.

Another important aspect of good communication is listening to what others have to say. How much of the time do you give the people you are talking with a chance to share with you before you cut them off? Avoid being the type of person who likes to hear the sound of his own voice. Give others an opportunity to respond before you move on to your next subject. If someone else is hogging the conversation, don't be shy about letting him know that he is not treating you with respect.

You can politely interrupt him and say, "May I comment on that?" or "Do you want to know how I feel about that?" It would be hard for him to say no. This will give you the time you need to convey your thoughts in the conversation.

All of these are simple keys to communicating effectively with others and having empathy with your friends, family and business associates. You will find that your most successful relationships are those in which there is a fifty-fifty give and take between you and the other person. When it becomes an eighty-twenty relationship, someone is taking more than giving, and the other is giving more than what they are getting in return. When you work with communication and your clairvoyant gift from this point of view and respect everyone around you, your life and relationships will be much more fulfilling.

Your Picture of Others

How we "see" others is another factor that can facilitate or hold back the flowering of our clairvoyant gift. We are often not aware of how our concepts and subconscious judgments color our interaction and communication with others and how that affects all areas of our life. The following exercise can help you surface and examine the judgments that shape your picture of others.

- **Language:** Do you admire or look down on others if they speak a different language than you?

- **Race:** Do you admire or look down on others who are of a different race than you?

- **Fat or thin:** Do you admire or look down on others who have a different weight than you?

- **Tall or short:** Do you admire or look down on others who are taller or shorter than you?

- **Dress:** Do you admire or look down on others who dress differently from you?

- **Speech:** Do you admire or look down on others who have a different accent or culture than you?

- **Education:** Do you admire or look down on others who have more or less education than you?

- **Parenting:** Do you admire or look down on others who have better or worse parenting skills than you?

- **Workplace:** Do you admire or look down on others in your business environment who may or may not have the same abilities as you?

- **Social status:** Do you admire or look down on others who have a different financial position or status than you?

- **Religion:** Do you admire or look down on others who have a different religion or philosophy than you?

You may want to add a few other categories to make yourself aware of how you see others in your society. Every country has unique mores and levels of social status that make up its culture. Do you judge a person based on which side of the

tracks they were born on or whether they grew up within earshot of the Bow Bells in the city of London?

By taking a look at how you have been programmed, you will realize how silly and trivial these prejudices are. In reality, we are all the same—human—and what we project onto others actually defines us as well. That's because what you see in others, you already have within yourself—otherwise you would not be able to recognize the trait you so dislike or admire. In short, if you see a negative quality in someone else, you most likely have it too. If it really bothers you, it usually means you haven't yet clarified how to change this aspect of yourself. If, on the other hand, you can see a negative quality and it doesn't particularly bother you, you may have already worked it out, and now you can share with others what you have learned for yourself. It's impossible to be a good example for others to follow if they feel that you are judging them. Remember, you may once have been where they are. We are all a mirror for each other.

By exposing your subconscious programming and adjusting your picture of others so you are receptive to everyone, you open up new possibilities to use your clairvoyant gift of empathy and communication effectively. When that happens, your circle of friends and business associates will not be limited to people who have a similar culture or background as you. When you realize that no one is greater or lesser than you, you can have soul-to-soul relationships with everyone you meet—anywhere in the world.

●■▲∞

Are You a Clairvoyant?

Basic Personality
Analytical

.........................

Personal Energy
Cool

.........................

Favorite Color
Yellow

.........................

Key Sense
Keen sense of sight and visualization

.........................

Key Question
When?
I need to know the timing of every situation in my life.

.........................

Possible Professions
Economists, teachers, salespeople, designers

.........................

Physical Concerns
Sinus, headaches, thyroid area, stiff neck and body

How Balanced Are You in Your Clairvoyant Gift?

Give yourself 10 points for each YES answer

(Check YES if you feel that you display this trait more often than you don't.)

Positive Traits	YES	NO
1. I can create what I dream of in my mind.	❏	❏
2. I have a sunny personality and disposition.	❏	❏
3. I have a keen sense of organization and love color coding.	❏	❏
4. I see where everyone fits in my life.	❏	❏
5. I can see the big picture with all of the steps in between.	❏	❏
6. I have tremendous empathy.	❏	❏
7. I communicate by painting pictures with my words.	❏	❏
8. I love to read books and am often disappointed when the movie based on the book comes out.	❏	❏
9. I am concerned about my personal appearance.	❏	❏
10. I love balance and harmony in my life.	❏	❏

TOTAL POINTS: _____

How Unbalanced Are You in Your Clairvoyant Gift?

Give yourself 10 points for each YES answer

(Check YES if you feel that you display this trait more often than you don't.)

Not-So-Positive Traits	YES	NO
1. I am overly concerned about my appearance.	❏	❏
2. I judge others based on their appearance.	❏	❏
3. I tend to be a perfectionist.	❏	❏
4. I take a tragic view of life and make everything into a big deal.	❏	❏
5. I compare myself with others.	❏	❏
6. I avoid confrontation at all costs.	❏	❏
7. I hide my emotional side with a smiley face or fake persona.	❏	❏
8. I am afraid to make decisions for fear of being wrong.	❏	❏
9. I think I am dumb because sometimes I can't picture what others are saying.	❏	❏
10. I dwell on past negative experiences and cannot release them.	❏	❏

TOTAL POINTS: _____

TOTAL SCORE: Balanced _____ / _____ Unbalanced

(Fill in the first blank with the score from the previous page and the second blank with the score from above. Example: 80/50)

Key:

If you are more balanced than unbalanced, congratulations!

If you are more unbalanced than balanced, concentrate more on developing the positive potential of your clairvoyant gift.

CHAPTER EIGHT

The Dynamic Direction of Clairaudience: Leadership with True Concern

Have you ever had someone say to you, "Get to the bottom line" or "Cut to the chase"? That person probably has a well-developed gift of clairaudience. Clairaudients are direct and honest with themselves and others and need only a few words to make a point. When others ramble on in their communication, clairaudients will get bored and insist that they get to the point quickly or will just walk away. Small talk is a no-no for them. They do not like to waste their time or anyone else's. Clairaudients can be just as sparse with their stuff as they are with their words. They don't like clutter and want everything to be in its rightful place.

Clairaudience is a French word meaning "clear hearing." Clairaudients' physical hearing is highly sensitive. Little drips from the faucet never escape their attention, and as soon as they detect them, they will spring into action to remedy the situation. Because of their heightened sense of hearing, clairaudients never forget a voice. Once they meet you, they will usually remember your name and pronounce it in exactly

the same way you enunciated it to them. If you change your name, it will be hard for them to adjust. For example, if you initially introduce yourself as Sam but then start calling yourself Samuel, they will always want to call you Sam.

My stepmother shared a story with me that shows how sensitive the clairaudient gift of hearing can be. Many years ago, before the days of self-service gas stations, she and my father were driving through a small town in Texas and they stopped at a local station. The attendant, who was around the same age as my father, filled up the tank as my parents carried on their conversation in the car. When the attendant came over to the driver's side to collect the money, he leaned toward the window, looked at my father and said, "Excuse me, but were you by any chance a captive in the Omori Prisoner of War Camp in Tokyo in 1945 during the war?" My father looked surprised and said, "Yes, I was." The attendant looked him straight in the eye and said, "I just want to thank you. I have never seen your face before, but I remember your voice. If it had not been for you and your men passing food underneath the wall, my men and I would have never survived."

Inner Hearing and Discernment

Those with clairaudience as their first gift also have a profound sense of inner hearing. They receive inspiration from their spiritual guidance through thoughts and the "still, small voice within." Sometimes these inspirations come through to them as a running conversation in their minds, making them quick to come up with great ideas. Even if clairaudience is not your first gift, with practice you can learn to unfold it and have conversations with your inner guid-

ance. Over the years, I have developed such a strong communication with my spiritual guidance that using my clairaudient gift comes naturally to me. I love communicating with my guidance this way, and we have running conversations all the time.

Once, when I was driving down the freeway with my brother, I heard one of my angels say, "He is going to give you a music tape for your birthday." My birthday was only a couple of days away. I decided to keep quiet to see what would happen. About twenty minutes later, we stopped in front of his apartment in Dallas, where he was attending college at the time, and he took one of the eight-track tapes from his collection and gave it to me, saying, "How would you like to have this tape for your birthday?" It was one of my favorites. I smiled at him and said, "You know, something told me you were going to give me this album. I love it!" Throughout the years, my brother and I have picked up on each other's thoughts, and I have occasionally called him and said, "What do you need?" before he has even had a chance to phone me to ask for something.

The thoughts that go through the minds of clairaudients are generally a combination of their own thoughts and the inspirations they receive from their inner guidance. How can you discern whether your thoughts are actually coming from your inner guidance? The easiest way is to notice whether they are positive or negative. When you are in your true feelings, you are open to hearing thoughts that are inspired by your guidance, and those will always be positive, not negative. Also, your guidance will never tell you what you should or shouldn't do. Negative thoughts, on the other hand, come from the programming you received as you were growing up.

When you are operating out of your emotions rather than your true feelings, you are more likely to tune into the "tapes" that are part of your childhood programming. Because of the clairaudient's sensitivity in the hearing department, the replaying of these tapes may be even more pronounced than in other people.

Clairaudients are highly introspective. They need to be in order to hear and pay attention to everything going on inside their heads. That's why they prefer quiet. Too much noise and chatter can be overwhelming to them. If clairaudience is your first gift, you might find yourself wanting to escape to another room during a party because the noise level gets to you, and you want to regroup and collect your thoughts before interacting with more people.

As a clairaudient, you have an uncanny knack for reading people. Your acute sense of inner hearing allows you to discern the truth and read between the lines of what others are saying. When someone walks through the door, you can easily discern from that person's energy what type of person he or she is. Your natural gift of discernment helps you determine if you want to be involved with certain people, whether on a business or social level. For example, if someone presents a project to a clairaudient, she will be able to sense inside her mind if something is not right about it. Her inner guidance will tell her to be careful. When clairaudients use their innate discernment, their spiritual guidance always backs them up.

Because they are so discerning, clairaudients can make decisions easily. However, if one or both of their parents had another strongly developed gift or was unbalanced, they may find it hard to listen to their own inner guidance and feel

confused about their true direction. This makes them more susceptible to going along with what others want.

Setting Healthy Boundaries

Clairaudients are usually very private people. They realize how important it is to have strong boundaries and to respect others' personal boundaries as well. As children, clairaudients don't particularly care to be cuddled or hugged and do not like people to touch them without permission. Their boundaries are usually clear and solid. As they grow older, they can sometimes become withdrawn.

If you are a clairaudient and someone tries to interfere with your boundaries or get too close without your permission, you may feel backed against the wall and want to rebel. You may even prefer that people ask your permission before entering into a conversation with you. Since you consider your time to be valuable, you tend to allot only a certain amount of time to hear what others have to say. Then you will evaluate whether the relationship or what the person is proposing is important enough for you to be involved with and proceed from there. Because of these tendencies, clairaudients usually have only a few close friends and many acquaintances. They are choosy about who they allow into their lives and will not bond with others unless they share common interests or goals.

It may appear from this description that clairaudients are not caring, yet they are some of the most benevolent people on the planet. When a clairaudient senses that someone is sincere in his dealings and has everyone's best interests at heart, she will back that person to the ends of the earth to

accomplish his goals. But the clairaudient first needs to be-
lieve in someone before committing to what that person
wants to do. If the idea is great but the management of the
idea is not solid, she will move on to another, more worth-
while endeavor. Remember, when you want to get involved
with clairaudients, you need to earn their trust and respect—
and the more you respect yourself, the more clairaudients
will trust you.

Being Patiently Impatient

If you are a balanced clairaudient, you love challenges
and have a strong sense of inner direction. Once you get an
idea that you believe in, you won't stop until it is accom-
plished. You will stick with it, no matter what. By concentrat-
ing on the ultimate objective, you can readily see how a
project can be completed, step by step. You have the ability
to clearly see the components of a project and make deci-
sions, qualities that make you a natural leader. Some of the
best leaders in society, such as heads of state, diplomats and
presidents of companies, are clairaudients.

As a clairaudient who makes decisions easily, you like to
be in charge. You want to be in control of your life. You do
not like to wait for others to make up their mind before you
move forward, and so you may want to become the head of
a corporation or be in business for yourself so you can make
the final decisions. But if you're not careful, you could be-
come a one-man operation. When people express their own
creativity rather than follow your specific direction, you may
feel as if you are losing control and so you decide to take over
the project completely. This results in you taking on too

much responsibility. When this happens, you may become overbearing and undermine the people around you. No one wins in this scenario, including the clairaudient.

One way to come back into balance when you notice this tendency in yourself is to delegate. Whether it's in a business or a household, the balanced clairaudient can be great at delegating opportunities to others so that they can reach their full potential and accomplish what needs to be done. Delegating is not just about telling someone what to do and then hoping for the best, and it's also not about giving away your responsibility. You are ultimately the one responsible for the final outcome when you are the person overseeing the big picture. So it's important to give clear guidelines and not expect others to read your mind. You have to create an image and give people all the facts about what you want before they start. This is the half you are responsible for. Their half of the job is to use their creativity within the structure to achieve the intended outcome.

The way to help people the most is to give them an opportunity, tell them the "what, when, where and why" of a project and check in with them to see how it's going. If they need help, give them an idea about how you would do it. Don't tell them what to do. When they don't do something your way, don't get discouraged. They may never live up to your expectations, or they may accomplish the goal in a better way than you had in mind. By training others, you create an opportunity for yourself to move on and upward. In a business situation, for example, your willingness to delegate may result in your getting promoted to a higher position, where you find you are challenged with new ways of doing things. The possibilities are endless.

People with the clairaudient gift also need to learn to be patient with others. If your inclination to be direct and decisive is out of balance, you may try to force people to do things your way instead of letting them make up their own minds. When people are indecisive, it's always best to allow them the space to decide what they want without adding pressure. Clairaudients do not like pressure, so in tough situations you may put pressure on others so you don't have to deal with it. Nothing could be worse. This will not earn you the respect you desire; instead, it's the quickest way to cause everyone stress, including yourself. Even though you may mean well by trying to force others to be more organized and decisive, if these people have less self-respect than you, they will undoubtedly take your actions personally. The solution is to gently help them organize what they want for themselves. This takes a little extra time, but it's usually worth it in the long run.

On the other hand, if others take advantage of your good will and want you to make their decisions for them, it's best to let them know that you are willing to help but that they have to take charge of their own life. I call this being patiently impatient. Don't cater to people who want you to do the work for them. A true leader allows people the freedom to make their own decisions, find their own answers and learn from their own experience, which is ultimately their true teacher. This doesn't mean you should let others fail, but you may have to give them an opportunity to find out for themselves what does and does not work for them. When it comes to helping others, it's also important to have a certain level of detachment since you cannot control the final outcome. A clairaudient's strong sense of boundaries is actually an asset when it comes to doing this.

Keeping Control in Balance

The issue of control can surface in other areas of a clairaudient's life. As a clairaudient, your concern for those closest to you can turn into a desire to control them, causing you to become overly possessive and protective. You may find yourself acting like a male lion, who will do anything to protect his mate and offspring. (These same qualities also make clairaudients great hunters and outdoorsmen.) Wanting to protect those you love is fine, as long as you are not overbearing. In the extreme, this type of possessiveness can develop into situations of family abuse and battering. In these cases, the person who is unbalanced and demanding has set too many rules and regulations for the family to follow.

Many times we attract this kind of abuse if there was a similar energy around us in our first seven years of life. No matter what our background, those on the receiving end of abuse must realize that if they don't do something about the problem, no one else will. You never have to feel as if someone else has a psychic hold on you. Once you decide to break the mold of what has been holding you back from being loyal to yourself first, you will attract the backing you need to protect yourself from further harm.

The clairaudient tendency to seek control can be seen in its extreme form in totalitarian regimes. Most dictators of the world are clairaudient. They go after what they want and are extremely protective of their territory. This aggressive nature creates fear in others, which is how these unbalanced clairaudients gain outer control. People give such tyrants power because they think that these "leaders" know what is best for them. Unbalanced clairaudients have gained the

upper hand with the strategy of pitting "us against them." Using the military tactic of divide and conquer, tyrants throughout the centuries have started wars in the name of some "righteous cause" and by claiming that God was on their side.

True control, however, means being in total control of yourself—being in control of how you feel and what you're doing in your own life—rather than controlling others. The true nature of a clairaudient is to live and let live. Even though clairaudients like to be the decision makers, when they are in balance, they realize that in any partnership, whether it's a company, a marriage or a family, all decisions must take into consideration the welfare of everyone concerned. In a true partnership there is mutual respect and understanding. At times, this may mean coming to a consensus and empowering others, including your spouse and children, to make their own decisions.

While most marriages start out with great hopes and dreams, the partners don't always take the time to look at the "business side" of the partnership. One of the biggest challenges facing the family unit in today's world is a lack of clarity about how the family "business" is to be conducted. There are so many expectations, assumptions and demands between spouses and between fathers and mothers and their children that the breakdown in communication is enormous. When two people have differing views about where their partnership is going—whether in a family or a business—the result may be divorce or dissolution. This usually happens when the policies and guidelines of the household or business are not clear. When clairaudients work to balance out the issues of control that inevitably surface, they can accent

their other positive qualities, which are exactly what's needed to hold a family or a business together.

Creating Systems That Work

Clairaudients are aware that there needs to be a system that is fair and balanced when dealing with people at every level, and this is where they can shine. They are masters at creating systems that work. While they're great at establishing the standards, policies and overall framework of a system, clairaudients don't like to get too involved in handling the details once everything is in place, although they will oversee the operation.

The rules and regulations of any system need to be communicated clearly and followed or rebellion and anarchy can result. One thing that clairaudients need to watch out for is that even though they're usually the ones who make the rules, they don't always want to follow them. If you expect others to follow your guidelines, you must be willing to follow them yourself. In a family, initially the parents will create the standards for the children to follow since they have more experience, but it's important that parents communicate the reasons for the guidelines so that everyone is on board. The earlier this begins in a child's life, the better. While it's important to communicate in simple terms, never talk down to your children.

If you are a person who is truly successful using your clairaudient gift, you will create a system that has fair boundaries, allows others the freedom to express themselves and takes into account their personal tendencies. The system needs to be flexible when the need arises or you may feel

frustrated when people do not respect the boundaries you have set. For example, a person with the prophetic gift, because of her love of freedom, may rebel against strong rules or guidelines. She has to learn to be creative within the family structure or business setting. A healer needs to have a blueprint and know exactly where his boundaries begin and end. A clairvoyant, on the other hand, will sometimes see the system as being an end in itself and try to make it too perfect or rigid.

Working with people with other gifts can be a challenge if you or the system you set up are not in balance. If you set boundaries that are too rigid, those who are required to respect them will rebel against the autocratic rule of the business or household. Micromanaging a business or a family never works. Others will feel that what they are doing doesn't matter in the big picture, that their creativity is not being respected and that they are only tools in the hands of someone else. There has to be a balance so that everyone can work together peacefully and cohesively. Once you understand how to create a system that works for your family or business, you will be able to enjoy an environment that is filled with love and respect for everyone.

Helping Others Help Themselves

As a clairaudient, you can be misunderstood if people perceive your direct manner as abrupt and uncaring. It is not that you don't care; it's just that you have too many things to accomplish and do not want to waste your time with people's trivia or complaints. You also may not have much patience for people who do not know what they want in life. But some-

times people will legitimately need your help, and you can benefit tremendously by learning to listen to them to understand what they are trying to communicate. Listen even when they have trouble putting what they feel into words. An adept listener can read between the lines and help a person organize what he or she really means to say or wants to do. Clairaudients have an advantage here because of their gift of inner hearing.

When one woman I know first learned that her primary gift was clairaudience, she found that it helped her become a better listener. "I would just take three deep breaths and cleanse, either physically or by visualizing myself cleansing," she said, "and then I would begin to *listen*—listen more to myself and to others. By doing this, I would learn more about everything within and around me. As a result, I have become a better friend to others and a much truer and better friend to myself."

When clairaudients are in balance, they have tremendous concern and can be gentle and patient. If you are a well-balanced clairaudient, your gentleness will make others trust you. You do not have to "try" to win friends and influence people; you do this naturally. Your energy is smooth and direct, which helps others to be more focused and committed to themselves. Those who are looking for direction can sense your confidence and inner direction and will seek your advice about many things—from business to personal matters, including spiritual growth. Since clairaudients are practical, if they realize that they cannot help someone, they will simply acknowledge this and will not try to do something inappropriate that could end up harming the person in the end.

As a clairaudient, you have the ability to give others a hint about how to organize themselves to accomplish their dreams. This involves empowering people by sharing the knowledge you have gained in your life when it can help them to help themselves. If, instead, you are possessive of your wisdom, this will only create confusion and will not help people to free themselves from ignorance. None of us has a spiritual right to withhold the knowledge that we have. In other words, if I have information that can help another person, who am I to keep it to myself? Consider it a privilege to help others who are searching for what you have already discovered.

Clairaudients recognize that in order for people to be spiritually free, they need to hear and understand the facts about who they really are. Once people realize who they are as a soul—that they are a soul with a physical body and not a physical body with a soul—they start to understand their purpose for being here. Our purpose is never to conquer and control but to inspire others based on what we have learned about ourselves.

Keep in mind that people will benefit from your personal experience and knowledge only when they can experience for themselves the truth of what you are sharing. You do not have to prove anything. Once they experience it, it becomes truth for them. Thus, the only way you can truly lead is by being a wayshower—leading by example rather than by telling people what to think or believe. This creates self-respect, and when people respect themselves, they will certainly respect everyone else. Imagine how many wars and conflicts could be avoided on planet earth if everyone followed this simple principle.

●■▲∞

How to Get Clear Direction through Your Inner Guidance

A PRACTICAL EXERCISE YOU CAN DO NOW

Whether you're in charge of a family or a business or just making sure that you get to work on time, your clairaudient gift can help you take responsibility for your own life and make it the best it can be. Use this gift to pay attention to your inner thoughts and ideas. Inspire yourself rather than wait for someone to tell you what to do.

The following exercise can help you tune in to your inner guidance for direction. It is a technique you can use over and over again, even six or seven times a day. Think about a specific situation in your life in which you need direction, or use this exercise to simply ask for direction or inspiration in general.

1. Do the Personal Energy Cleansing technique so that you are relaxed and receptive to the ideas and thoughts that will come to you from your inner guidance.

2. Take three big, deep breaths—in through your nose and out through your mouth. It is best to take the air in through your diaphragm first (expanding the stomach) and then into the chest area. When you let the air out, just let go, making sure to relax your shoulders.

3. Ask your personal angels to come close around you.

4. Take another gentle breath and say to your angels, "Please give me one key word that has to do with my true direction at this time." Then write the word down.

5. Say to your guidance, "Please give me two words having to do with my true direction at this time" and write them down.

6. Next, say to your angels, "Please give me a phrase that has to do with my true direction at this time" and write it down.

7. Then ask for a sentence and write it down.

8. Next, ask for two sentences and write them down.

9. Lastly, say to your guidance, "Now share with me anything you would like about my true direction at this time." Just listen inside your mind and see what ideas and thoughts come to you. When you are finished, write them down.

10. Take a look at the words, phrase, sentences and other inspiration you wrote down and meditate on what they mean to you at this time.

11. Sometimes the words you receive will be symbolic or poetic. At other times, they will be crystal clear in relation to your direction.

12. Now you can make a clear decision using the guidance you received.

Be sure that the words you are getting are positive and helpful to you. If they are not, it means you are not in your true feelings. When you allow your emotions to get involved instead of your true feelings, you may not get clear answers. If you did not get positive words, relax and try the exercise again. After doing this exercise several times, you will start getting clearer answers each time.

This exercise will be natural for people whose primary gift is clairaudience. If clairaudience is your second, third or fourth spiritual gift, you may need to practice. Remember, no matter which gift is your primary gift, you can still develop your clairaudient gift to its highest potential.

CHAPTER NINE

How to Unfold Your Gift of Clairaudience in Your Personal, Business and Social Life

When it comes to getting things done, clairaudients have it made. Their natural tendency to get all of the facts before they move forward prepares them to be successful in whatever they do. People with the other spiritual gifts will sometimes hold back or jump in before they know where they are going. For instance, a person with the first gift of prophecy might have an inclination to doubt himself before following through on a hunch and therefore hold himself back. A clairvoyant might create a picture that is so rigid that it is difficult for her to change it. She might want everything to be perfect before charging ahead. A person with the first gift of healing might jump in and then wonder, "What happened to the plan?"

Clairaudients should not have those issues—as long as they remember that they are clairaudients. However, if they are influenced too much by the unbalanced traits of the other gifts, they will tend to take on those traits and then feel as if they are disorganized. But this is not their true person-

ality. One of the ways clairaudients get mixed up is by being told their entire life that they are too aggressive or direct— they say what they mean and they mean what they say. Because of the reaction this brings from others, clairaudients sometimes feel guilty for being so honest and will then do everything in their power not to offend others. In reality, they end up hurting themselves because they are not being true to their own personal energy.

This is especially true with clairaudient women. Even though the social roles are becoming more balanced in today's world, women are still taught to be ladylike or demure. For clairaudient women, this is like telling them to crawl into a hole. Even though they can be congenial in their relationships, whether in a business or social setting, they will be most successful when they can speak their mind and make sure people know where they stand in relation to them. Because clairaudients have inner discernment and can quickly judge people, they will instantly know whether or not they can trust you. When they are balanced, they will respect you but never cater to you.

Once a clairaudient woman realizes that she does not have to hold back and play the game of society, she can relax and reach great heights with her leadership abilities. The main key for her to remember is that she does not have to accept pressure from others. Since she's a clairaudient and therefore likes to be in control, she needs all of the facts before she can make a final decision. When she feels as if she is being pushed into making a decision before she has all of the information necessary to move forward in an organized way, she may react and return the pressure. As a result, she will probably end up blaming herself for coming

on too strong. She can avoid this scenario by putting people on notice that she needs all the facts when they communicate with her.

THE PERSONAL SIDE OF THE CLAIRAUDIENT GIFT

Sometimes we just need to listen. Have you ever heard your name called, turned around and found that no one was there? This happens to clairaudients regularly. It may be that you are not paying attention and your personal angels are trying to alert you to keep your energy fully engaged in what you are doing.

I said in chapter 8 that clairaudients tend to have a conversation running through their minds. If you are a clairaudient, the conversation in your mind can be so strong at times that you have trouble shutting it off. Not only do you hear your own thoughts, but you are tuning in to what your personal angels are sharing with you about yourself, the people in your environment and your overall direction in life. If this sounds like you, one remedy is to collect your thoughts. You will be able to quiet your mind as long as you don't analyze and dissect everything you hear. You don't want to turn the conversation off altogether because this is where most of your inspiration comes from. Just think, you are having a constant conversation with your spiritual helpers and you may not even know it!

One word of caution here is to remember that if the voices you hear in your head are negative, they are not your spiritual guidance talking to you. Our guidance is never negative. Whenever you hear negatives, you are hearing the tapes playing inside your head of the emotional concepts you

picked up in your first seven years of life. When you hear something in your mind that brings you down or makes you depressed, the best solution is to do the Personal Energy Cleansing technique. It's simple but extremely effective. This will clear your mind so that only positive thoughts and ideas come to you.

The key is to do this technique consistently. Remember to do it before you even get out of bed in the morning, any time during the day when you feel pressure or stress and definitely before you go to sleep. Once you make this a positive habit, your personal energy will be high and directed twenty-four hours a day. Then, when inspiration comes to you, you will be ready and waiting. Just pay attention. Do not discount your inspirations or feel as if they are random streams of thought rambling through your mind.

You can think of a positive affirmation while you go through the physical motions of the exercise, such as "I cleanse my mind, my body and my soul," or visualize a beautiful sunset in your mind's eye. I will never forget showing a woman in Ireland how to do this technique. Although she was going through the motions, she was saying to me out loud, "Those in-laws of mine—I just can't stand them!" I had to remind her not to think negative thoughts when she was in the process of learning how to relax. How many times do we spend hours—or even days—dwelling on situations in our life that are beyond our control before we finally relax and release them? This exercise is all about making sure your body and your mind are in total unison with each other.

Before I started using the Personal Energy Cleansing technique, over thirty years ago, I had a lot of trouble going to sleep because I would get all these great ideas in my

mind at two in the morning—and clairaudience is my third gift! I felt that I had to write these ideas down, and this would sometimes keep me up all night. I would have paid a million dollars for the ability to rest my mind. As soon as I started using the cleansing technique my problem was solved. My mind became very quiet and I was able to relax and fall asleep.

Even if clairaudience is not your primary gift, you can benefit greatly by developing this gift more and more. I used my clairaudient gift a lot because, as a musician, I was always hearing music in my mind. Entire compositions would play in my head over and over again until I wrote them all down. Since I couldn't play the piano, in order for me to write musical arrangements for a twenty-piece orchestra, I would have to take what I was hearing in my mind and write it down on manuscript paper. I wrote tight harmony and open harmony and became very good at it. In those days, it wasn't like it is today, where you can use computer programs to simply type in the notes and immediately "hear" what the arrangement sounds like. I had to write the score, copy all of the individual parts for each instrument and find a band that could actually play the music. This was a long and time-consuming process, but it worked, thanks to my clairaudient gift.

You Have the Answers at Your Fingertips

By listening to yourself, you can get the solution to just about anything. All you need to do is figure out what it is you want to know and then ask for the answers (if you don't know what you want, your guidance can't give you a clear answer). When you're experiencing difficulty communicating with

someone, for example, you can ask your spiritual helpers, "What do I need to do to improve my communication with this person?" Then listen for their response. You can enjoy a constant form of meditation in action by staying in your true feelings, discerning what you want to know, communicating it to your guidance and then listening for their feedback. Just keep your energy cleansed and keep your attention on what you are doing and you will be able to get inspiration all day long. When you are receptive to what your inner guidance is giving you—every minute of the day—you will realize that you have the answers at your fingertips whenever you want them.

I can't tell you how many times my angels have said to me, "Turn on the television" or "Listen to the radio" and it has paid off. The moment I act on these internal messages, I find out why they are giving me the suggestions. It may be because there is a program on *Oprah* talking about a spiritual topic that I need to hear, or I get the answer to a question I have about my personal health. It's a never-ending process. Who needs a *TV Guide*? Just listening to these little ideas that pop into your head can give you insights that will change your life forever.

I have a friend in Seattle, Washington, who told me that as she was walking on a sidewalk in the downtown area one evening just as it was getting dark, she heard her inner voice say, "Go to the other side of the street." She was familiar with paying attention to her sensitivity, and so she obeyed this thought and continued her journey on the other side of the street, where there was more light. Nothing eventful happened and she wondered if there had been a good reason for following her intuition. The next day, she opened *The*

Seattle Times to the local section and read that a person had been mugged and beaten in the exact area where she had crossed the street the night before.

I love it when listening to my inner guidance sends me off in an unexpected but meaningful direction. Once when I arrived in England for a lecture tour, I heard my angels say, "If you have a free weekend, go to Rome." I asked them why and I got back this response: "To experience where you had your first spiritual awakening." I was surprised to hear that, even though I already knew I had many spiritual awakenings in past lifetimes. My first reaction was "I never have a free weekend. I'm always instructing classes, and Saturdays and Sundays are usually booked solid."

One Friday afternoon, a few weeks later, I realized that for some reason I had no workshops scheduled for that weekend. I remembered what my spiritual helpers told me when I first landed in the UK: "Go to Rome!" So I raced over to the nearest travel agency about ten minutes before they were scheduled to close. I went to the desk of the nearest agent and asked urgently, "Do you have any flights to Rome for tomorrow?" She checked the computer and there was one seat left on Alitalia. I took it. I hadn't had time to book a hotel before I left Manchester, but I trusted that I would find what I needed. As I came out of the customs area in Rome, I noticed a dark-haired man standing next to a desk in the corner of the terminal with a sign that read: Hotel Rooms— Book Here.

The next thing I knew, I had a second-floor room near the Spanish Steps. It overlooked a beautiful courtyard, which I could see as I peered through the wooden shutters of my room. It seemed as if a fantasy had come true—here I was in

Rome surrounded by ancient historical landmarks. Since it was still early on Saturday, I went to the front desk, procured a map of Rome and set out on my walking tour. The first major landmark I saw was the Roman Senate building. I had an immediate affinity with it and somehow knew that I had been there before. As I continued down to the Forum, I saw an engraved ancient map of the Roman Empire in all of its four major evolutions. You could easily see the progression of the invasions into the Middle East, Egypt and northern Africa. The fourth stone map showed the route of the Roman soldiers as they marched through Gaul (now France), Germania, and then up through Angleterre (England). They never made it to Scotland or Ireland.

As I studied that map, I suddenly realized why I had been directed to go to Rome. In order for me to understand the spiritual energy of Europe, and especially England, since I was there working with her people, I had to know their roots. For me, it was an awakening as to how the attitudes and culture of different peoples evolve. It made me realize that the Roman Empire never fell—it just moved! Not the physical part, but the energy itself. The British Empire was founded on the same energy that was embodied in the Roman Empire over two thousand years ago. I always wondered why many people in England looked Roman, with the square jaw and handsome carved features. This must have been the result of many centuries of intermarriage between the soldiers who originally settled there and the native people of the time. You can still walk around the two-mile-long Roman wall in Chester, near Liverpool, where the main arsenal was stationed.

The next day, I went to the Vatican and enjoyed the mystical rays of sunlight as they shone in perfect position to

illumine the holy exhibits. I found it interesting that you could give confession in at least twenty-three different languages. The Sistine Chapel was closed on Sundays, so I was not able to view Michelangelo's heavenly masterpiece, but I could feel his energy there. As I took a taxi back to my hotel, I thought to myself, "What a great experience this has been. Now I know why my spiritual helpers opened up this weekend for me. Before this trip, I had only part of the picture of how English society became what it is today." What I learned is that every culture is influenced by the first people who settled there. To me, this also explained why Scotland and Ireland never felt as if they were a part of British culture, both in terms of religion and politics.

These are just a few of examples of how the clairaudient gift can change your life when you listen to the still, small voice within. If you are open, you can receive fleeting moments of insight all day long that will always send you in the right direction.

THE BUSINESS SIDE OF THE CLAIRAUDIENT GIFT

Many people have asked me if our angels help us in all aspects of our lives. Your spiritual helpers will back you in everything you are involved with—and that includes business. Of course, they won't help you take advantage of people or get involved in get-rich-quick schemes. Usually that involves a misguided motive of not wanting to earn what you receive. Even if it is easy for you to attain success and material abundance in your life, you have to earn it one way or another. Your helpers will always find a way for you to get the money you need—when you need it. You have probably

had the experience of having just the right amount of funds show up at your doorstep or in your mailbox right when you needed it the most. This is not merely a coincidence. Don't you think you may have had some spiritual help?

In 1984, when Chrysler was having a hard time and Lee Iacocca had just come on board to turn the company around, I was watching one of their commercials. When I saw the automobile they were promoting, I thought to myself, "That car is going to be a hit." Then I heard, "Why don't you invest in Chrysler?" The prompting was so emphatic that I invested some money in the stock when it was at 19½. A few weeks later, I sold it when it had risen to 29½. By following my inspiration, I was able to finance a trip to Australia in order to present a series of training workshops on spiritual energy. That was the quickest way my guidance could find to help me get the funds that I needed.

When I returned from Australia, I tried my hand again at investing, just so that I could earn some extra money. The energy and backing wasn't there for me to do it, so this time I lost money. I quickly learned that there always has to be a good reason for my angels to back me to receive a financial windfall. That doesn't mean that you can't invest in stocks and bonds for future security, but if you are going to "play" the stock market or day-trade for a quick killing, your spiritual helpers may not put any energy behind you.

Here's another example of how the clairaudient gift can help you in your business life. When I was in my early twenties and in between film production projects, I needed to create extra income for myself until a new editing job came along. I asked my angels for help. A few days later, I was talking with a woman I worked with about setting up media and

publicity for a lecture tour she was engaged in at the time. For some reason, we started talking about our childhood, and she told me about how she and her father used to earn money by buying shrimp off a boat in Galveston, Texas, and then selling it from the back of a pickup truck in Houston. My ears perked up, and I heard my guidance say quietly in my mind, "Howard, this is what you have been looking for."

The next thing I knew, we were sitting down at the dining table and figuring out how we could make the trip from Dallas to Galveston and purchase a few hundred pounds of shrimp. I knew I needed a business license to sell seafood, so I went down to the local government office the next day and purchased a shrimp license for twenty-five dollars. Then I got the inspiration to go to a costume shop near the state fairgrounds and rent a red-and-white-striped vest. I already had a pair of white pants and a white shirt, which completed the creative wardrobe I needed to open our "storefront." We both thought this would be a fun thing to do, and since she had some time off, she agreed to be the one to go down to the south coast of Texas and make the purchase of both small- and large-sized shrimp. Being a shrimp lover, I made a commitment not to eat our profits ahead of time!

Several days later, we stationed ourselves in a parking lot and sold over three hundred pounds of fresh shrimp to eager customers. We had simply doubled the price that we paid for the shrimp, and that was our profit. The next week, I got an "idea" that it might be easier to go around to people in the office building where I worked and collect money for shrimp orders. This was successful as well. Even though I was in the seafood business for only two weeks before a new film project came in, the money that we generated from this small

venture more than paid for what I needed at the time. It taught me that as long as I am always willing to try new things, be creative and listen to my inner guidance, I never have to worry about money. Money is already made—the government prints a lot of it. All I need to do is come up with a way to earn it. Thanks to my gift of clairaudience and following through with my angels' suggestion, that's exactly what I was able to do.

A woman who has taken part in our virtual university program from Canada told me that bringing her first gift of clairaudience to the forefront has helped her tremendously in her business life. "I have always thought of myself as more of a person who is clairvoyant since my parents were great visualizers," she said. "When I found out that my first gift is actually clairaudience, I was somewhat surprised. It was very important for me to discover this, and it has helped in ways I can't even put into words. My name is Melody, and I guess you could say that the Universe really did know who I was in this life, even before my birth. When I really think about it, I am all about the 'audio' and, yes, although the other gifts come naturally, clairaudience is really me.

"Because my parents were visually oriented, I have used visualization nearly all of my life. I use it every day in my work. I am a designer of stage wear for performers, and in order to do my work not only do I need to visualize the designs in advance, but I also have to visualize how everything goes together. I was getting so caught up in the visualization part of it, though, that I was missing other important elements. I can build beautiful designs until the cows come home, but I also need to use my first gift of clairaudience in order to get my wares out into the world. It is my inner voice

that tells me when and where to be, how to go about my business and how to take it to the next level so I can thrive, expand, be successful and be in the right places at the right times. I am clearer and more focused now, and I am using all of my gifts in much more productive ways. All of my life, I have felt off track. I am forty years old, and for once in my life, things are clicking. I am finally listening."

Getting the Facts and Creating Systems

Clairaudients are natural business people. They are firm and direct. They don't waste their time on trivia because there are more important things they can be focusing on that will provide a valuable service to others. This is what makes them successful at whatever they put their mind to. Their discernment of people and their ability to sense if the energy of others is on or off is also a great asset in a business setting.

Since clairaudients like to be in charge, they will gravitate toward starting their own business or overseeing a division within a large corporation. When someone says that something can't be done, clairaudients will do anything to prove them wrong. My father was like this. After his first consulting company went bankrupt, he didn't give up. He simply went at it from a different point of view. When the opportunity to purchase the small rural telephone company in central Texas presented itself, he jumped at the chance.

The clairaudient philosophy is "If you can't do it one way, just do it another way!" When clairaudients run into a brick wall, they will simply go around it. They don't try to break down the wall unless it is the only solution to getting to the other side. They will usually find the path of least resistance

to achieve their goals so as not to waste time or energy. While others may go off on tangents or say, "This is too difficult," a clairaudient will simply ask someone who is standing in the way of getting the project accomplished to get out of the way before he or she moves forward.

Clairaudients realize that in order to be successful and accomplish their goals, they must have all the facts. When they don't have the facts, they tend to feel lost. Because of their innate sense of organization, they will insist on getting all the facts in this order: what, when, where and why. Having this information when working on a business project, for example, gives them the ability to keep things clear and simple. Once the plan and procedures are finalized—including the policies (or rules that everyone will follow), the job descriptions and the checklists for the management of the project— they will begin implementing the plan. Clairaudients won't jump in before the plan is complete, the standards are set and they are sure that all the pieces of the project fit together. Because clairaudients are quality driven, they pick their team members carefully and then empower them with the facts to move forward. By planning ahead, everyone who works with the clairaudient benefits because the intention is clear and everyone can enjoy what has been created.

I saw the clairaudient gift in action when I once helped a corporation with their customer service program. The president of the company was decidedly clairaudient. One of the ideas he came up with for their call center was to have a form with guidelines that the customer service representatives could use to keep the incoming calls brief, preferably under three minutes. Sometimes customers would try to keep the reps on the phone for as long as they

could and tell them their whole life story, including what they ate for lunch!

To help the representatives get the information they needed from the customers as quickly as possible, the form was divided into five sections: (1) what, (2) when, (3) where, (4) why, and (5) who to forward the call to, if necessary. Instead of having to listen to customers for a few minutes before getting to the point of their call, the reps were instructed to ask specific questions as soon as the call came in. They would ask these questions in this order: "*What* can I help you with?" "*When* would you like this to be done?" "*Where* are you calling from?" or "*Where* is this problem taking place?" "*Why* are you having this problem?" or "*Why* did this happen?" Sometimes they didn't even need to ask all the questions. By being more direct at the outset of the call, customers would pick up on the energy and instantly be more organized in their communication. If the representative wasn't able to resolve the problem during the call, he or she would send a memo to the person who was in charge of the department that could best handle the situation.

The clairaudient solution to this company's customer service issues was to create a system that had clear procedures and that, at the same time, let customers know that the representatives and the company really cared about them. In my own business, I have found it helpful to set up our company database so that any concern can be recorded. When the issue is handled to the satisfaction of everyone concerned, a completion date is entered into the system. If the person ever calls back, we have a complete history of *what* they needed, *when* they needed it, *where* they are located and *why* they were initially calling or emailing us. Most companies

today use this type of organization in order to create quality customer service.

People with a highly developed clairaudient gift thrive when they use their talents to create tools or systems to help others. While many people rebel against working with a system, what they don't realize is that it provides the framework or vehicle for a large number of people to participate and successfully achieve a goal. By creating a system to help others take control of their own lives, you reach a lot more people than in a one-on-one situation and can therefore be of greater service. A successful system allows a business to duplicate itself over and over again. That is the difference between a corner grocery store and an international corporation.

Setting Standards and Being Fair

Clairaudients have high standards and inspire others by making the standards consistent and easy to follow. When people don't follow the policies or procedures that keep the project on track, it's important to remind them why the standards were set to begin with. That way, all those involved feel as if they are contributing what they do best and can gain personal fulfillment from doing their part.

A clairaudient's strong inner direction can sometimes give the impression that he or she is stubborn, especially if someone tries to divert a project in a different direction than the clairaudient initially outlined. An unbalanced clairaudient will run over the person interfering with completing the project, whereas a balanced clairaudient will ask the person to "please" stand aside before he continues on his chosen path. If someone tries to bring his own agenda into a plan

that has already been decided upon or attempts to change the procedures without first consulting with management, he will soon learn that this is not the best way to work with a person who has the first gift of clairaudience.

While clairaudients are not willing to lower their standards, they may be open to trying a new way of doing something if consulted ahead of time. But once clairaudients make a final decision, that's it. If you blatantly disregard their plan or policies, you will probably receive a warning or two. After that, you had better be on board. Otherwise, you may find a pink slip in your in-box. This does not mean that clairaudients are unfair. On the contrary, they will always give people a second chance to earn back their respect and prove that they are trustworthy and up to the task. Although clairaudients will forgive, they will never forget.

If you are a balanced clairaudient, you are fair in your dealings with others and will not tolerate dishonesty. Fairness is essential if you are to achieve your highest potential. When you sense that someone is taking advantage of others, you will do whatever is necessary to balance the situation. Because you are fair, you want to make sure that everyone benefits from what you do. You want everyone to win. You are not interested in popularity contests and do not care about what other people think of you. You will do what you feel is right, no matter what. If for some reason you do go along with someone whose standards are lower than yours, you will soon discover that you have compromised your personal values and will feel as if you have let yourself down.

America is an example of a clairaudient country and is unpopular among many in the world today because she refuses to lower her standards and accommodate the tyrants

of the world. America has had a long history of standing up for what she believes instead of pandering to those who abuse her or who abuse other people. In keeping with the clairaudient gift, America is built on a system of individual freedom, opportunity and free will, where anyone who wants to live his or her own dream can do it.

The Problem-Solving Power of Clairaudients

Clairaudients usually think in solutions. Over the years, I have learned that in problem solving, if you don't know the cause of the problem, then you have a problem! But if you can search for what it is in your life that is creating the stress, you can come up with the exact solution. I remember being inspired to focus on this concept when I was asked to appear on a radio talk show in Manchester, England. The country was going through a major recession at the time. Many people were out of work and the energy of the country was depressed. I asked my personal angels what to share on the show and the approach to take with the people who phoned in. They said, "The people who call in are thinking in problems, not solutions. Just let them know that there is a solution for everything in life and all they need to do is change their thinking pattern, and the law of attraction will take over."

My angels proved to be right. As a matter of fact, when I gave the lecture later that week, everyone who asked a question during the session started off by saying, "I have a problem . . . " I had to continuously remind them that they really didn't have a problem. They just needed to clarify where the pressure was coming from, and then the solution would automatically appear.

Once you know the source of the problem, you can begin to work with your guidance and take steps that will lead to a total solution. This may involve releasing concepts about yourself that you find are no longer true. The "problem" that most people have is that they don't take the time to discover what is creating the pressure. In many instances, the pressure comes from having the idea that you need to make other people more important than yourself. The problem you think you are having might not even be your problem. It could be pressure that you are taking on as a result of feeling responsible for what others are going through.

In reality, it is not your responsibility to come up with every solution to every problem. If you have a family or friends and associates you care about, you may have a tendency to try to solve their problems, when, in fact, they need to do this for themselves. I know I have mentioned this concept earlier in the book, but it bears repeating. Sometimes it takes three times for a major concept such as this to sink into our consciousness. Once we understand the concept, we can change the habit that was created by the negative attitude and move in a different direction.

Patience Can Open Up Opportunity

Because clairaudients are so direct, they may get impatient with people or situations in their life that don't seem to be moving in the direction they desire. It's important to be aware of this, because if you put yourself under pressure and get impatient, it's much more difficult for your spiritual guidance to give you the inspiration you need to create the opportunity you want. One of the biggest keys to getting

what you want in your business life is to stay out of your emotions. A young woman named Waleska shared with me how she found her perfect job and was able to overcome the doubts she was having.

"I was recently faced with an opportunity to create the kind of job that I wanted—the perfect job—in the medical field," she said. "I looked everywhere and used all of the spiritual tools I knew, which included defining what I wanted and why I wanted it. I wrote my thoughts down on paper and described it all in detail. I even talked to my angels about it. I visualized it. I did everything I knew how to do—and nothing happened.

"I was getting pretty frustrated and impatient. All this work and nothing was materializing. Where were my angels when I needed them the most? I decided to go back and reexamine the steps I was taking to find my perfect job. There had to be something I was not doing or something that I was overdoing. It actually turned out to be the second reason. I realized that I was giving my spiritual helpers so much detail that I was limiting my options. I wasn't being flexible enough to allow them to find what I *needed* and not just what I *wanted!*

"I sat down one more time and said, 'Guidance, this is what I really want. The rest is up to you. I will let it go. You have always shown me that every time I needed you, you have been there for me—even if I didn't want to accept it. I'll be patient.' It worked! A few days after that, I was going about my daily chores and I found a job application I had filled out but had forgotten about. I was going to throw it away, but then I heard one of my angels say, 'No, don't throw it away. Call them.'

"I contacted them again, and they offered me an even better job than the one I had originally applied for. The job they offered would give me an opportunity to meet all of the department heads at the hospital where I would be working—plus they were going to pay more than I had asked for. I could make my own hours and it was within walking distance of my home. What an incredible opportunity to realize how to be patient and live my own life dream. It works!"

Why Am I Doing This?

Clairaudients are builders and have a hard time dismantling or destroying what they have built. They also usually never quit until they achieve their goal. However, if clairaudients are unbalanced and afraid of success, when they get to a point in their life where everything is going well, they may suddenly develop a fear of success. They realize that the more successful they are, the more other people will be depending on them and the more they will have to be responsible for the welfare of others, especially in a business environment. If you are afraid of responsibility, you will unconsciously start to tear down what you have built so that you don't have to experience the pressure that success brings. This can become a cycle of failure. Tearing down what you've built up isn't a good solution, because you will just have to start all over again. You have to understand that, in reality, you are not afraid of failure; you are afraid of success.

Because clairaudients are always seeking the facts before they move forward, another pitfall they need to watch out for is their tendency to overanalyze a situation and become overly intellectual. This leaves little time for their feelings,

especially when they just want to get the job done. They may end up using their work as an escape and forget to be involved in life. Many clairaudients dedicate their entire lives to working and earning a lot of money but forget to enjoy themselves in the process. Then, when they decide that it is time to take pleasure in what they have spent a lifetime creating for themselves and their family, they discover that all of the pressure they have put themselves under has taken a toll on their physical body and they are unable to benefit from their commitment to succeed in business.

To avoid this situation, the solution is to periodically ask yourself, "Why am I doing what I am doing? Am I trying to prove myself to myself or to others, or am I doing this because I enjoy it and it gives me fulfillment?" By asking these simple questions for your own benefit, you can come to grips with how you might be overextending yourself and forgetting to do what you came here to do, which is to learn about yourself.

THE SOCIAL SIDE OF THE CLAIRAUDIENT GIFT

The social side of our life involves our interactions and communications with others. When you're looking for the solution to an issue that involves others, realize that you can use your gift of clairaudience and rely on your helpers to coordinate with the personal angels of others around you to come up with the perfect solution.

When I first learned that I had spiritual helpers I could tap into to get inspiration, I thought to myself, "I wonder if I could ask my angels what Christmas presents to buy for my family?" So I did. When I asked them what to get for my step-

grandmother, I heard a voice in my head say, "A book of trinkets." Initially I thought this was strange, but I decided to go to a local department store and look around. When I arrived in the book section, I was immediately drawn to a catalog of mail-order products. It was a book of trinkets! When she opened it up on Christmas Eve, she was so taken by it that she never even noticed what everyone else got. That experience made me a true believer in the power of inner guidance.

I have a close associate named Dennis, who, with a little help from his clairaudient gift, was able to get the best Christmas present he had ever received. It all started a couple of years ago when he was involved with a project in his office called Angel Gift Cards. These were special wishes from needy children in the community where he lived. Of course, most of them wanted bicycles! His first thought was "I'm not going to buy a bike!" When he went shopping for a small gift for one of these special kids, he first went to the skateboards, but that didn't feel right. Then he went toward the rollerblade section of the store. Eventually, he found himself standing in front of the bicycles. His intellectual side was saying no, but his feelings were saying yes. Guess which side of him won.

As he was driving home with a new bike in the backseat, he heard one of his personal angels ask him, "Dennis, if you could have anything you wanted for Christmas, what would it be?" He answered to himself out loud, "Clear intimacy." This felt good to him, but he just let it go for the time being. Two months later, he got his Christmas wish. He met someone with whom he was able to share laughter, warmth and intimacy, and she became his wife. They just recently found out they will be having their first child.

The Need for Quiet and the Temptation to Escape

Because clairaudients are private people, they will keep their distance if they don't know you, but once they feel comfortable around you, they will open up and tell you their life story. All you need to do is ask them for permission to come into their personal space.

Thoughts are extremely powerful, and since clairaudients have a lot of them, they have a hard time being around people for long periods of time. They may find it necessary to retreat to a quiet room, not because they don't want to talk with you, but so they can get back into their own energy. I was visiting with a friend of mine recently and we were talking about her daughter. As she shared with me, I realized that her daughter was clairaudient. Since my friend is clairvoyant, she always had a hard time understanding her daughter completely. She said that when they would drive in the car together, they would drive for miles and sometimes hours without saying a word to each other. This had always bothered my friend because she felt that her daughter didn't want to communicate or socialize with her, especially during her daughter's teenage years.

I explained to this mom that her clairaudient daughter was not avoiding her or ignoring her, but just carrying on a conversation with herself. She was probably talking with her guidance, planning and strategizing as they were driving along, and she was just too busy to talk. Parents or partners of clairaudients should not think that there is something wrong or take it personally when the clairaudients in their life are quiet. They just need their space. That's how they are wired.

Sometimes clairaudients' inner thoughts and the pressure from the outside world will get overwhelming and they will want to escape through alcohol, drugs or work. When this happens, their social skills, of course, become less than desirable. They have a tendency to avoid people, get depressed or become overly aggressive. This can lead to spousal or child abuse in families. If you are dealing with this, don't be afraid to ask for help if you need it. Just because you may have experienced social abuse when you were a child doesn't mean that you have to act out old habits or the personality traits of your parents or whoever raised you.

If you're a clairaudient, the way to avoid these tendencies is to make sure that you always have a positive challenge in your life. Clairaudients need to feel challenged in their profession. If you are bored with what you do for a living, it means that you have learned everything you need to learn in that situation, and it's probably time to move on to a new challenge. You don't need to be stuck in a dead-end job. At the same time, the best challenge for a clairaudient and for any of us may simply be to provide a positive example to our loved ones of who we really are.

One solution to overcoming any kind of pressure or stress that makes you feel as if you want to escape from life is to ask yourself these questions and write down your answers to them:

1. *What* is it that is bothering me?

2. *When* does it affect me?

3. *Where* does it happen to me (home, work, social occasions)?

212 | INNER GUIDANCE AND THE FOUR SPIRITUAL GIFTS

4. *Why* do I feel the way I do?

5. *Who* is affected when I act out my aggression?

This simple technique will help you clarify the exact areas of your life that are causing you to feel frustrated or to withdraw. Self-pity is the opposite of the self-confidence that is inherent in a balanced clairaudient. Recognize that you are a natural leader and that the first person you need to lead and inspire is yourself. You can do this exercise over and over again until you identify what direction you need to move in. It is possible to take all of the energy that is tied up in frustration, self-pity or depression and channel it into a more positive course of action so you can be a positive example for others.

●■▲∞

Keeping Your Boundaries Clear

A PRACTICAL EXERCISE YOU CAN DO NOW

Because of their benevolence, clairaudients will sometimes allow people into their personal buffer zone even though they may not totally trust them or enjoy dealing with them on a daily basis. Here is a way to keep your relationships organized so that you know exactly where you stand with everyone in your immediate and surrounding environments. Since you are choosy about your friends and associates, this technique will give you a tool to make sure that you are always in solid control of who you let into your circle.

1. Do the Personal Energy Cleansing technique on page 42 before beginning this exercise.

2. Take a sheet of paper and draw a circle in the middle of it. Leave enough room inside the circle to write names or initials.

3. Draw a larger circle around the outside of the inner circle, leaving enough room inside of it to write names or initials.

4. Draw a third circle around the outside of the middle circle, again leaving enough room inside of it to write names or initials.

5. Be sure to leave enough room between the outside rim of the third circle and the edge of the paper to write additional names or initials.

6. Then meditate on who you want to have in your *inner circle*—your loved ones, closest friends, etc. You may only have two or three friends you consider to be your best friends. Write their names or initials inside the inner circle.

7. Then meditate on the people you want to have in your *intermediate circle*. These are people you associate with on a regular basis but who may not be as close to you as the people in your inner circle. Write their names or initials inside your second circle.

8. Next, discern the people you want to have in your *outside circle* of friends or associates. These are people you know but do not associate with that often or people you have occasional contact with in your business life. Write their names in your third circle.

9. In the space outside your third circle, around the edge of your paper, write the names or initials of people you consider acquaintances.

10. Now that you have a complete list of the people in your environment and your relationship with them, take a look again at the inner circle. If you find that there are people in your inner circle you cannot trust or count on, move them to another circle, where you can keep them at a distance. You can always reevaluate your relationship with them in the future.

Remember, people and situations can change. By doing this exercise on a daily, weekly or monthly basis, you will always know exactly where your boundaries are—and that is important to you. You can open and close the door anytime you want. It is up to you. You are always in charge of your own energy.

●■▲∞

Are You a Clairaudient?

Basic Personality
In charge

....................

Personal Energy
Smooth and direct

....................

Favorite Color
Red

....................

Key Sense
Keen sense of inner and outer hearing

....................

Key Question
Where?
I need to know where the situation
is taking place so that I can do something about it.

....................

Possible Professions
Business owner, executive, scientist, attorney

....................

Physical Concerns
Ear infections, heart problems, prostate problems, ulcers

How Balanced Are You in Your Clairaudient Gift?

Give yourself 10 points for each YES answer

(Check YES if you feel that you display this trait more often than you don't.)

Positive Traits	YES	NO
1. Once I make up my mind, I don't quit.	❑	❑
2. I am fair and honest in my dealings with people.	❑	❑
3. I am a good judge of people.	❑	❑
4. I love challenges.	❑	❑
5. I am a natural leader and I like to be in charge of projects.	❑	❑
6. I am factual and concise in my communications.	❑	❑
7. I am introspective and thoughtful.	❑	❑
8. I give people a second chance until they prove me wrong.	❑	❑
9. I am a good organizer of people and materials/ programs.	❑	❑
10. I make decisions easily.	❑	❑

TOTAL POINTS: _____

How Unbalanced Are You in Your Clairaudient Gift?

Give yourself 10 points for each YES answer

(Check YES if you feel that you display this trait more often than you don't.)

Not-so-Positive Traits	YES	NO
1. I get impatient with less-organized minds.	❏	❏
2. I am overbearing and aggressive in my approach with others.	❏	❏
3. I push my way through projects and situations without communicating first.	❏	❏
4. There is only one way to do something—my way.	❏	❏
5. I set my boundaries too strongly.	❏	❏
6. I ignore people if they bother me.	❏	❏
7. I have a tendency to undermine people or put them down.	❏	❏
8. I am overwhelmed by the negative thoughts in my head.	❏	❏
9. I am a one-person operation because it's easier to just do the work myself.	❏	❏
10. I have a difficult time opening up and sharing my true feelings.	❏	❏

TOTAL POINTS: _____

TOTAL SCORE: Balanced _____ / _____ Unbalanced
(Fill in the first blank with the score from the previous page and the second blank with the score from above. Example: 80/50)

KEY:

If you are more balanced than unbalanced, congratulations!

If you are more unbalanced than balanced, concentrate more on developing the positive potential of your clairaudient gift.

The Gentleness of Healing: Moving from Self-Sacrifice to Self-Loyalty

If your first gift is healing, or feeling, you are warm and gentle in nature. You are also enthusiastic and bubbly, have an intuitive sense of what people need, and possess the unique ability to help them feel good about themselves. You can feel when someone around you needs a kind word or a hug, and you don't hold back from showing your affection. People will naturally be attracted to you because they feel good around you, and so you tend to have a lot of friends. Your cheerful personality often makes you the life of the party and you are a great example to others of how to be happy and enjoy every moment.

Healers like to touch because this is how they communicate best. When they find someone who needs help, they want to get close to him or her and become affectionate. When in balance, healers can tell where a person is hurting, both physically and spiritually. They naturally gravitate toward the healing arts, such as medicine, so they can help others who are in need. When out of

balance, they may be constantly overconcerned about their health.

As children, healers enjoy being cuddled. They may curl up next to someone and stay in that position for hours until they decide it is time to do something else. A close friend of mine with the first gift of healing calls this "smushing." After a stressful day at work, he and his wife will sometimes cuddle up just to be close or give each other massages. Being touched helps healers to instantly relax and revitalize their energy.

Healers love to work with their hands and they pay great attention to detail. Another good friend of mine who is a healer has a pottery shop, and he is happiest when he is creating with his hands. Whenever I visit him and his family in Mississippi, I have the opportunity to see what it takes to make a great piece of art as well as the love and patience that go into each of his ceramic masterpieces. He is highly respected nationwide for his work, and with good reason.

If you are a healer, your inner guidance communicates with you through your deep feelings of what is right for you and what is not. If you trust your feelings, you will usually be on the right track. By staying in your true feelings rather than your emotions, you can remain open to the inspiration that your personal angels are always sending you for the purpose of helping or healing others.

Staying in Your Own Energy

Healers are naturally concerned and caring, especially about the people closest to them—their families, friends and even business associates. They feel a oneness with others and care more about people than anything else. You will usually

find healers in supportive roles rather than leadership positions. Although they can be great leaders if they really want to be, their main focus is working directly with people.

Because of their benevolence and sensitivity, healers need to be aware of where their energy ends and others' energy begins. They are so sensitive to their surroundings that they will routinely pick up other people's feelings. If healing is your main gift, you will tend to take on the negative emotions of others when you are around them, not realizing that this energy is not your own. If you are unable to release these emotions, you may feel depressed or be in a bad mood. Many healers complain of small aches and pains and even headaches that, in reality, don't belong to them. One way negative emotions can manifest in healers is through their skin, which is very sensitive. They are prone to getting rashes when they are in an emotional state.

When healers are around large groups of people, they may start acting out the desires of others if they are not careful. For example, healers who are in a large shopping mall may have difficulty throwing off the feelings they pick up from others, which can lead to impulse buying. If this happens to you, you are simply being influenced by other people's buying lists and acting on their feelings, not yours.

Once you discover that you are picking up energy from people in your environment—whether it's someone who lives close by or half way around the world—you can shake off those feelings and stay in your own energy. Now that you know how to do the Personal Energy Cleansing technique, you can use it at any time to change your personal energy and build a buffer around yourself to keep out the unwanted energy, thoughts and emotions of others. If you are with

other people and need to deal with their energy right away, you can do the technique mentally.

It's important to understand how powerful the mind-body connection is. Emotions can contribute to our discomfort and even to "dis-ease." By changing how we think about ourselves and by separating our thoughts from the thoughts of others, we can often change how we feel. Surgeons, for instance, have proven that when patients meditate before and after surgery, the recovery time is much shorter. Major medical centers at Harvard, Stanford and other prestigious universities have even opened up alternative and complementary medicine clinics to promote and practice mind-body techniques for relaxation and wellness. (Of course, this does not mean you should ignore medical techniques to treat a condition you have. Always seek medical help when you need it.)

Not only do those who have healing as their first gift take on other people's energy, but they also have a tendency to take on their troubles. To compound the situation, they may hold onto those troubles long after the people have found a solution for whatever was happening in their life at the time. If you are out of balance, you might even pick up others people's bad habits and create more problems in your life. In the extreme, you could become a hypochondriac or even an alcoholic or a drug addict to escape the emotions you are experiencing—and then blame others for your acquired bad habits.

Empathy, Not Sympathy

Whenever there is an inner cry for help, a sensitive person will hear it. Unfortunately, our response to the pain of others

may sometimes take the form of sympathy rather than empathy. It is not uncommon for a person who has healing as his first gift but who is not in balance to feel accountable for the inequities in the world. As a healer, you may feel that someone in Africa or Asia needs your personal help. While this may be true, it's also true that some of these people are souls who came to planet earth to learn basic survival skills. Even though what they're going through may look difficult by your standards, they are doing exactly what they came here to do, and you are not personally responsible for their livelihood.

Because it's so easy for healers to get caught up in the emotions of others, they need to learn to be detached and not force themselves on people in an effort to solve their problems. On the other hand, it's important to give people a helping hand when they ask for it and truly need our guidance. Even when the pleas for help are unspoken, a healer may pick up on them and respond. That is how the law of attraction works. I have a good friend who works with the United Nations Humanitarian High Commissioner for Refugees (UNHCR), based in Geneva, Switzerland, which is organized to help people in extreme need. As a healer, he knows that he can best channel his energy into a system so that he doesn't have to get personally involved in the pain and suffering he witnesses each day.

How can healers stay in balance and decide on the best course of action when it comes to helping others? One way is to offer assistance when people are ready to receive your help. You can offer suggestions or a possible avenue or tool they can use to get their own answers, but you can only take them as far as they are willing to go. They have to be ready to take their next step—and sometimes that next step must

be taken with their own two feet. Never feel sorry for anyone. If people try to make you feel guilty for not doing something for them that they can do for themselves, you can feel free to avoid them without remorse. Help those who really want to help themselves. If you try to live their life for them, you will not be living your true purpose.

As a healer, you are a spiritual leader, whether you realize it or not. You can be a great example of what it means to follow your true feelings and not your emotions. Just by being yourself, you show others that you are the most important person to yourself. If you do not take care of your own spiritual and material needs first, how can you help others? Once you learn to keep your boundaries clear by staying in your own personal energy, you can be a powerful motivating force and move mountains by inspiring others. You have the unique ability to rally people together and give them a sense of purpose and a desire to accomplish. You already have everything you need to be successful. All you need to do is tap into the real you—the part of you that loves life.

As a healer, your natural state is to feel one with everyone, and you may wonder why others don't feel as you do. Your deep feelings may make you feel as if you don't belong on planet earth, to the point that you sometimes ask yourself, "Why is it that I just don't fit in society?" Because healers come from their feelings and don't concentrate simply on the facts, people sometimes think they are not intelligent. You may have experienced this, especially when you were young. People who are not in touch with their feelings may even put you down or make fun of you because you are so sensitive and vulnerable to the emotions of others, which may cause you to feel sorry for yourself and withdraw. In

reality, there is nothing wrong with you. You're fine; it's others who don't understand how important it is for everyone to get along. They are the ones who should be pitied because of their cynicism and refusal to allow themselves to feel, a sign of their own insecurity.

Letting Others Be Responsible for Their Feelings

Not only must healers learn that they are not responsible for other people's problems, but they must also learn that they are not responsible for how other people feel. As a healer, you are naturally thoughtful and considerate and will do whatever is necessary to keep someone you care about from feeling bad. In your desire to help others, you have a tendency to try to make them happy. You may sometimes devote so much energy to doing this that you neglect what *your* soul really needs. This can leave you feeling frustrated and unhappy yourself. You do not need to sacrifice your happiness because you want someone else to be happy. As I have said throughout this book, it's essential to do the things that first and foremost make *you* happy.

You don't need to feel guilty or that it is somehow your fault if your loved ones are not as happy as you are. Someone once said to me, "How can you feel so good when I feel so bad?" I was stunned. Why would I be responsible for how she felt? I certainly didn't do anything to cause her unhappiness. No one is responsible for anyone else's feelings, so there is no reason to blame yourself if a loved one or someone you care for and admire feels sad or unhappy. All of us need to take total responsibility for how we feel and allow others to do the same.

As I was sitting in my office writing this, I heard a person around the corner say to someone else, "Why are you so mad at me? I didn't do anything to hurt you." How easy it is to blame others for how we feel. It was no coincidence that I heard this at the exact moment I was writing about this concept, and it only reinforces how often this happens.

Dawn, a young married woman in Canada, shared with me how she handled a situation similar to this. She said, "I was having an argument with a family member and all of a sudden I felt a tap on my shoulder. That is what I have asked my personal angels to do when they need to get my attention. I stopped to take a deep breath and realized that I was being the person I did not want to be. If it wasn't for my angels, I might have said or done something that could have been damaging to my relationship, and I did not want that to happen with my family. My angels have tapped me on the shoulder many times since then, and I have been very happy to have them bring me back on track."

Dawn went on to share with me the lessons she learned: "No matter what, we are all human. I am a very simple person who just wants to love and be loved. I used to take on other people's feelings and troubles, but my personal angels have taught me to step back and let others lead their own lives. I can listen and lend a hand when asked, but as far as taking on another's problems or feelings, I have come a long way from where I was before. Since I learned how to communicate with my angels, I have been a lot happier with myself on a day-to-day basis, and it shows by the people I have around me today!"

When healers deny their feelings and make others' needs more important than their own, there is often a price to pay.

Several years ago, I met a middle-aged woman who was going into surgery for cancer that was affecting her uterus. When I asked her if she was the type of person who always made everyone else more important than herself, she answered with an emphatic yes. I had known for years that the energy center in the groin area relates to our ability to express how we really feel. Problems in areas of the body related to our sexuality can indicate a difficulty with self-expression because sex is, in reality, a form of communication.

If you have a tendency to hold back your true feelings and not allow yourself to be creative and imaginative in your relationships, this can cut off the flow of energy and break down the cells in that area of your physical body. As long as you are expressing yourself freely and openly and honoring your right to communicate what you need and want to your loved ones, your personal energy will flow harmoniously and you will feel fulfilled. Not only that, if you can create a light and happy environment that others feel relaxed in, you will help them to feel uplifted. When you find happiness within yourself first, your example and your energy will help others to also be happy. As a healer, you already understand that smiling and having a positive attitude takes less effort than a frown. It's natural for you. When you are simply an example of how beautiful life can be by being your joyful self, you are automatically helping others get in touch with the passion inside themselves to follow *their* life purpose.

Supporting Others without Neglecting Yourself

Because of their innate concern, healers truly want to see people be successful and will even celebrate their successes

more than their own. Supporting others is a wonderful qual-
ity, but in the process you may sometimes forget what you
yourself came here to do. In essence, when this happens you
make other people more important than yourself. If you
have a habit of neglecting yourself, you will end up feeling as
if you have sacrificed your life for your loved ones. This
benefits no one. The biggest challenge in life for you as a
healer is to help yourself first and not feel guilty about it.

Another pitfall to watch out for is letting your support of
others turn into a kind of devotion toward them, which is not
spiritually healthy. Paradoxically, this misplaced desire to
help others may be a way of unconsciously wanting them to
be devoted to you. In other words, you're looking to be rec-
ognized for the sacrifices you're making. In situations like
these, we hear the oft-repeated phrase "After all I have done
for you . . ." To help balance out your tendency to support
others and neglect your own needs, you need to have clear
direction in your life. Without it, you can become lost helping
others fulfill their dreams and end up moving in a different
direction than you chose before coming to planet earth.

What's more, when someone you have devoted yourself
to decides that he or she no longer needs your help, you will
feel unappreciated and as if you have been left high and dry.
If the person ends the relationship or moves elsewhere, you
may become devastated and feel as if your entire life has
been destroyed. It's not really your life that has been shat-
tered; it's your identity, which was tied up in the other per-
son. Whenever you identify with a relationship rather than
with who you really are as a soul, anything that happens to
change your concept of that relationship will also disrupt
your concept of who you are. If this relationship was your

whole life, as in the case of some marriages, you will feel as if you have nothing left. This can lead to feelings of depression and anger, especially toward the person who no longer wants to be involved in a relationship with you.

I know someone who, after forty years of being divorced, still held onto her resentment and could not see herself as free to set a new personal direction for herself. This scenario is inevitable in cases where one person has become completely devoted to another and has delegated the responsibility for who he or she is to the other partner, or where one person is strongly identified with and attached to the concept, or idea, of a relationship that is no longer viable or available to her.

From Self-Indulgence to Self-Worth

As a society, we have become overly self-indulgent. With all the conveniences that have been created over the last century, we are consuming more and more products. Some are good and some are not. If your first gift is healing and you do not understand the difference between your true feelings and your emotions, you may be more susceptible than others to this constant bombardment of opportunities to indulge yourself as a way of escaping the emotions you are experiencing in your life.

You may find that you partake of more food than you need. As a result, you could become overweight or obese. It could be that your parents overindulged you as a child because they wanted to give you more than they received when they were growing up. Although many of the generation who experienced the Great Depression are no longer here, their

concepts are still with us, having been passed down from generation to generation. This could compound (and add pounds to!) your problem. The tendency toward overconsumption could also manifest in your demanding more than you really need from your loved ones and from people in general. You may expect them to cater to you, and you might even throw a temper tantrum if they don't indulge your whims.

It's easy these days to take for granted the amount of goods and services available to us, especially as they become available at lower costs. The danger for you as a sensitive healer is that you may accumulate more and more "things" to feel better about yourself and boost your self-worth. For example, every time you feel the need to bury emotions you have because of problems with relationships in your business or social life, your first reaction may be to go shopping. "After all," you tell yourself, "I deserve it." Your spree becomes a justification for all of the sacrifices you have made for your husband, wife or children or for the time you have spent at work. This could become a major crutch if not curbed in time.

The balanced healer will realize that self-worth is not based on how many cars or houses we own. We already know inside that we do not take all of our material possessions with us when we graduate from planet earth. Enjoying the conveniences that life has to offer is fine, but striving to have more than our neighbor is futile. Once you realize that overindulging to console yourself is not the solution, you can take the time to clarify the underlying cause of the emptiness you feel inside. Expressing your true feelings instead of getting caught up in your emotions will set you on the right track. The ultimate solution is to always be loyal to yourself first, no matter what. Once you realize that you are the most

important person to yourself, the pressure will dissipate and you can relax.

Another area you may need to watch out for is gossiping about others. Because relationships are so important to you as a healer and such an integral part of your life, you tend to want to comment on what other people do or say and how they act. It may appear to others that you are being judgmental, but what you are really trying to do is sort out your personal relationships. If a person doesn't treat you the way you want to be treated, you will want to talk about that person with others until you overcome any feelings of lack of self-worth you are experiencing. Those who have a well-developed healing gift must learn to balance the need to talk about their relationships so that they do not alienate other people in the process.

Giving, Sacrifice and Money

If you are unbalanced in your gift of healing, you will have a tendency to want to sacrifice for others. When someone asks you for help, even if you do not have much to give, you will give them what you have—and sometimes more!

Healers love giving gifts and must remember that they don't have to do anything to "buy" other people's love or affection. Healers are already like a magnet. When they feel good, everyone feels good. Therefore, be careful about buying presents for people just so they will like you. They already do. If your motives are off and you are just trying to please people, you may unwittingly make your friends feel obligated to you or as if they owe you something. This can create a false sense of devotion and does not produce a

healthy relationship. Sooner or later, they may end the friendship because of your excessive need to please them.

My mother had the first gift of healing, and she had the healer's desire to give gifts to those she loved. Once, when I was in college, she wanted to buy me an inexpensive black-and-white television set. When I told her that I was already saving up for a large color TV, she became very emotional because she felt as if I was rejecting her kindness. This certainly wasn't the case, but there was nothing I could say to convince her otherwise.

The other problem with giving gifts, of course, is that if you give beyond your means and make others more important than yourself, you can easily end up shortchanging yourself. This then creates a feeling of struggle and a sense that there is never enough to go around. These feelings may have been passed down to you from your parents, and therefore you may not understand them when they arise. Remember that they may not be your true feelings at all.

Being true to yourself and having enough money go hand in hand. If you set goals based on what makes you feel happy and fulfilled, the money will simply be a byproduct of the larger goals you want to accomplish. Since life as a human being takes place in the blinking of an eye compared to your life as a soul, why worry about money? Many of us in the United States have still not outgrown the sense of hardship that was present during the pioneer days of the 1800s. To add to that, during the 1930s in America, there was such a strong work ethic that if you did not work your fingers to the bone, you were not considered worthy. There have been similar struggles surrounding the issue of money in other countries, such as when people have experienced class warfare.

As a soul who has come to planet earth, you need to keep everything in perspective. Your worth is measured neither by your money nor your possessions. Your only true worth is the wisdom you have accumulated throughout your lifetimes, and that is the most important thing you can give to people. If you hold onto your wisdom, you are being greedy.

The key to gaining more wisdom is to give of yourself and share what you have learned with others. When you hold onto what you have, you become spiritually stagnant and may have to come back to planet earth over and over again until you learn how important it is to share your wisdom to help others to help themselves.

Your guardian angels, or spiritual helpers, have already learned this lesson. That is why they graduated from planet earth. Their spiritual contract with you is to help you learn what they have already learned for themselves. They do this by constantly putting you in situations that will force you to share of yourself. If you go against what you came here to do, your life will be a struggle and you won't experience fulfillment. But if you do what makes you happy, everything will fall into place at the right time.

................................. ● ■ ▲ ∞

How to Discern Your True Feelings from Your Emotions
A PRACTICAL EXERCISE YOU CAN DO NOW

For a person with the first gift of healing, the biggest challenge in life is to differentiate between true feelings and emotions. When you are aware of the emotions you learned from your parents and

that you picked up from your environment during the first seven years of your life, you can bypass them and be free to enjoy the good, kind and loving part of you—your enthusiasm and passion for life.

To discern your true feelings from your emotions, be patient and practice tuning in to the energies of the numerous feelings and emotions you experience every day of your life. Here's an exercise that can help you to do this.

1. Practice the Personal Energy Cleansing technique on page 42 so that you are totally in tune with yourself.

2. Meditate on the good feelings you have about life and write down what they feel like to you. These could be feelings such as joy, love, peace, satisfaction, enthusiasm, etc. Take the time to really tune in to the energy of each one of these feelings so that you can go back to them at any time to center yourself.

3. Meditate on emotional feelings that do not feel comfortable but are familiar to you in your everyday life, such as frustration, impatience, anger, depression, resentment, etc. (To prevent your energy from getting too low, do not allow yourself to dwell too long on the negative emotions. The purpose of the exercise is to simply help you recognize how they feel.)

4. Write down how each one of these emotions feels when you tune in to it.

5. Cleanse yourself again so that you can release these emotions and get back to your true self.

6. Recall and write down the situations in your life that originally stimulated these negative emotions and under what circumstances you allow yourself to indulge in them now.

7. Ask your spiritual helpers to remind you and inspire you when you are allowing these emotions to control you and when you are not being your true self so that you can change your attitude immediately.

8. Lastly, go back to the positive feelings you wrote down in step 2 and continue to meditate on each of these key words or feelings so that you are totally at peace with yourself.

How to Unfold Your Gift of Healing in Your Personal, Business and Social Life

We all have the gift of healing. Whether it is your first, second, third or fourth gift, you can unfold its qualities of warmth, enthusiasm and patience in all areas of your life to establish a deeper connection with others. The gift of healing (or feeling) will help you tune in to your true feelings in any situation, which will also make you more receptive to the inspiration of your inner guidance.

One of the greatest strengths of those who have healing as their first gift is the ability to be one with everything and everyone around them. This same trait can pose serious problems if you have not learned how to separate your own feelings from what others are feeling. When you are around other people, do you ever find that your naturally open and joyful disposition turns into depression or frustration? This can happen when you allow the energy of others to over-power you—when you are not taking care of your own needs and not listening to your own feelings but are instead taking on the feelings of others.

If this happens to you frequently, it's important for you to learn how to discern which feelings are yours and to detach yourself from the emotions of others in your environment. By trusting and respecting your feelings, you won't get swallowed up by others' concerns and you will be better able to use your enthusiasm and compassion to help people.

THE PERSONAL SIDE OF THE HEALING GIFT

Healers are like sponges. They soak up all the feelings in their environment. This can make them like chameleons, adapting to whatever is happening around them. Feeling what others feel isn't always comfortable, so healers may subconsciously think, "If only I could make everyone around me feel good all the time, it sure would make my life a lot better!" They think that by changing how others feel, they can ward off the negative emotions they so easily pick up. This approach never brings us the peace we are looking for. That peace can only come from being true to ourselves first.

When healers are true to their authentic feelings, they are a powerhouse of energy and can be a wonderful influence on everyone around them. They just need to make sure they have a secure personal direction so they are not swayed by those they are attempting to help. If your first gift is healing, make sure that you know what you want before you start trying to help everyone else.

As a healer, you may at times enthusiastically share your true feelings about where you want to go in life and find that people ridicule you. Family members or friends may discount what you are feeling or try to influence you to change your direction simply because you can't explain why you feel the way

you do. Just because you don't always know why you feel so strongly about moving in a certain direction doesn't mean that following your feelings isn't right. Only you can know what's best for you and what you need to do in your life. Be aware that people who don't take you seriously can threaten your sense of self-worth. You may start feeling sorry for yourself, or worse, depressed. Indulging in these emotions is a trap that many healers fall into. Unfortunately, some people have been programmed to mock those who are happier than they are. They may be so intent on discouraging you from feeling great that it becomes a pastime for them to do this to you on a regular basis. The moment they see that you are in higher spirits than they are, they become jealous and taunt you until you are pulled down to their level. Then they feel as if they have won. In reality, they are insecure and end up losing out on the incredible value you could add to their life.

You can't accept this energetic put-down; otherwise you will get as depressed or unhappy as these people. Because you are so sensitive, you may even get more unhappy than they are. The solution to dealing with people like this is to agree with them. Don't try to challenge their ignorance. Whenever someone tries to put you or your feelings down, just say to that person, "You may be right." It's as simple as that. Then move to a different environment, even if it's another room in the house, and continue to do whatever you want to do.

People will always have their opinions—about everything under the sun, including you—but you can't let that influence what you know is best for you. Never let others control how you feel. People who try to dissuade or hinder you from

following your true feelings don't have your best interests at heart and are only thinking of themselves. No one has a right to enter into your personal life and dampen your spirit or make you feel bad about yourself. Your personal life is the place where you can and should have total dominion.

This is as true for our children as it is for us. We can help our children be true to themselves from a very early age if we respect the way they communicate through their primary gifts. My business associate Dennis shared with me how difficult it was for him as a child to be a healer/feeler because his parents didn't realize that he had an entirely different way of thinking and feeling than they had.

"From my earliest memories, my most powerful experiences were related to feeling," Dennis said. "I can still remember as a toddler the feeling of sitting naked on the grass and the cool water of a garden hose running over me under a hot sun. I could feel everything around me, including what others were feeling. This became a problem for me, as I was raised by parents who had a very strong visual influence. Things needed to be perfect—the shower curtain pulled all the way shut, the table wiped a certain way, etc. The inequities of my father were upon me. And for most of my life, I 'tried' to be something I wasn't. I tried to do things right and was always aware of what others might possibly be thinking about me.

"As an adult, the moment I found out that I was a healing person first, it was as if the person I thought I was supposed to be went out the window. Now I could be messy! I could relax and find out what was right for me. Gradually, I came back to the place of inner feeling that had guided me through all of my life. I moved away from being afraid of

being who I truly am to being free and not judging my natural communication with the universe."

How to Stay in Your Own Energy

We can protect ourselves from feeling lesser than others by learning how to stay in our own energy. The following exercise, which concentrates on the people in your immediate environment, can help you discern who is supporting you and who you are allowing to drain your energy.

1. Make a list with two columns. In the left-hand column, write the names of your closest family members and friends.

2. In the second column, describe how they make you feel when you are around them. Do they make you feel uplifted? Obligated? Lesser than them? Encouraged? Depressed or angry? Supported? Do not leave out any of the vast range of feelings and/or emotions you may experience when you are associating with them.

3. Take a look at who really supports you and who doesn't. Note whether you feel uplifted when you are around them or whether you feel as if they are trying to change you or bring you down to their level.

4. Identify the emotions that you pick up from each of the people who continuously drags you down. Realize that these emotions are *their* emotions, not yours, and that they are all doing the best

they know how. People may become negative when they are attempting to work out a challenging situation in their lives, but that challenge is theirs, not yours. If you get embroiled in the problem, there will be two people down in the dumps, not just one.

5. As you are identifying the people who bring you down, you may at first think, "How can I change this person so that she likes me more or so that she's the person I want her to be?" Do not indulge in this fantasy. You can't change anyone but yourself. If you're investing a lot of energy in getting people to be more positive and respectful toward you, give up the idea that you can or should change them. Release them to be who they want to be.

6. Begin to detach yourself from any emotions that do not uplift and strengthen you by repeating the following statement in your mind at least three times or until you feel it has become a part of you: "I am not responsible for how anyone else feels."

Now that you have identified those who are uplifting and supportive of who you are and where you are going in your life, you can truly relax and enjoy their company. At times when they are not caring or compassionate, just accept that and do your best to be a good example for them to follow. If at times they try to drag you down, don't fall into their negativity. This is the best time to leave them

alone to figure things out for themselves. When they ask for your advice, give them some suggestions, but don't try to save them from themselves.

THE BUSINESS SIDE OF THE HEALING GIFT

To a healer, business is all about relationships. Because you are a people person, you may have a difficult time in jobs that don't give you the opportunity to have contact with others. It's hard for you to sit at a desk by yourself. You need other people in your environment with whom you can share and develop meaningful relationships.

In a business setting, you can easily sense if someone is not doing what is in his best interest, and you will want to help. However, you may have a tendency to go overboard and get too involved in the person's energy and do too much for him. When that happens, your personal life gets mixed in with your business life and you lose the detachment that is necessary in a business relationship. This is not healthy for you or the other person. Overdoing your support for someone who is perfectly capable of helping himself can make the person weaker, not stronger. In addition, if you spend too much of your time on one person, you will be neglecting the people who really need your service. This is another good reason for you to learn detachment.

If healing is your first spiritual gift, you will think of business in terms of how you can be of service to people— and that's the way it should be. It's not about the money. You know inside of yourself that earning money is simply a byproduct of helping people do what they want to do in

life. Your primary concern is to do whatever it takes to make sure people get the service they deserve.

This genuine concern is your best asset. People will come from miles away to buy your product or avail themselves of your service just so they can be around you and feel your positive attitude. You may end up being their best friend without them even knowing why. People also feel comfortable with you because they sense that you understand the underlying reason why a service or product works or is valuable. They can trust you, and with good reason. You wouldn't recommend something that doesn't work for you or that you don't have a good feeling about in the first place.

A friend of mine shared with me recently that when she's in line at the post office, she always hopes she will get served by her favorite teller. Now that she knows about the four gifts, she suspects that he must be a healer/feeler type. "He is always genuinely happy and puts all of his being into connecting with every single customer," Anna told me. "He works efficiently but takes the necessary time to answer your questions and to make sure all your needs are met. He carries on a conversation with you, whether it's about something he observes as he's serving you or about the vacation you just took. And he's really interested—he's in no way being superficial.

"There hasn't been a day in the past five years that I've been in that post office when I haven't seen him with an upbeat attitude. He's such a role model for me of someone who can be truly present and engaged with each person he serves. And you can tell that he enjoys his work, even though it's what some might consider a 'routine' job. Being in his presence really warms my heart."

Attention to Detail and Quality

Healers are great at making sure that everything is of the highest quality, down to the finest detail. They see details that others miss, which is indispensable in the business world. It's often what can keep an organization or project team out of crisis mode. Have you ever had an experience where you were halfway into a project and realized that one tiny but critical detail was missing? When this happens, it usually holds up the project until you can address the missing element of the plan. It's better to attend to all the details ahead of time and move forward with faith and confidence than to experience trial and error. When healers are out of balance, however, they have a tendency to argue over which of the details is more important and, if they're not careful, they could lose the big picture of what really needs to be accomplished. Getting lost in the details can cause a project to get bogged down.

For healers, another key to success on the business side of life is keeping their emotions out of the business and remembering to stick to the facts of the job at hand—when it is scheduled to be completed, where it needs to go and what their role is in the venture. That kind of focus will help the project go smoothly and ensure that everyone will enjoy the final product or service, which is a healer's main concern to begin with.

When it comes to assessing a project, if you really want to know at the outset how successful it will be, just ask a feeling-type person how he feels about the initial plan. If he doesn't feel right about it, you could be in trouble. During the implementation phase, recheck with him about how he feels the

plan is progressing. Have him point out details you may have missed.

I recently invited two of my associates to recheck a video training project I was working on before it was finalized. One is a clairaudient, who is sensitive to making sure that all of the necessary facts are incorporated and that the plan is being followed. The other is a healer, who is an expert at pointing out important details that might otherwise be overlooked, and there were a few I would have forgotten if he had not been there. All three of us have the second gift of clairvoyance, so I felt secure that the visual presentation would be the best it could be. I owe them both a great deal of gratitude. Since my first gift is prophecy, I was more concerned about the big picture, or main purpose for the video, which is to train community leaders in spiritual energy techniques. This experience is a good example of how people with different spiritual gifts can form a complete inner and outer communication system while working together on a specific project.

Planning for Success

When healers are in balance, they have the patience to make sure that all the details are in order before undertaking something new. If they are out of balance, however, they may have the opposite tendency—to push ahead before having a plan in place. Their enthusiasm and eagerness to start working with people and to participate in the fun of making a project successful can cause them to jump the gun. That is why they sometimes have to stop in the middle of a project, regroup and get the missing facts before they can move back into action. If you have this tendency, here are some steps

you can take to use your healing gift to its fullest for success in any venture, big or small.

1. *Plan* what you want to do, when you want to do it, where it will take place, why you are doing it and who is going to benefit from it.

2. *Communicate* the what, when, where and why to each team member so that everyone knows his or her role in the endeavor. You will also have to make a list of the materials everyone will need to get the job done as well as the funds required to complete the project—and don't forget to add at least 10 percent extra as a contingency (anyone who has worked on a film or video budget knows about this one).

3. *Act* on the plan, making sure to check and re-check that each task is being done at the right time and in coordination with all of the other assignments. When part of the plan is not working at the grassroots level, it is the duty of the people involved at that level to pass a communication up the line so that the plan can be reexamined and a new strategy implemented.

You can implement these simple steps for planning anything in your personal, business or social life. You don't have to be a genius to be successful. It just takes a little patience to make sure all the details are in place. Many people have great ideas but don't take the time to create the best formula for putting them into action. If you are a healer, following

this effortless and straightforward method will also help you to avoid feeling guilty that you didn't do the best you could have done for yourself and the people who were counting on you to provide the best service possible.

Working with People and Policies

In order for healers to be successful in business, they need to have a blueprint, or structure, that clearly defines the group or organization they are working in. They like to have well-defined parameters so that they know what their responsibilities are. When the structure of the business is clear and they can sense where everyone fits within it, they feel secure and are able to move forward.

Healers also need to understand the reason for each policy and procedure. If a policy doesn't feel fair to them or isn't in line with the blueprint they were given, you can be sure that they will not abide by it. When this happens, it's usually because the management of the organization either created a policy or procedure that isn't a good match for that particular business setting or they failed to communicate its purpose to their associates. All those involved need to know why they are doing what they are doing or they will not feel as if they are part of the team.

Healers can sense when particular members of the group are not pulling their weight or don't understand where they fit. Dennis shared with me how he used his healing gift in a situation like this when he was working as an advisor for a company. He was planning to go on a business trip to another city but could not shake the feeling that something wasn't right with the program he was imple-

menting for them. So before he left, he took the time to do a review of the program to make sure everything was moving according to plan.

He sensed that one of the key team members did not have 100 percent of his energy in the project. By tuning in to his inner guidance, Dennis was able to bring to light why this man was distracted from what he needed to be doing and was able to communicate with him and with the rest of the team about it. He clarified where the problems were so that this team member's energy would not interfere with the project or with the other team members. As a result, the man was able to straighten himself out and become an integral part of the team again without creating any major roadblocks.

It's really true that a group or organization is only as strong as its weakest link. Because Dennis was able to feel that something was not right ahead of time and do what was necessary to rectify the situation, he could leave for his trip and feel secure that everything at the company was back on track and flowing in the best possible rhythm. Some businesspeople just charge through and force a project to completion without the depth of sensitivity it takes to tune in to potential problems that could affect a project's successful outcome.

THE SOCIAL SIDE OF THE HEALING GIFT

People who have healing as their first spiritual gift shine the most in social situations. Their vivacious personality can be infectious, and if you meet them at a party, you might feel as if they are your best friends by the end of the evening. Don't be surprised if they want to get close to you and find

out all the details of your personal life, including your latest fling or recent family outing. Although this may seem intrusive to some people, for healers it's simply their way of getting to know you and finding out what kind of person you are. It's all part of the fun they have in developing lasting relationships. They certainly won't use anything they learn against you, unless their motives are completely off.

Healers/feelers can instantly tell if you're having difficulty in your life and if something is bothering you. In order to relate to you and help you feel better, they may start sharing all of their hardships and suffering. Healers already have a tendency to carry around memories of these depressing events for years. If they are out of balance, they will continually talk about them and the misfortunes and heartbreaks that brought them on with anyone who is willing to listen. While their intentions are good, this is not a positive approach. Instead of bringing your energy up, they could end up bringing it down.

When you pick up this tone in a conversation with a healer, it's usually best to graciously change the subject. It is not beneficial for you or the other person to dwell in this negativity. It's critical that healers learn to let go of these emotions, but not by dumping them on anyone with a receptive ear. Not only is it counterproductive, but it could also chase away the very people they love and care about the most.

If you are a healer, the key to releasing these emotions is to put all of your relationships, past and present, into perspective. Anyone who has dragged you down or taken advantage of you in the past needs to be ancient history. By dwelling on these relationships, the only person you hurt is

yourself. When you don't let go, you are, in effect, holding onto the problems of the people you were involved with, even though their problems do not belong to you. If you continue to let their problems bother you, you will prevent yourself from moving to the next level in your spiritual growth. Also, the more you dwell on these past negative experiences, the lower your personal energy will become and the more difficult it will be for your spiritual helpers to get through to you.

Another big challenge for healers is that they take things personally. It's hard for them to receive any kind of criticism, and they will avoid it like the plague. If their identity is weak because they have identified too much with other people's feelings, they will get upset when people make fun of them or anyone close to them. This became apparent to me when I was in high school. At the time, I was the first chair in my high school band and had my own small dance band. I had been invited by our church to play a trumpet solo at their Easter service. It was to be a fanfare. My mother, whose first gift is healing, was among her friends and was anxiously and proudly awaiting my performance.

When the moment came for me to hit the high pitch, I cracked the note! After the service, I apologized to the pastor, who graciously accepted my apology. But on the way home in the car, my mother became incensed. How could I have embarrassed her like that in front of all her friends and people she didn't even know? I tried to calm her down, but the more I tried, the more enraged she became. As a feeler, my mother had a hard time letting it go; but for me, the cracked note was just one of those things that happens along the way—you win some and you lose some.

A Two-Step Formula for Staying Loyal to Yourself

How can you get to the place of self-mastery where you never feel bad about yourself ever again? How can you keep from feeling guilty, inferior, apologetic, ashamed, sad, remorseful, sorry, regretful, repentant, contrite or taken advantage of? What is the secret to having a full and abundant life without feeling as if other people are decidedly more important than you? And how can you heal from the habit of accepting others' opinions as superior to your own?

It's simple, as long as you don't make it complicated. The first step is to realize that you are not responsible for anyone else's feelings. If you have practiced the techniques I have shared so far, you know, without a shadow of a doubt, that you are not responsible for how other people feel. Can you breathe for them? Can you eat for them? Of course not. They are responsible for taking care of themselves, whether or not they realize it. When you understand and accept this basic premise of life and remain loyal to yourself first, you will be well on your way to healing yourself. This is the foundation for all positive therapy. If anyone tells you that you owe something to someone else or that you have to be obligated to anyone outside of yourself, that person is not giving you good advice.

Accepting the concept that all of us are responsible for ourselves is a critical step for a healer, whose vital concern is to never hurt anyone. The truth is that you cannot "hurt" others; they can only hurt themselves. I am not talking about this in the physical sense but in the emotional sense. We may do something that triggers someone's emotions, but that person's emotions can only get triggered in the first place if

he or she allows them to get triggered, just as our emotions only get triggered when we let them. No matter what anyone else says or does, we choose how we will react.

The second step to staying loyal to yourself is to find out the concepts that are weighing you down and keeping you feeling emotionally indebted to other people. Guilt is one emotion that has been used to manipulate us, even if it was used unwittingly by our parents and teachers. Guilt keeps us in line. From our earliest childhood days, before and after we started attending school, we were made to feel guilty about what we did. When we ventured too far away from our mothers to explore our surroundings, we were told to come back. If we did not obey, we were punished. If we said something that was unkind, however candid and truthful it was, we were told never to say anything like that again. How dare we be so frank and open? Eventually, we decided it was not worth being criticized for being straightforward.

When you got a toy for your birthday that you truly enjoyed, were you told to share it with others? Did you hear, "Shame on you for being so selfish!" Even though sharing is a good thing, you were probably told to share while you were in the middle of playing with the toy yourself, not when it was sitting idly by. The best time to share an experience you treasure is after you have gained fulfillment from it yourself, so no wonder you screamed when your parents made you feel as if you were being greedy for not letting your friend play with your toy. You hadn't even had the opportunity to enjoy it yourself yet!

The sense of guilt that has been instilled in us since childhood is what keeps us from being loyal to ourselves first and finding true happiness. You will continue to be vulnerable to

this guilt until you make this one decision that will change your life: the decision that you are going to play with your own "toy" (experience) before you share it with others. In other words, you can decide that you are going to enjoy everything in your life before passing it on. It's as if you are polishing and shining up what has been given to you to experience so that you can then pass it on with enthusiasm. After all, how can you pass on anything until you have learned from that experience for yourself? Making this decision can change your life.

Once you have allowed yourself the opportunity to find and enjoy what you are truly searching for in your own life, you can turn right around and offer the same opportunity to others. This is your spiritual right—and privilege. Honor yourself by deciding that you come first. Not second. Not third, but first. Everyone else comes second, third, fourth, fifth or sixth. Living in this way will give you the true joy you are looking for. I will be the first to tell you that I am not a psychologist (psychology is, in essence, the intellectual expression of spiritual concepts), but I do know that once you understand the core concept of being loyal to yourself, you will be able to release any guilt or frustration that may be ruling your life. That is what will make you happy. Whatever you do, don't feel guilty for feeling guilty!

The moment you start feeling unworthy, guilty or lesser than someone else, you need to take a second look, shift your perception and remember who you are as a soul. You are now, always have been, and always will be pure energy, or soul. You can't do anything wrong because life is a learning process. Believing that you are flawed is a concept that has been passed on from generation to generation. Someone has to stop the cycle of ignorance. It might as well be you.

Sharing Your Wisdom

Once healers overcome their own emotional stumbling blocks, they can help others get rid of their barriers. When they share the wisdom they have gained from experiences in their lives with those who may be going through similar experiences, they are actually furthering their own healing. This is what happens when any of us verbalizes and passes on our wisdom—it makes it more real and solid in our own beingness. As you work on getting your own life in order and are a living example of being loyal to yourself first, you will also find that people will be attracted to you in droves. Why? Because everyone, almost without exception, has been taught that others come first. They are missing that one key that will give them what they are truly searching for, and they are looking for someone who can help them find it.

When you are successful at being true to who you are, you will realize that there are hundreds and even thousands of people on planet earth who came to learn from you. If you think I'm exaggerating, take a look at this story. Once, when I was in Washington, D.C., I hailed a cab to get to a meeting. The moment I settled into the backseat, I started talking with the driver and noticed that his outlook on life was very upbeat. I was impressed with his wisdom and experience and how much he loved his job. During the conversation, I discovered that this was his last day of work. He had decided to retire. As I got out of the cab, I wished him well and mentioned to him that he must have inspired many people during his career. I thought that was the end of it.

A couple of hours later, I needed another taxi to get to my next destination, and to my surprise, the same cab driver

pulled over. My first thought was "What a coincidence. There are hundreds, maybe thousands, of cabs in the D.C. area and I got the same one—twice in a row." I got an inspiration from my guidance that it would be good to help this man see what a great service he had provided to people over the last thirty years of his career. I asked him, "How many people would you say you picked up every day?" He said that it averaged around twenty-five, give or take a few. I figured that since he probably didn't work seven days a week, he would have been on the job around three hundred days out of the year. So I said to him, "What you're saying to me is that you have reached approximately 7,500 people a year with your positive message." Surprised, he turned around and looked at me and replied, "Yeah, I guess you're right."

Then, with my calculator in hand, I said, "So over the last thirty years, you have helped over 225,000—almost a quarter of a million—people with their lives." He looked stunned, and I could see tears welling up in his eyes. He had no idea how many people he had affected in a positive way. I told him that it's not what you do for a living that's important, but how you do it, and that driving a cab was an avenue for him to do what he came here to do—to share his message. By the time I had reached my destination, I felt as if I had also done a part of what I came here to do, which is to help people understand the benefit of sharing the wisdom they have inside of themselves with others. I sincerely believe that this was the best retirement gift I could have given him and that meeting him was not a coincidence.

● ■ ▲ ∞

Are You a Healer?

Basic Personality
Supportive

........................

Personal Energy
Warm

........................

Favorite Color
Blue

........................

Key Sense
Keen sense of touch and feeling

........................

Key Question
Why?
I need to know why I am involved
in this situation and how I can help.

........................

Possible Professions
Doctor, nurse, massage therapist,
customer service representative

........................

Physical Concerns
Skin rashes, lower back pains, migraine headaches

How Balanced Are You in Your Healing Gift?

Give yourself 10 points for each YES answer

(Check YES if you feel that you display this trait more often than you don't.)

Positive Traits	YES	NO
1. I love life and enjoy people.	❏	❏
2. I have a bubbly and enthusiastic personality.	❏	❏
3. I have many friends and acquaintances.	❏	❏
4. I inspire others to be involved in life.	❏	❏
5. I have tremendous patience and concern for others.	❏	❏
6. I can sense when a person needs healing.	❏	❏
7. I can feel vibrations from people or objects.	❏	❏
8. I am open and giving in every aspect of my life.	❏	❏
9. I follow my true feelings and not my emotions.	❏	❏
10. I love to work with my hands and am detail oriented.	❏	❏

TOTAL POINTS: _____

How Unbalanced Are You In Your Healing Gift?

Give yourself 10 points for each YES answer

(Check YES if you feel that you display this trait more often than you don't.)

Not-so-Positive Traits	YES	NO
1. I feel depressed when I am around people who need help.	❑	❑
2. I feel left out or ignored when people don't listen to me.	❑	❑
3. I feel sorry for myself and complain when I don't get attention.	❑	❑
4. I take things personally and avoid criticism at all costs.	❑	❑
5. I am a care-taker (I make others feel guilty by letting them know how much I give to them) rather than a care-giver (who is benevolent but not demanding of others).	❑	❑
6. I indulge in food, etc., as a way of avoiding my emotions.	❑	❑
7. I throw temper tantrums when I don't get my way.	❑	❑
8. I gossip about people when I feel wronged by them.	❑	❑
9. I give people gifts so they will like me or be devoted to me.	❑	❑
10. I get bogged down in unimportant details.	❑	❑

TOTAL POINTS: _____

TOTAL SCORE: Balanced _____/_____ Unbalanced

(Fill in the first blank with the score from the previous page and the second blank with the score from above. Example: 80/50)

KEY:

If you are more balanced than unbalanced, congratulations!

If you are more unbalanced than balanced, concentrate more on developing the positive potential of your healing gift.

CHAPTER TWELVE

Communicating and Connecting
Successfully with Everyone

Now that you have a solid grasp of each of the four spiritual gifts and how to tap into the wealth of inner guidance that is available to you, it's time to explore two final pieces of the puzzle that will help you capitalize on your strengths: how your first and second gifts work together and how to effectively communicate with and relate to those whose primary gifts are different than yours.

Understanding who you are based on the order of your gifts is an essential part of accepting yourself as well as being true to yourself. As I've discussed throughout this book, as children we absorb what is in our environment and therefore have a tendency to take on the characteristics of our parents. If your father or mother had a different primary gift than you, you may still be trying to communicate like one or both of them rather than in your own way using your inherent communication system.

When you're not being yourself, it's impossible to have fulfilling relationships or to discover and accomplish what is

most important to you in your life. To come back into align-
ment with your true inner nature, you need to take a good
look at who you are divorced from your environmental in-
fluences. If you have done the exercises presented so far in
this book, you should have a clearer picture of who that is.
The next section will give you even more insight.

How Your Second Gift Shapes Your Personality

Your basic personality is shaped not only by your primary
gift but also by your gift order, especially the order of your
first two gifts. Together, these two form the foundation of
who you are and how you move through the world. Knowing
what both your first and second gifts are can provide you
with important clues for how to live your life and be happy.
Very often, the way you communicate through your gifts is
compatible with the type of profession you choose and even
the person you marry. You will have an affinity with and find
it easier to converse with people who have the same gift
order as you, especially when it comes to your first two gifts.

If you think you have identified your first gift based on
what you have learned so far, take a look at the following
combinations to see if you can recognize the two-gift combi-
nation that best characterizes your personality.

> ***Prophetic-Clairvoyant:*** If you are a prophetic first
> and a clairvoyant second, you receive your inspi-
> ration as a hunch and then a picture almost at the
> same time. You tend to be more visual and want
> everything to be organized and perfect in your
> environment.

Prophetic-Clairaudient: If you are a prophetic first and a clairaudient second, you receive inspiration as a hunch (which is like getting inspiration through all of the gifts at the same time), and then you get a thought or idea. You are more factual than other prophetics and you like to be in charge.

Prophetic-Healer: If you are prophetic first and a healer second, you receive inspiration as a hunch and then a feeling. You openly express your feelings, are extremely sensitive to your environment and may even be gregarious or flamboyant.

Clairvoyant-Prophetic: If you are a clairvoyant first and a prophetic second, you receive inspiration by getting a picture and then a hunch. You are more creative than clairvoyants who have a different second gift and are also likely to be more flexible and laid back.

Clairvoyant-Clairaudient: If you are a clairvoyant first and a clairaudient second, you receive inspiration by getting a picture and then a thought or idea. Your energy is dynamic and directed, and once you make up your mind to do what you want to do, you don't give up until it is done.

Clairvoyant-Healer: If you are a clairvoyant first and a healer second, you receive inspiration by getting a picture and then a feeling. You love people and are warm and gentle with them. You can be recognized by the sparkle in your eyes.

Clairaudient-Prophetic: If you are clairaudient first and prophetic second, you will receive inspiration by getting an idea or thought and then an impression or inner knowing of what you want to do next. You come across softer than clairaudients who have a different second gift. People love to be around you because of your creative approach to getting things done.

Clairaudient-Clairvoyant: If you are clairaudient first and a clairvoyant second, you receive inspiration by getting a thought or idea and then a picture. You get clear pictures of what needs to be accomplished. Your energy is forceful and you are self-motivated.

Clairaudient-Healer: If you are a clairaudient first and a healer second, you receive inspiration by getting a thought or idea and then a feeling. You make decisions quickly through your clairaudient gift and you are also concerned about how your choices affect other people. You love to work with children in a leadership role.

Healer-Prophetic: If you are a healer first and prophetic second, you receive inspiration by getting a feeling and then an impression or hunch. The prophetic's tendency to explore, when combined with the healer's tendency to socialize with a lot of people (at times without discerning their energy), can cause you to become fragmented. You will need to set your boundaries clearly and may need to regroup your personal energy often.

Healer-Clairvoyant: If you are a healer first and clairvoyant second, you receive inspiration by getting a feeling and then a picture. You love to be around people but have a greater ability to remain detached than other healer types. This helps you to keep a balanced perspective of what is right for you and what is not.

Healer-Clairaudient: If you are a healer first and a clairaudient second, you receive inspiration by getting a feeling and then a thought or idea. You have the best of both worlds—the feeling side of life and the practical side. When you are balanced in your first two gifts, you enjoy the opportunity of working with people. You also like to have all the facts before moving into action.

Communicating through All of the Gifts

While all of us are naturally stronger in two of the four spiritual gifts, never forget that you have all of the gifts within you, and you can learn to move in and out of each gift with ease. The more you develop your inner communication system, the easier it will be for you to use your gifts as avenues to connect with others, whether you're trying to get a job done, communicate with those who are close to you or interact effectively with people you meet for the first time. In addition, by taking the time to recognize what gifts others are using to communicate with you, you will be more sensitive about the best way to approach them. Think of how valuable it would be to know exactly how your boss or your spouse or your children are using their spiritual gifts to communicate their needs to you.

If you find yourself having difficulty exchanging ideas or feelings with someone you really care about, or if you want to develop a better relationship with anyone in your life, keep the following tips in mind. You can return to this chapter over and over again whenever you need reminders about how to communicate effectively with people whose primary gifts are different than yours.

Learning to communicate holistically, with all of your gifts, may take some practice. Don't be judgmental of others if they don't get what you're trying to convey to them the first time. Sometimes it's just a matter of slowing down to be certain that the person you are talking to is with you before you move on to your next topic, something every professional public speaker understands. As I noted in chapter 7, talking too fast is a sign that, at some level, you really don't want people to understand what you are saying. On the other hand, talking much more slowly than others forces them to move at your pace and could leave them feeling frustrated or as if they're being manipulated.

As you read the following pages, you may think of people you have dealt with in the past and find yourself wishing you had been able to use these insights back then. Instead of looking backward, think of all the relationships you can build for the future.

Now is the time to take charge of one of the most important areas of your life—how to express yourself so that you mean what you say and say what you mean. The information that you are going to read will also help you to meet people where they are so you can become a better listener. Effective communication is always a two-way street. Above all, be patient with yourself. With practice, you will learn how to get

your point across when communicating with people who have all of the various gift combinations. So sit back and relax as I take you on a tour through the range of combinations and interrelationships of our inner and outer communication system.

PROPHETICS

As a prophetic, how do I communicate and connect with clairvoyants?

- Give them all the details so they have a complete picture.

- Don't judge them for asking questions, which is their way of fully understanding what you're saying.

- Patiently answer all their questions.

- Draw a picture when you want to make sure that what you're saying registers with them.

- Remember that when they point their finger at you, it is because they are so quick to judge themselves.

If your first spiritual gift is prophecy, you will already *know* what you want to say before you say it. You might even expect the person you are communicating with to automatically know what you mean when you say it. But what may seem obvious to a prophetic will not necessarily be obvious to a clairvoyant, or anyone besides another prophetic, for that matter. Whereas a prophetic might think "It goes without saying," in reality, it does need to be said. Don't assume peo-

ple have the same picture or understanding that you have. They probably don't. Their perspective is based on their personal experience.

Words form pictures in our minds, and especially in clairvoyants' minds. Look at the word *peace*, for example. Take a moment and meditate on what this word means to you. See what images come into your mind. Let's say that when you were a child your mother always said, "Can't you just give me a little peace?" A person with this experience may equate peace with something he needs to do in order to avoid bothering someone else. For others, peace may bring back images of peace rallies and the 1960s. For example, you might tell a friend that all you ever wanted in your life was inner peace, but for her the word *peace* may conjure up memories of campus riots and the Vietnam War. "Give peace a chance" signs may appear in her mind while you're thinking of waterfalls and mountaintops or sitting quietly on a beach in Hawaii.

When you share your experiences with clairvoyants, realize that they will be formulating pictures in their mind and could easily leave out important details unless you provide them. Be certain to give clairvoyants a complete picture so that they understand fully what you are trying to say. If you hurry or leave out important details, their picture will be spotty and they will be forced to inject their own interpretations into your picture. They may assume that they have the whole picture when, in reality, they don't and therefore could end up taking away a completely different meaning than what you intended to convey.

Sometimes it will help to draw a picture for a clairvoyant, especially if it's a child or a person you will be working with on a particular plan. How many times have you done this in

restaurants on a napkin or on a legal pad at the office? This is a technique that works great when you want to make sure that what you're saying registers with clairvoyants.

Be sure not to judge clairvoyants if they ask questions. This is the best way for them to complete their picture and understand you. Remember, when two prophetics get together and have a conversation, they never finish a sentence. They already know what the other person is going to say. But if you do this with clairvoyants, they may look at you with a confused expression. By having patience and clarifying all their questions as you go, you will never have a problem communicating with them.

> As a prophetic, how do I communicate and
> connect with clairaudients?

- Get to the point and give them the bottom line rather than rambling.

- Clarify the facts—give them the what, when, where and why.

- Go with the flow and don't hold back or try to push.

- Be sure you intend to complete your project before asking them to get involved.

- Accept their help in keeping you grounded and on track.

Communicating with clairaudients is simple once you understand that all they need to move forward are the basic facts—what, when, where and why—in that order. To successfully communicate with them, it's essential that you give

them an understanding of *what* you're proposing to do, *when* you want to do it, *where* you want it to take place and *why* you have come to them.

That is the natural flow for getting something done in the most effective way possible—and a clairaudient knows this instinctively. The *what* is the big picture, the *when* is the timing and a visual of the end result, the *where* is the structure and the system, and the *why* is the fulfillment that comes from accomplishing and being involved in the project or endeavor. Finally, the *who* is the effect that the endeavor has on the people around you. This will give the clairaudient everything he or she needs to evaluate and implement your ideas.

Because of your tendency as a prophetic to constantly scan for information, you have a lot you want to share and may try to give clairaudients the whole big picture instead of just the bottom line. But the bottom line is all clairaudients need. They want you to get to the point so they can make a decision about whether or not they want to be involved with your endeavor. This is what makes them good businesspeople. They don't get easily distracted with trivia unless they let down their guard. They consider their time to be extremely valuable and have a mental or written schedule for every moment of their day. If they see you as being a constructive part of that day, they will let you into their space. Otherwise, they may ask you to make your point or leave.

The worst thing you can do with clairaudients is ramble, which is a tendency of people who have prophecy as their first gift. When you ramble on and on about nothing, clairaudients will get frustrated and either tune you out or throw you out, depending on their inner level of self-respect. They will want to know why you are wasting their time.

Since prophetics hate to be bored, working with clairaudients can be a lot of fun because there is never a dull moment. Clairaudients don't like to sit around and are constantly on the go, which can make life interesting for everyone around them—you will always be moving to keep up with them. All you need to do is go with the flow. But if you hold back or try to push, they will start setting their boundaries more rigidly, and both of you will feel pressure. You may find that you lose the opportunity to be involved with them or that they transfer whatever pressure has been generated back onto you.

Clairaudients are very practical, so don't try to fill their minds with a lot of fairy tales or "great ideas" that will never come to fruition. They may buy into it and back you for a while but will soon wake up to the fact that you were just talking out loud and you don't really intend to follow through. If you are an unbalanced prophetic, you might create a lot of hype around some fantastic scenario you envision but then get bored with the whole idea and drop it as if it never existed. Clairaudients don't like to be taken for a ride, and they will be very cautious about trusting you from then on. In order to gain the respect of clairaudients, be sure that you intend to complete your project before asking them to get involved.

On the other hand, if you have something worthwhile to say or do, clairaudients will invest their energy in being involved with you. Once they are convinced that you are serious and committed, they will back you all the way. A person with the first gift of clairaudience can be a great asset to you because she will help you stay grounded and on track so you don't get lost in continually scanning for information.

My associate Lauren Rose is a clairaudient, and she helps make sure we have all the facts on the table before moving forward with any plan. As a prophetic, sometimes my ideas are directed toward the future. She is great at bringing me back down to earth so that we take things in a step-by-step manner. Actually, it's easy for me to go along with this since my father was a clairaudient and I learned a lot from him about building from the ground up. I watched him invest almost twenty years building his business, and it inspired me to understand what it takes to create a program that works for everyone.

> ### As a prophetic, how do I communicate and connect with healers?

- Listen to what they have to say.

- Ask them for the what, when, where and why of their plan.

- Show them that they are equal partners with you, and be as committed to them as they are to you.

- Accept their help, but don't allow them to suffer as a result of taking care of you.

- Make sure they know you appreciate their contribution.

Carefully is the key word to remember when you communicate with healers. As a prophetic, it's important for you to keep in mind how your energy affects people with the first gift of healing. You can easily overwhelm them if you're not careful. When a healer feels the enthusiasm that

comes from a prophetic, he may get caught up in it and hop on board without first discerning whether what he's doing is the right thing for him. Then if the prophetic gets bored with having the healer around, he may drop him like a hot potato, leaving the healer to realize the mistake he has made.

The intensity of your passion can sweep healers off their feet so that they want to give everything they've got to help you succeed. They will do anything for you, and if you're not careful and alert, they may become devoted to you. If you are gentle and compassionate, you will respect their willingness to assist and back you, and you will also make sure that you are as committed to them as they are to you. Otherwise, they may eventually feel as if they're getting shortchanged and become depressed and angry. The relationship will start breaking down, and then nobody benefits.

To prevent this from happening and to get the most out of your relationships with healers, listen to what they have to say. Whenever they suggest an idea, take the time to flesh it out. It's challenging for healers to be factual in their communication, especially if they're not using their clairaudient gift to convey their feelings. However, they are great at coming up with grassroots plans that take into account how people are going to feel and be benefited by what you're doing. Just ask the healer to give you the what, when, where and why of the plan so you're both on the same page. Sometimes prophetics get so caught up in the idea of what they're doing that they forget about how it will affect everyone. Healers can usually tell you how the people around you will be impacted. This is where they excel—and they can cover your flanks if you pay attention.

Remember, healers are all about people and relationships, and they don't want to see you suffer. If you're a workaholic, they will try and make sure that you're taking time for yourself. In the process of taking care of you, they may deny themselves, end up suffering and ultimately complain that they've been doing everything for everyone else and blame it on you. Don't fall into this trap. Help them realize that you're a team, equal partners, and that each of you is just as important as the other. You can make the most of what they have to offer by providing them with direction so they stay on track and feel involved with what you are doing. All they want to do is help. When they no longer feel they're contributing to your success, they may start looking for someone else who will appreciate their incredible concern.

CLAIRVOYANTS

As a clairvoyant, how do I communicate and connect with prophetics?

- Pin them down by encouraging them to explain exactly what picture they have in mind.

- Ask questions when you won't be interrupted or under pressure.

- Ask how all the pieces of the puzzle fit together so you can see in your mind how their ideas will work.

- Don't judge their ideas but instead ask questions like "Have you thought about this?" or "Did you know that this may happen if you do this?"

■ Realize that they *are* interested in what you have to say
and are incorporating your ideas into their plan.

As a clairvoyant, you like to have the overall picture of a
project or plan before getting involved in it. Once you have
that, you can make sure that everything unfolds in its right
timing. So when a prophetic—who is often focused on mak-
ing things happen for the future—comes to you for help with
a creative enterprise she has envisioned, she may already be
miles ahead of you in her mind. You may feel as if you're
being pushed forward into the future before you have a clear
picture of how everything is going to fall into place. This may
cause you to feel panicky and as if you're not in control. In
an attempt to take charge of the situation, you may discount
the idea simply because you can't yet see what she has in
mind. You will tend to think that there must be something
wrong with the idea if it doesn't make sense to you.

Because the prophetic has had an inner knowing about
what she is conveying to you, she has a sense of the big pic-
ture. She may see all the possibilities, whereas you see only
what is in front of you. This is natural, since you weren't the
one who came up with the idea and you're not a mind reader.
So don't panic. To successfully communicate with a prophetic
in this kind of situation, you simply need to pin her down
and have her explain to you exactly what her picture is. Since
it's not really possible to explain an inner knowing, you need
to encourage the prophetic to translate the inner knowing
or hunch into a visual image that you can grasp and appre-
ciate. It is your responsibility to make sure that the prophetic
slows down enough to show you the components of the plan
so that you understand them.

In order to get all the details you need to complete your picture, simply ask questions. Set up a time when there won't be any pressure on either of you. If both of you are busy, it won't work. You need to set aside a time when you are able to face each other directly and there will be no interruptions. Otherwise, the prophetic will get distracted and you won't get a straight answer. An unbalanced prophetic will lose her train of thought and go off on tangents about other areas of the project that have nothing to do with your question, and you may not get the exact answer you are looking for.

Once you pin a prophetic down and she feels you are truly interested in her ideas and want to work with her, she will rely on you to help clarify the direction of a plan or project so that it benefits everyone involved. This goes for a family as well as a business situation. You can be of incredible benefit by making sure that everything fits where it's supposed to and that the plan is being implemented in the best possible timing.

Because of your knack for seeing all the pieces of a project—the goals and objectives and when each phase needs to be accomplished—you can make sure that the endeavor does not slow down or get too far ahead of itself as a result of important steps being missed. Project boards, spreadsheets, checklists and calendars are your best friends. Anything that helps you see how a project is progressing and unfolding according to its natural timing satisfies your analytical nature and gives you a sense of fulfillment. If you can see something, you know it can happen. As I mentioned earlier in the book, if you can't see in your mind how your business is going to work, it won't. But if you can see how all the pieces of the puzzle fit together, you are working with something

that will come to fruition with the least amount of effort. A prophetic will be your best friend once she realizes that you can help her implement her plan.

So the keys to having a positive and constructive personal relationship with the prophetics in your life are (1) listen to the prophetic's plan and what she feels needs to be accomplished, (2) find a time and place where there will be no distractions and ask her key questions about how the plan is going to work, (3) clarify with her the timing of each step, (4) ask her where she most needs your help putting the pieces together to make the plan happen, and (5) recheck along the way to see if there is anything else she needs.

Since you're naturally more analytical than prophetic-type people, you will see areas of the business or relationship that they may have missed. They will be eternally grateful to you for pointing them out, as long as you do it with an attitude of benevolence—in other words, without judgment. The moment a prophetic feels put down or undermined in any way, he will escape. You may never see him again. This is why the best approach is to ask questions such as "Have you thought about this?" or "Did you know that this may happen if you do this?" In a way, you're steering the energy and keeping the whole relationship on track—and the prophetic won't even know it! See, you *are* in charge.

As a clairvoyant, how do I communicate and connect with clairaudients?

- Let them know when you don't understand something they're saying.

- ■ Don't interrupt clairaudients when they are talking.

- ■ Pay close attention to what they are saying so they do not have to repeat themselves.

- ■ Prepare your questions for them ahead of time so you don't waste their time.

- ■ Allow them to rely on you to help them open up and be with people.

Clairvoyance and clairaudience are closely related because people with both gifts have very high standards. But there is a difference between them. The clairvoyant has a propensity toward perfectionism, whereas the clairaudient simply wants the best for himself and others. Nevertheless, their shared appreciation for quality creates a special bond between them, and if they are both in balance, their communication is usually easy and simple.

The best way to communicate with clairaudients is to let them know when you don't understand something they are saying. They may give you a fact, but it may not be clear to you where it fits in the overall picture. Clairaudients think in key words, and unless clairvoyance is their second gift, they may only give you enough facts to formulate a sketchy picture in your mind.

Be careful, however, not to interrupt clairaudients when they're talking, as it disrupts the flow of their thoughts. If you interrupt them midstream, they won't necessarily pick up where they left off, and you may miss the opportunity to find out what they were intending to convey. Since clairvoyants are so busy painting pictures in their minds when other

people are talking to them, they periodically forget to listen. You don't want to do this with clairaudients. Make sure you pay close attention, because they do not enjoy repeating themselves and often won't, even if you ask them nicely. They may also get impatient with you or feel encroached upon if you ask the same question over and over again, or even more than once.

It's sometimes a good idea to prepare your questions ahead of time before talking with clairaudients. When they feel they're not moving forward and making progress in a conversation, they may blow up and get argumentative. If you argue back, they will usually sever the relationship. Clairaudients don't see the point in communicating with you if they think you're not willing to listen or take direction from them, even if they are just making a suggestion. If they feel as if you're not compatible with their mode of thinking, they may decide it's too much trouble to maintain a personal or business relationship with you. They want to feel as if you are with them—mentally and spiritually.

However, once an affinity is established, you will make a great team. Clairaudients appreciate someone who listens to the facts and can formulate a clear vision of how a system can be coordinated and implemented. They consider you to be a valued advisor. If it is a true partnership, they will defer to you to make a decision. Be aware, though, that delegating in this way was their decision, not yours, and if they don't want to go along with your final conclusion, they will most likely try to convince you to change your mind to go along with what they think is best. If they can't persuade you, they may compromise, depending on how high the issue is on their priority list.

When the direction they want to go in is really important to them, they might go around you at the risk of damaging the relationship—and you may not even know about it until it's too late to do anything to change it. But if they are honest and fair, which is the true nature of clairaudients, they will let you know that they have overridden your decision or revised it so that it fits more with what they want to do. In situations like this, clairvoyants must decide if the matter is crucial to their picture or whether they can be flexible enough to compromise with the clairaudient. Ultimately, someone has to make the final decision, and it is up to you to make sure you have all of the facts before you try to force the issue simply because it changes your picture.

Since clairaudients tend to be loners when they don't feel comfortable around people, a clairvoyant can help bring them out of their shell. Because of your sunny personality, you can even act as a buffer between them and other people. Your intervention could be especially helpful for clairaudient men who have been taught to hold their feelings inside and who have a difficult time socializing. You can act as a go-between until they feel at ease with a new acquaintance.

Clairaudients ordinarily have only two or three close friends. They may rely on you to help them communicate with people they don't know or have not yet developed a close relationship with. Don't feel put upon. Their admiration for you in this area is insurmountable. You can't even put a price on it. They may not tell you, but they consider you to be much more competent than they are with human relations—a skill they consider to be paramount—and they count on you to help them bring this ability out in themselves. They are learning from you how to open up and be with people.

Clairaudients can help you learn how to discern the energy of other people. For example, you may be at a party in the midst of a delightful exchange with someone you barely know, and your clairaudient friend or spouse will be evaluating his personal energy by listening to the tone of his voice. He will have the person sized up within a matter of seconds. Then, on the way home, you will hear exactly what was on the clairaudient's mind while you were busy exchanging niceties. The clairaudient may confide in you that he has no intention of developing a deeper relationship with the person and why. He is not in any way being judgmental; it's simply his way of keeping his personal standards high by associating with people he trusts and respects the most.

All in all, a person with the first gift of clairvoyance will find clairaudients to be tremendous colleagues or companions because they both share an innate sense of organization. The clairaudient takes a step-by-step methodical approach, which is compatible with the clairvoyant's energy of evenness and dependability. Your energy is cool and steady; a clairaudient's is smooth and direct.

As a clairvoyant, how do I communicate and connect with healers?

- Do not judge or ignore them.

- Give them the details and fine points.

- Avoid unrealistic expectations by communicating clearly where they fit in your life.

- Take control of conversations that get bogged down

with too many details by telling them what you have to
do next and when.

■ When they talk about their troubles, ask them to articu-
late how you can help them.

You are, in many cases, the best type of person to com-
municate with healers. By giving them all the details so they
feel as if they are part of a conversation, you do them a great
service. This will delight them when you are talking with
them about how they can get involved with something you're
doing. It's easy for you to communicate in this way since
you're just as insistent on getting the same fine points for
yourself to complete your own picture.

People with the other spiritual gifts may have a more dif-
ficult time communicating with healers. For instance, if a
clairaudient is not balanced, a healer will recoil when he feels
the clairaudient's strong energy directed at him. If a
prophetic is not in balance, she may leave out the details that
a healer needs in order to feel secure and acknowledged in
the relationship. As you can see, communicating with a
healer can be delicate at times, and people who have little
understanding of themselves may be oblivious to this, espe-
cially if healing is their third or fourth spiritual gift.

The secret to developing a strong bond with healers is
not to judge them. If you do, they will surely withdraw and
may feel sorry for themselves. Those who already have a ten-
dency to be quiet will more than likely not tell you how they
are feeling but leave you to guess what the problem is. The
best way to avoid this trap is to communicate clearly with
them about where they fit in your life so they don't have

unrealistic expectations about your friendship or business relationship. If you remain silent, someone you don't care to associate with may assume that you are his best friend and could end up taking advantage of you and your energy. If you try to avoid that person, he may take it personally; and if he feels the least bit slighted, he may even create rumors about you. Then you may find yourself having to invest a lot of energy to dispel those misconceptions.

Healers just want to feel included. Don't make the faux pas of ignoring them. If you don't want to associate with them after a period of time, a good way out of the relationship is to introduce them to other people in your circle of friends or associates who would be more compatible with them. In a business setting, have them work with someone else who would appreciate the opportunity of working with them so you don't have to spend as much of your valuable time explaining all of the numerous details they may need to be part of the team.

On a personal level, let healers know that you only have so much time to talk. Unbalanced healers will go on forever and eat up the time you have allotted for your family or other friends. To make sure you're not left hanging on the phone forever, take control of the conversation. Tell them what you have to do next and when. They will realize that they need to wrap up what they're saying and be more respectful of your time.

When healers engage you in conversation about their trials and tribulations, ask them how you can help them. This keeps the boundaries of the relationship clear and forces them to face squarely their motive for talking with you about the issue. Are they really interested in you helping them find a

solution for their problems or are they just trying to get your sympathy? If they're insistent on drawing you into their personal misfortunes or spreading hearsay about other people, simply ask them, "What would you like me to do?" Again, this impels them to organize a purpose for the conversation as opposed to just chitchatting and involving you in their troubles or prejudices. Once healers know where their boundaries begin and end with you, they will love and respect you.

You can also be of great service to healers by helping them learn how to be loyal to themselves. Give them hints and a reference point—you. When you are in balance, they will follow your lead, and both of you can have the time of your lives sharing personal and business experiences. Just remember, they are all about people.

CLAIRAUDIENTS

As a clairaudient, how do I communicate and connect with prophetics?

- Stay relaxed and don't make a big deal out of anything.

- Be direct but gentle.

- Motivate them by providing a variety of tasks.

- Direct the conversation to extract the facts that you need.

- Pay attention to their suggestions and inner knowing of what might happen.

- Help them organize their many ideas and show them how to focus on one thing at a time.

The main goal in life for prophetic-type individuals is to have fun and make life interesting. When you share an experience with them, you will often hear them say, "That's interesting!" Even though they may seem to be off in their own dreamworld instead of listening to you, when you are finished talking they will invariably let you know how "interesting" they found your conversation. Prophetics do this because they are curious about everything and are scanning the universe for more information on the topic you are discussing.

Prophetics are more unconventional than both clairvoyants and healers, and if they have developed their healing gift, they may even be extroverted or flamboyant. As a clairaudient, you are more introverted and thoughtful and therefore may think prophetics are crazy. Just realize that they are experimenting with life and like to shock people out of their conventional outlook. Once they have your attention, they will relish the opportunity to help you see that life is to be lived, not endured.

The best way for clairaudients to have good relationships with prophetics is to stay relaxed and not make a big deal out of anything. They don't, so why should you? Even though this might be challenging for you because of the intensity you invest in your career and life in general, if you put yourself under pressure and then complain to a prophetic that life is hard, he may not want to stick around and be friends much longer. He will look for someone with a lighter outlook on life, especially if you're in the habit of lecturing him on becoming more responsible. Prophetics are responsible in their own way, even though it may not seem like it to you. They just go about handling their affairs differently than you, that's all.

By letting go a bit and allowing prophetics to be themselves, you will discover that they can be a great asset to you. Harnessing their creative energy and imagination, which can be quite remarkable, will be well worth your while. They are also likely to be attracted to you for what you can do for them. If they're sharp, they will take advantage of your inborn organizational skills to help them fulfill their creative ideas. They may perceive working with you as an opportunity to come down from the clouds and live a more practical life instead of jumping around from one relationship or career to another.

Clairaudients need to be aware of the tendency of prophetics to get bored easily and move from one project to another. When you're working together on a venture of any sort, you can help them stay motivated by giving them a variety of tasks so they don't get bored and abandon the project. If they seem to be getting ungrounded, this may be a sign that they're hungry. When you notice that they become very quiet and their energy is getting thin, offer them a snack or a good meal, which will instantly perk them up again so they're ready to move back into action.

You can be a great mentor to prophetics by helping them organize the many ventures and ideas they have floating around in their heads and by showing them how to focus on one thing at a time. Once on board, their inherent flexibility allows them to adapt to your way of thinking and functioning. Because they make great managers and executives, prophetics can help relieve some of your burden of responsibility and make your job a lot easier to handle.

As I mentioned earlier, clairaudients sometimes have a hard time pinning down prophetics and getting them to stick

to the facts. To effectively deal with their tendency to ramble, direct the conversation to extract the facts that you need. Simply ask pointed what, when, where and why questions, like "What is it you're saying exactly?" or "Why are you doing this?" This will force the prophetic to organize his thoughts and give you the information you need, and it will save you a lot of valuable time in the long run. Be aware, though, that when you're communicating with prophetic-type people, it's important to be gentle and direct in your approach. If you come down too hard on them, they will feel as if you don't see their merits and may resent you for not acknowledging their true value.

Always ask prophetics for their opinions—they're full of them. You will get honest and helpful answers. If one of their suggestions seems too "way out there," see how you can make it fit with the overall plan of action you're taking. Recognize that there is always some truth in what they have to say. They may be sensing something that's going to happen in the future and offering a strategy that will prevent you from jeopardizing your plan. Because you deal with facts and prefer not to conjecture about what "might happen" down the road, you may be reluctant to hear what they are projecting. Be forewarned—you may regret not paying attention to their inner knowing of what is yet to come and may end up on the wrong side of "I told you so!" To better understand where a prophetic is coming from and to expand your own creativity, pay attention to your inner knowing as well.

Your forte is coming up with ideas that benefit a great number of people. Here, again, a prophetic can help you implement your ideas by communicating their value to the masses. At times, they may take credit for an idea since they

were so involved in bringing it to fruition. But they don't mean any harm by it—it's simply a result of their believing so strongly in the concept. When you complete a project with a prophetic, remember to celebrate. This will help her regroup and close the energy on the experience so she's ready to move forward with the next project. When in sync, working as a team with a prophetic is a win-win situation for both of you.

> ### As a clairaudient, how do I communicate and connect with clairvoyants?

- Give them the big picture with vivid details.
- Let them know they are important.
- Help them set their priorities to reduce their stress.
- Take the time to communicate so they know where they stand.
- Treat them as equal partners.

The best way for you to communicate with clairvoyants is to give them the big picture of what you're talking about and then break it down into compact units. As you introduce each concept or idea, give them enough detail to portray what you're describing and also let them know the purpose that each detail fulfills in the context of the overall scheme. For example, if you're having a conversation about a project they will be involved in, describe each step as vividly as possible so they can clearly see themselves participating in the process. Clairvoyants see in colors and will have an inner movie going on as

you talk with them. They will be busy formulating in their minds the approach to take for each phase—in collaboration with you, of course—so they can see whether the picture is clear and everything makes sense. They may even be able to fill in details you haven't thought about.

Clairvoyants will pull from their personal experience and visualize people who may also be valuable to the project and even fulfill specific tasks. They are good at perceiving people's strengths and knowing where each person can make the best contribution. Initially, you may not want to delve too deeply into the creative details of the plan, but give the clairvoyant enough so that she can see the images that come to her from her spiritual helpers as you illustrate each phase. Once she can see the whole picture come together, she will have the sense that your plan can work and will be able to see how she can be involved. Ask the clairvoyant how the plan looks to her, how many people she thinks will need to be involved and, in the overall scheme of things, how many people will be influenced as a result. If she can see a clear picture of how to make it work, you know you have a winning proposition.

Once a project is agreed upon, clairvoyants have a tendency to want to get involved right away. You may have to remind them that you need to organize the entire agenda before the first step can be implemented. If they're smart, they will let you do this. They will also want to communicate the plan immediately to everyone who will potentially be involved. Let them know that you want to make sure only the right people are selected and that you would appreciate the opportunity to sit down and discuss everyone's recommendations before determining who is most suitable. Your first priority is ensuring that the standards are kept to the highest level possible.

Clairvoyants also have a tendency to want to drop all of their other projects and move forward right away with the latest one. When this happens, you may need to help them organize their priorities so they don't get overloaded. As you may remember, clairvoyants put themselves under pressure by taking on too much at once. Because they're anxious to see the product or service in its final form, they sometimes get overwhelmed and stressed out before they even start.

In two-income families, where both parents are working, there can be a lot of stress unless household tasks and responsibilities are managed properly. Juggling jobs and home can be a major challenge. Obviously, one person can't handle everything. When a clairvoyant and a clairaudient are in this situation, they can work as a team to reduce the pressure. Having a schedule is a necessity. With the clairaudient handling the priorities and the clairvoyant overseeing who needs to get where and by when, you have a very successful combination.

To effectively communicate with clairvoyants, it's important to let them know that they are important to you and that they really do matter. Also tell them what you want to accomplish together. Taking the time to do this will pay off for you in the long run. Sometimes you may get so headstrong that you think you don't have time to talk. This could spell disaster in your relationship with clairvoyants because they will feel as if you're leaving them behind, and they won't have a clue about what you're doing or thinking. When they don't have a picture in their mind, they may invent a scenario that is not factual and then assume that they are right.

In cases like this, because of their reluctance to cause friction, clairvoyants may not say what's on their mind and you'll

assume that everything is all right. But don't count on it. The situation can explode in your face if you're not careful. You can save yourself a lot of grief by communicating openly with clairvoyants every step of the way so they don't erroneously fill in the missing details. Otherwise, you may lose the peace and harmony that you both value.

Clairvoyants want to be equal partners with you. Their sense of self-respect demands it. When they are in balance, they have the natural ability to see that there is no greater or lesser person on planet earth—that everyone has strengths and weaknesses and that the important thing is to concentrate on the good qualities and let the rest fall by the wayside. This helps them in two important ways. Not only does it inspire them to demand the respect they deserve, but it also makes them less quick to judge people. Because of your superior ability to discern people's strengths and weaknesses, you may judge someone and discount him before giving him a fair chance. With the clairvoyant by your side, you will be more inclined to allow that person an opportunity to prove himself in the right setting and situation. It could be that the clairvoyant is able to see a dormant talent and ability that is not immediately apparent to you.

When you look at the dynamics of a relationship such as this, you can see how the different spiritual gifts can work together to create a vital inner and outer communication system. What a person with one gift doesn't sense, another will. It's like having a mean, clean spiritual machine with the gears constantly interacting to generate a tremendous amount of power and energy—for yourself and others. When you use your gifts, and those of others, to their fullest potential, you can accomplish anything. You don't have to lean on

others; just learn from them and try new things. In terms of clairvoyants, recognize that once they have a clear picture of what you want to create and they believe in it as you do, they will be one-pointed about making sure each step—just as you described it to them in the beginning—materializes before your very eyes. When this occurs, they will be more than ready to move on to the next endeavor and will handle it with pride and conviction.

> ### As a clairaudient, how do I communicate and connect with healers?

- Acknowledge their feelings.

- Steer conversations about people in a positive and constructive direction.

- Help them clarify the facts behind why they are emotional without getting involved in their dramas.

- Take the time to impart all the important information they need to feel secure.

- Don't judge them for being emotional.

Because of your strong energy and direct approach, a healer may feel as if you're being abrupt when you are simply conveying the facts in a straightforward manner. That's because healers are all about feelings, not facts. While you may not want to take the time to give them the details, this is the wrong approach when you're communicating with a healer. When you give them only the bare skeleton without the meat, they may feel as if you don't care because they

don't feel concern behind your words. Instead of saving time, you may have to spend more time later patching up the relationship. You would do better to exercise a little more patience at the outset.

The key to effectively communicating with healers is to always acknowledge their feelings. They need to know that you care about them and believe in them. Once they feel you have their best interests at heart, they will go the distance with you. By giving them an opportunity to be involved with people, you do them a great service, and they will thank you for it—over and over again. But be cautious; their dedication to you can border on devotion and they will do anything to get your approval. To steer the relationship in a more healthy direction, help them to find their niche and use their strengths to excel in their work. This will boost their self-esteem, which is important for healers, and will open them up to finding their true purpose in life—uncovering the spiritual message they yearn to share with others. Once they go deep inside and begin to recognize and appreciate their true worth, healers will be a powerhouse of energy and will inspire all the members of your team.

As I mentioned in chapter 11, it's important to regroup with healers frequently to make sure that they understand the direction you want them to take and also to see how a plan or project is unfolding. Because they are often working directly with people at the grassroots level, they can give you valuable feedback as to what is working and what is not. When their sensitivity tells them that a part of the plan is not falling into place, they can usually find out why. By taking the time to tap into this ability of

theirs, you can save time and money. In a family situation, if a healer does not feel good about how something is working, it's usually because the clairaudient has not taken the time to explain exactly what his intentions are and how he wants the healer to be involved. I am not implying that the clairaudient is the one in control, simply that it takes two to tango, and it's usually the clairaudient who forgets to impart all of the important information that a healer needs to feel secure.

Since healers talk about people as a way of processing issues in their relationships, try to steer conversations of this nature in a positive and constructive direction to help neutralize any harsh feelings the healer has toward others. This can be touchy if the healer insists on being negative and feeling sorry for herself over such things as a relationship that has gone sour. The only option you really have is to acknowledge her feelings and agree with her that the situation needs to be clarified. Ask her what she thinks the solution is. If she can't tell you and insists on being angry or annoyed with the person, just let her know that you are there for her if she needs you. Don't try to help her too much. All she really needs to do is calm down and release the emotions she is experiencing. Above all, don't judge her for being emotional, or she will have two problems to deal with instead of one. She will work it out. Just give her some time. Once the initial antagonism has subsided and she is back to her true feelings, the healer will be able to sort it out on her own.

When people are really looking for your help and not just using you as a sounding board to indulge in their emotions, you may be able to help them find some clarity. If they don't understand how to deal with their feelings or the situ-

ation, you can help them break down the problem using steps such as these:

1. Ask them what the problem is.

2. Ask them what they would like to do about it.

3. If they don't know, ask them what emotions they are experiencing.

4. Ask them why they feel that way.

5. If it's because someone said something that caused them to react or did something that they didn't like behind their back, you may want to ask, "Who is responsible for how you feel—you or the other person?"

If they say, "I am," you may have helped them realize that no one is responsible for making them miserable—or happy—but themselves. They usually just need to see that it would benefit them to be more loyal to themselves and not worry about what other people do or say. If they insist that the other person is responsible for their feelings, ask them if they really think it's possible to change someone else. The answer should be self-evident.

What I've described is not therapy. You are simply helping them clarify the facts, no more and no less. You're helping them get clearer about what they're experiencing on an emotional level so they can decide what to do about it. If you start giving advice, you have gone too far. By being there for them but staying detached and not getting involved in their dilemma, you are helping them more than you know.

···················· HEALERS ····················

As a healer, how do I communicate and
connect with prophetics?

- Pinpoint their second gift, which is what they use to
 communicate.

- Avoid getting caught up in their hype; put what they say
 and do into perspective.

- Cleanse yourself, tune in to your feelings about what
 they propose and know that your opinions matter.

- Keep your boundaries clear.

- Pin them down to share details about projects you will
 be working on together.

Because healers are so sensitive, you pick up feelings
from others without even realizing it. When you are dealing
with enthusiastic prophetics or people with other gifts who
may be unbalanced and not as positive or gentle as you, you
can easily get overwhelmed if you're not careful. It can be
difficult for you to buffer yourself from their energy unless
you consistently use the Personal Energy Cleansing tech-
nique throughout the day. You can do it many times a day if
you like, but at the least, I suggest doing it once in the morn-
ing, once at noon and again before going to bed.
To reap the full benefit of this exercise, do it every time you
start feeling pressure or someone else's energy encroaching
on your boundaries. You can do it either physically or men-
tally, depending on whether there are other people around.

It's not easy to discern your feelings from your emotions in the midst of conversing with people who are more forceful or less positive than you. So you may need some extra backing to help keep you clear. Here's a way to get an extra dose of cleansing action when you really need it: First, cleanse yourself using the Personal Energy Cleansing technique. Then ask your personal angels to come around you and cleanse you. Since their energy is much stronger than yours, you may feel a rush of energy flow through you that feels like a charge of electricity. May the force be with you! I don't suggest doing this every single time you need cleansing, but you can do it when you need a little extra oomph to get you back into your true self. Your angels are always there when you need them, and this will give you the confirmation that they are real and are continuously looking out for you.

When you're around prophetics, especially ones who are unbalanced, they may dominate the conversation, and you could easily feel besieged by all their creative ideas and promises. Since they are mainly concerned about what will happen in the future, be careful not to buy into something that might not even happen. It may happen, but it may not. Avoid getting caught up in their hype. Take time to cleanse yourself and tune into your own feelings about whatever they're proposing.

Prophetics often get involved in moral issues and feel that they have to save the world. They may lack the understanding that the world is a giant schoolroom, where all of us are growing spiritually by learning how to survive and respect ourselves and each other. An unbalanced prophetic may spend his whole life engaged in trying to alter the state of consciousness of everyone on the planet. Good luck. This

does not mean they can't be a positive force for change. Many prophetics become social workers, ambassadors, international businesspeople or philanthropists and help a lot of people.

What prophetics need to understand is that in order to make lasting change in the world, you need to change yourself first. As Mahatma Gandhi said, "We must be the change we wish to see in the world." We need to be examples for others to follow. If you join prophetics in trying to change people into who you think they should be, you will be inviting total frustration into your life. What's more, you could easily end up wasting your time on issues that have nothing to do with your personal life purpose. By putting what prophetics say and do into perspective, you can help them realize that they need to be loyal to themselves first.

Healers and prophetics will be naturally sensitive to each other's energy—your energy will become their energy and vice versa—so it's important to keep your boundaries clear. If you allow yourself to be devoted to anyone outside yourself, you may wake up a few years later and realize you have been influenced or manipulated into taking up another person's cause. Stay clear in your own mind about what you want for yourself so that you don't follow someone else down his or her path but choose the one that is right for you.

Prophetics are easy to talk to once you get to know them. Since they communicate mainly through their second gift, you will have more success understanding how they feel, think and act if you can pinpoint what that gift is. They are also a lot of fun to be around, so you should have no problem getting along with them famously. They will make you laugh

and help you see the brighter side of life. Their laid-back attitude is infectious and will help you stay out of your emotions. They may sometimes move a little too fast for you, but if you let go, you will enjoy the journey.

If your spouse has prophecy as his or her main gift, it's important that you do not become the underdog in the relationship. Because unbalanced prophetics will fall into the trap of being know-it-alls or mama- or papa-goose types, they could make you feel as if your opinions don't matter. Yes, they do matter! Their assessment of a situation may be right for them, but you need to rely on your own sensitivity and how you feel about a situation. Trust your feelings, because they are always right for you. In actuality, when two people have different opinions about an issue, they are both right. No one has the total truth. By sharing your views, you can come to a reasonable solution about what needs to be done. It's also important that you don't try to give prophetics advice. This just opens the door for them to do the same with you—and then you have two people caught up in trying to change each other.

Make sure that you pin prophetics down to share the details of what they intend to do. Even though they may have all the details in their head, you need to know what those details are if you're going to be working together toward a mutual goal. To assure that everything is congruent, ask them to set aside a time to sit down with you to coordinate the elements of the big picture. This is something they love to do, and you may end up having a brainstorming session that generates all kinds of new ideas and directions. Then you can choose the ones you want to follow through with and know that both of you are on the same page.

As a healer, how do I communicate and
connect with clairvoyants?

■ Help them overcome their tendency to judge them-
selves by reminding them of the incredible qualities you
see in them.

■ Use colorful images when giving them the details of what
you're describing.

■ Tell them as much as possible about the people you're
talking about without being judgmental.

■ Give them a synopsis of the picture you are going to
paint for them and then fill in the details.

■ Share an experience or give an example so they can
relate what you're saying to their experience.

You're a great asset to clairvoyants because they need the
details you're so good at providing in order to formulate a
picture in their mind of what you're saying. You can convey
colorful images through the tenor of the story or experience
you're describing. When you give them direction, consider
yourself an artist and paint a word image that lets them see
where they fit into the picture. Because of their immense
empathy for others, they will also want to know as much as
possible about any of the people you mention. Since healers
are all about people and relationships, this should be easy
for you.

Clairvoyants formulate a vision in their mind's eye of
who they are by comparing themselves with other people.

When they don't feel they measure up to what others are achieving, they tend to judge themselves, which is unhealthy and threatens their self-esteem. On the positive side, they sometimes use others as benchmarks for how they can grow spiritually. When they look at people who are living their dreams and being true to themselves, they see examples of what's possible for them to achieve.

As a balanced healer, you can be a perfect example for clairvoyants. You naturally feel one with everyone and all things and do what feels right for you. When you follow your feelings and not your emotions and remain true to your own purpose, you will inspire clairvoyants to live their lives for themselves rather than continually seeking to please and cater to others. People who have a well-developed healing gift can help clairvoyants gain perspective and realize that what other people think does not matter.

One way to help clairvoyants overcome the pressure they put on themselves to live up to everyone else's expectations is to remind them of the incredible qualities that you see in them. This is a healing in itself. How many times do you take the opportunity to simply say to a person you admire, "I love and respect you, and I appreciate your qualities of _____"?

I'm sure you can think of at least two or three positive traits for each of your friends and associates. You might even want to invite a few of your closest friends to your home so you can share your appreciation for each other in a formal way. Have one person sit in a chair while you stand and look straight into her eyes. You can even hold her hands if you feel comfortable doing this. Then say out loud, "Mary, I love and respect you, and the qualities I see in you

are your incredible concern for yourself and others and your positive outlook on life." Of course, be genuine and point out the qualities that are unique to each person. Then change places and have Mary do the same with you. You can repeat this simple healing technique several times, depending on how many people you have in the room. I suggest doing the Personal Energy Cleansing technique in between each person so that your spiritual guidance can give you the insight you need to share from your innermost being.

Just think how consciously appreciating others can impact your life. Instead of having a tendency to criticize yourself and others in your home or work environment, you will more readily see the positive qualities everyone has. Not only will this be healing for them, but it will become a way of life for you and make your life much more enjoyable.

> As a healer, how do I communicate and
> connect with clairaudients?

■ Give them the facts—the what, when, where and why.

■ Don't ramble on about your feelings; back up your feelings with facts if possible.

■ Don't be afraid to speak up—be sincere and say what you feel or think.

■ Prepare yourself ahead of time for meetings and conversations, creating a detailed agenda if necessary.

■ Avoid asking personal questions or getting too chummy when you first meet.

■ Be an equal partner in relationships, and remember to
 be loyal to yourself first.

Give clairaudients the facts. This is the cardinal rule for
communicating with them. They will love you for it. Let
them know that you respect their time and energy by not
rambling on about your feelings. When you do discuss your
feelings, back them up with facts if you can. Even though
you may not always be able to put your feelings into words,
sharing with clairaudients the experience that stimulated
your feelings will help them to help you identify the point
you want to get across. Don't be embarrassed when you're
not able to find the right words. Just take a big, deep breath
and say whatever comes to your mind. You will notice that
a clairaudient will do anything to help you as long as you
are sincere.

Most healers are used to talking about their feelings and
emotions surrounding an experience. Be aware that some
clairaudients may not be willing to listen to all the details
you are inclined to share; they may simply want the bottom
line. When you sense this, it will probably make you feel un-
comfortable. If they are the least bit unbalanced, they may
not be willing to wait for you to get to the point and may de-
mand that you come to a quick conclusion. This could make
you uneasy and cut off the flow of your feelings. It can be so
jarring to you that your mind will go blank. Clairaudients
can't relate to this because they have the natural ability to
hear their inner voice. They don't understand why someone
can't just speak up! The more pressure they put on you, the
emptier your mind may become. You may start to feel as if
you're in a void, forget what you're doing there in the first

place and wonder why you put yourself in such a compromising position.

The best way to avoid such a confrontation is to prepare yourself ahead of time. Make a detailed agenda and, if possible, communicate it to your friend or associate before you begin the meeting or conversation so she knows what you would like to discuss. Doing this will help you organize what you want to say before you knock on the door or walk into the room for your meeting. Also, when you're both in agreement about the items you will be covering, if one or both of you deviate from the agenda, it will need to be by mutual consent.

During the conversation, ask the person if she has any questions before you move onto the next topic. She will feel as if you've done your homework, and you have—on clairaudients! Obviously, it's important to do research, if necessary, on what you will be talking about. That's where advance preparation pays off. Be sure to communicate the what, when, where and why of each topic on the agenda and fill in any important details. The clairaudient will appreciate this. Gathering details is one of the main strengths of healers, which is why they make such great researchers. They have the extreme patience it takes to pull together all the fine points necessary to make conclusive decisions, including ones that could potentially affect many people.

Communicating with clairaudients in a social environment is much easier than dealing with them in business. Your enthusiasm and passion for life will inspire them to open up and be themselves and not feel as if they have to prove themselves to you or anyone else. With clairaudients you've just met, don't get chummy or ask too many personal questions,

because they don't like that. They consider it an invasion of their privacy. If you get too personal with them before they get to know you, they may avoid you in the future. But it's fine to ask them what they like to do. This may help them relax enough to start sharing about themselves, which they rarely do.

At a party, don't take it personally if a clairaudient sees a friend or associate across the room and dashes over to have a private meeting with him. That may be the main reason he came to the gathering to begin with. Clairaudients are not party animals. They are very choosy about their friends, and there has to be a purpose for every close relationship they have. If you try to force yourself into their inner circle, you may end up being rejected, especially if your motives are not pure. Clairaudients can sense when people want to get close to them for reasons other than mutual comradeship.

Your gift of healing can translate into a strong sense of support, which is fine as long as you realize that clairaudients want you to stand up with them and not under them. They want an equal partner, whether in a business or personal relationship. Be careful not to let their strong and decisive energy overpower you. Above all, you need to retain your personal identity—you are your own person. Don't ever forget that.

If you find yourself divorced or separated from a clairaudient, realize that your circle of friends will change. Because you live for relationships, you may get depressed and feel as if you have been abandoned. The truth is, as a couple you attracted certain people for a reason. Perhaps they were business associates of your spouse or they were couples who were simply interested in socializing with couples. If someone is

truly your friend, he will stick with you. If the person was simply an acquaintance, don't make more out of the change in your relationship than it really is. Understand why he was part of your life to begin with, and just let him go. This is part of the releasing process you will need to go through in this type of situation.

Even though it's customary for a woman in our society to keep her former husband's name after a divorce, many women take back their maiden names in order to help them cut the tie. There may be practical reasons for keeping your former husband's name, especially if there are children involved. There's no right or wrong when it comes to what you call yourself; this is a personal decision. Be aware, however, whether your choice to keep your married name is a reflection of the fact that you're still identifying with your husband. Whatever you decide, be sure you do what's right for you and that you are setting your own personal direction and not holding onto the past.

Clairaudients and healers need each other. For example, outgoing healers can encourage unbalanced, introverted clairaudients to open up and share their true feelings. Clairaudients can teach unbalanced healers to be more grounded and factual. Since clairaudients have strong identities, they also provide excellent examples to healers of how to maintain their self-respect, draw healthy boundaries and be more faithful to themselves. What could be better?

... ● ■ ▲ ∞ ...

Human Relations: Communicating with Others through the Four Gifts

A PRACTICAL EXERCISE YOU CAN DO NOW

Here's a final exercise you can do with friends or even by your-self. By now you should have a solid understanding of all the spiritual gifts and the different ways people with these gifts interact and com-municate with each other. The purpose of this exercise is to highlight these differences so that you recognize how important it is not to expect others to see and do things the same way as you. You will see what happens in an unbalanced situation, where those involved do not listen to each other and they "expect" their family and friends to respond in the same way as they do. By role-playing the balanced aspects of the gifts, you will also experience how miscommunication can be turned into great communication and positive interaction.

You can also do this exercise by yourself to help you unfold your own spiritual gifts and better understand how you communicate with yourself and others. By imagining each of these roles in your mind—or by speaking them out loud as you role-play by yourself in a private room—you can create an inner and outer conversation with yourself that will help you learn how to communicate in a more productive manner. You can do this technique with others or by yourself countless times to help you gain a more in-depth personal perspective on how to handle day-to-day exchanges of ideas and better connect with people in your family and work environment.

Step One: Who's Listening?

It's ideal to have more than four people participating in this ex-ercise, but it can also be done with larger or smaller groups. If done

with less than four people, some people will need to act out more than one role.

1. Ask everyone to do the Personal Energy Cleansing technique.

2. Ask for four volunteers (or have one or two people play more than one role). Have each person choose a different spiritual gift: prophecy, clairvoyance, clairaudience or healing. People may want to choose to play a gift with which they feel an affinity, but this is not necessary. They will be acting out the *unbalanced* aspects of these gifts.

3. Come up with a situation in which the people playing each of the four roles need to communicate with one another. For example, have the group enact a situation in which they are on a camping expedition far from civilization and they get lost in the woods. Or they can act out the roles of a family who is meeting to decide where to go on vacation. Be creative. The stipulation is that no one is willing to listen to anyone else.

4. The prophetic will act out being the know-it-all, the clairvoyant will act as if everyone sees the same picture as he or she sees, the clairaudient will act out being the "boss" and "in control," and the healer will act out feeling sorry for himself/herself or being the underdog.

5. Give the group four to five minutes to act out the scenario. (To keep the energy high, don't let this go on too long.)

6. After the role-playing, have everyone do the Personal Energy Cleansing technique again.

7. Have each person in the role-playing situation share what he or she experienced.

8. Have those who did not participate in the role-playing share what they observed and what they learned from watching the interaction take place.

Step Two: Spiritual Communication

1. Ask everyone to do the Personal Energy Cleansing technique.

2. Choose four more volunteers—or have the original volunteers play the roles, taking the same spiritual gifts they previously chose (if necessary, have one or two people play more than one role). This time they will be acting out the *balanced* aspects of each of the spiritual gifts.

3. Use the same scenario that was used in Step 1. This time, the people role-playing each gift will listen to each other and cooperate. Tell them that the emphasis is on positive communication and coordination.

4. Give them four to five minutes to act out the scenario.

5. After the role-playing, have everyone do the Personal Energy Cleansing technique.

6. Have each person in the role-playing situation share what he or she experienced.

7. Have the people who did not participate in the role- playing share what they observed and what they learned from watching the interaction take place.

8. Ask everyone to share how they can make what they learned and experienced practical in their everyday lives.

.

Conclusion

With what you now know about your inner guidance and how it works together with your four spiritual gifts, you are ready to make some decisions that will affect your life forever. By using your inner and outer communication system to discern what is working for you and what is keeping you from being loyal to yourself, you have what you need to create the life you want from this point on.

As you move forward, remember that you never have to feel alone. You have a team of spiritual helpers backing you every step of the way. You have all the tools you need to access their guidance at any time and to communicate successfully with yourself and with everyone in your life. You will also feel more comfortable communicating with people from all walks of life, anywhere in the world, when you realize that essentially we are all the same. We all want to know who we are, where we came from and where we are going in life. We simply have a different way of expressing ourselves through our four spiritual gifts. By putting into practice what you have learned about the four gifts, you will have a better idea of what makes people feel and act the way they do and how to connect with them. You will also be better prepared to share your wisdom with others.

You have already taken what you have learned from your parents, put it to the test and discovered what has and has not worked for you. As you grow in your understanding of who you are and learn how to change the habits that produce stress and pressure in your life, you will be able to pass that wisdom on to others. Most importantly, whatever you learn about yourself through your experience will set the example for those who come after you—your children, their children, and so on.

If you decide that you want to have the best possible life experience and maximize the inspirations you get every day, all you need to do is set your personal energy in that direction. Tell your spiritual helpers that you want to:

1. Learn as much about yourself as possible throughout your life.

2. Have a solid and clear communication with them at all times.

3. Unfold all of your spiritual gifts to your maximum potential.

4. Have the best communication possible with your loved ones, friends and business associates at all times.

5. Have equitable, fifty-fifty relationships with everyone you meet.

6. Keep your motives clear when dealing with people and be discerning when someone else is trying to take advantage of you.

7. Be spiritually and materially abundant for the rest of your life.

8. Be solution oriented at all times.

9. Create the opportunity to share your spiritual message and your wisdom with everyone who needs to hear it.

10. Learn from everything you have experienced in your life and release the past, live in the present and plan for the future.

If you set these intentions to create the lifestyle you have always wanted, you will never fail, even when you go through major learning experiences. Gathering wisdom from your experiences is the whole point of living. The best way to move forward is to set your personal direction to do what makes you happy. Don't think so much about how you are going to do it. Just let your spiritual guidance know you are serious about what you came here to do and realize that if you don't do it, it won't get done. Letting go and seeing what unfolds is part of the fun.

The only thing that can stop you is doubt and fear because that is what creates indecision. As soon as you make the decision to be loyal to yourself first, there is nothing that can stop you. You will have the solution to every challenge in your life and all the backing of the universe behind you.

For Further Study

Howard Wimer is the creator of Inner Expansion Workshops, an international community-based program that teaches spiritual energy techniques that can be used in everyday life. These workshops show how to tap into the inspiration that is available to every one of us to accomplish our life purpose. Howard Wimer also offers community workshops and eCourses through Inner Expansion Virtual University, including an online leadership training program for people who want to form community involvement circles in their own areas. His programs are built around the eight spiritual laws that govern the big picture of life.

To learn more about the individual and community programs that are offered through Inner Expansion Workshops and Inner Expansion Virtual University, visit www.innerexpansion.com or call 1-866-241-6708 toll free (U.S. and Canada) or 001+ 949-474-5542 (international).

PHOTOGRAPHY BY RENEE LEVINE

Howard Wimer has been involved in the personal growth field for over thirty years. Since 1973, he has given lectures and workshops throughout the United States, Europe, Canada, the Caribbean, Australia and New Zealand. He has appeared as a guest on hundreds of radio and television programs and has been featured in major newspapers around the world.

He is the founder of Inner Expansion Workshops and Inner Expansion Virtual University, successful international community-based programs and courses designed to give people the tools to understand who they are and what they want to accomplish in life.